Four Lines a Day

THE LIFE AND TIMES OF
AN IMNAHA RANCH WOMAN

Also by Janie Tippett

Janie's Journal
Vol 1: 1984-1987
Vol 2: 1988-1991
Vol 3: 1992-1996
Vol 4: 1997-2004
Vol 5: 2005-2009
Vol 6: 2010-2015

Janie's work appears in
the following anthologies:

Talking On Paper: An Anthology
of Oregon Letters and Diaries

Crazy Woman Creek:
Women Rewrite the American West

Four Lines a Day

THE LIFE AND TIMES OF
AN IMNAHA RANCH WOMAN

Janie Tippett

Lucky Marmot Press
www.luckymarmotpress.com
Wallowa, Oregon

Originally published by Pika Press.
First and second edition layout and cover design by Janis Carper.

ISBN 978-1-9565300-2-5 (paperback)
ISBN 978-1-9565300-3-2 (ebook)

This third edition was published by
Lucky Marmot Press in Wallowa, Oregon.
https://www.luckymarmotpress.com

*Garden gate at Uncle Ira and
Aunt Louise's place — now the Driver place.*

TABLE OF CONTENTS

Memory Is Elusive... Capture It

THE MIND is a wonderful machine. It needs but be just refreshed and incidents can again be revived in their former clarity.

A LINE each day, whether it be of the weather or of more important substances, will in time to come bring back those vague memories, worth remembering, to almost actual reality.

— from the cover page of the first diary Mary Marks owned

PREFACE TO THE FIRST EDITION

This book has been well over ten years in the making. The chapters were written during those first years and subsequently lost in my computer. Since the days of submitting hard copy manuscripts are now a thing of the past, I was totally defeated. All I could do was write on the laptop. I knew nothing else. I had given up hope of ever retrieving them when Fishtrap, a Wallowa County literary organization, rescued me.

My wish was to have the book published before Mary passed away just before her 90th birthday, but that didn't happen. However, I read each chapter aloud to her before her death, and the look of satisfaction and remembering in her eyes told me what I wanted to know. It is my sincere wish that you, the reader, will enjoy this attempt to capture, not only Mary's life, but the culture of Imnaha as well.

— Janie Tippett
March 12, 2010

Acknowledgements

Many folks helped with this book.

I wish to thank Ellen Waterston for coming up with the title, "Four Lines A Day", Stanlynn Daugherty for copying the photos onto discs, and the Write People, my writing group, who provided valuable critiques. The Fishtrap Writers' Retreat on the Imnaha, where the bulk of this book was written, provided a quiet, safe place to write in the very environment I was writing about.

Thanks also to Janis Carper and the staff at Fishtrap for making this happen, to Pam Royes and Addie Marks for proofreading the manuscript, and to my husband Doug, who has supported my writing over the years. And mostly to Mary, for her inspiration and friendship. If I have left out anyone, I'm sorry.

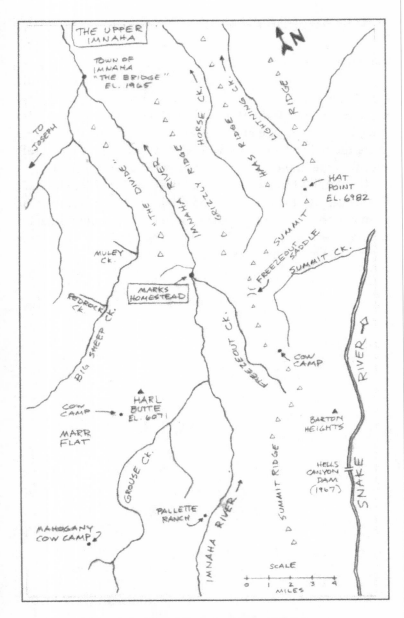

Map of the Upper Imnaha by Rick Bombaci.

Four Lines a Day

THE LIFE AND TIMES OF
AN IMNAHA RANCH WOMAN

*This third edition is dedicated to Rick Bombaci,
without whom this book would not exist.*

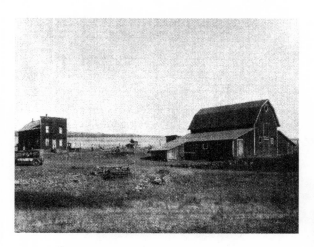

Midway Stage Stop near Camp Creek Rd.

1 THE IMNAHA

Near the mouth of Freezeout Creek, on the upper Imnaha River in Wallowa County, Oregon, the view extends upward in all directions. Upriver, canyon after canyon is separated by draws and creeks, leading to Jayne's Ridge, which is nearly all forested. The trees are mainly ponderosa, with cottonwood and alder growing along the river's course, until the river disappears from sight around a bend.

Thickets of serviceberry and wild rose are scattered up and down the steep hillsides and along the "benches," those high, open, gentler slopes between the vertical rims and above the river. Fences built by early settlers march in straight lines up to barren ridges that end in sky. Sky is at a minimum in these steep canyons, and seems to wander above like a river, allowing the imagination to wonder what lies beyond.

To the east the view is of the same steep country rising to a high ridge line, Summit Ridge, where, from the fire tower at Hat Point, one looks down on a canyon even more rugged than the Imnaha. Here, the Snake, another north-flowing river, carves its way through Hells Canyon. According to some, this is the deepest gorge in North America. The scene is both beautiful and forbidding, where miles of hazy blue shadows in mysterious separations fade into the Bitterroot Mountains of Idaho and Montana. To the southeast, the abrupt, jagged spires of Idaho's Seven Devils Mountains rise above seemingly bottomless canyons. To the west, the Wallowa Mountains create another beautiful boundary for this isolation.

Far below, in quicksilver light, the waters of the Snake gleam as the river winds through rugged canyon walls etched by water, weather, wind, and time. Here, as on the Imnaha, hundreds of miles of silence are broken only by the distant roar of rapids or the lonely sound of the wind. North flows the Imnaha toward its confluence with the Snake, and those waters, soon swelled by the Salmon and the Grande Ronde, empty into the broad Columbia, and thence to the Pacific.

People not native to these canyons have a difficult time trying

to distinguish between views, the sheer vastness overwhelming their senses. But old timers can stand on any high promontory and name every creek, as well as name the people who settled at the mouths of those creeks. Like Freezeout Creek, which drains the high country southeast of the Imnaha, streams like Chalk Creek, Indian Creek, and Grouse Creek were named for the stories that wrote their history.

Following ancient Indian trails, the early settlers gained access to land "on top." Here above the yawning breaks of the Imnaha, where the canyon slopes and high plateaus meet, grow large forests interspersed with meadows kept green in summer by snow-fed streams and natural springs. Here, also, begin the lesser canyons of Big and Little Sheep, each with their own creeks. Between the Sheeps lies a great, high, grassy plateau known as "the Divide," where early stockmen summered their livestock, and their descendants still do.

Marr Flat, another large, open meadow in the high country between Big Sheep and the Imnaha, was also used for summer grazing. Above Marr Flat is Harl Butte, where a fire lookout tower commands a sweeping view of all this vast country.

On Summit Ridge, which divides the Imnaha from the Snake, lies a low point called Freezeout Saddle. From the saddle one looks down Freezeout Creek to the west and Saddle Creek to the east. The Saddle Creek trail, which dives off into the depths of Hells Canyon from the top of Freezeout Saddle, once provided a lifeline to those scattered settlers living along the Snake.

A supply cabin, which still stands near the mouth of Freezeout Creek, was stocked with staples needed by those Snake River ranchers. Men leading pack strings of horses and mules would ride up Saddle Creek from the Snake and down Freezeout canyon to restock their supplies. The only other transport was by boat many miles downriver to Lewiston, Idaho.

It is beyond the imagination of most people that homesteaders came to these places to settle, raise families, and farm the rough, rock-strewn benches and sparse river bottoms; to raise cattle, sheep, and horses, to battle summer heat and frigid winters, and to deal with isolation. For those who lived along the upper Imnaha, rare trips "outside" were made over rough, rocky wagon roads

that required frequent fording along the downriver miles to the small settlement of Imnaha, known as "the Bridge," where, indeed, a bridge did span the river near the confluence of Sheep Creek and the Imnaha River. From that tiny town a narrow, winding dirt road led out on top to the towns of Joseph, Enterprise and other settlements by way of Camp Creek, where the Midway stage stop provided a place to stable horses and spend the night.

Into this land, this formidable land built by scores of basaltic lava flows, came these first white settlers. They would inhabit part of the former homeland of Chief Joseph and his Wallowa Band of Nez Perce.

Among them were Benjamin and Elizabeth Marks, with their eleven children. In 1889, by team and wagon from the lush rainforests of western Oregon, they came to homestead at the mouth of Freezeout Creek. Their grandson Clarence, known all his life as Kid, would in 1934 marry a young woman named Mary Heaverne. This is Mary's story, told through the pages of the diaries she so faithfully kept from 1938 to 1998. It is also a story about this place, the Imnaha, a place in the heart as well as on a map.

Mary by her historic old log barn. (Janie Tippett photo)

2 Meeting Mary Marks

My earliest memory of Mary Marks goes back to the summer of 1968, when my first husband Lyman Nash and I, along with our four children, moved to Wallowa County. Lyman's first job was working as a cowboy on a ranch on the lower Imnaha River. It was a large cow/calf operation, and the cattle summered up on top. The headquarters on top was the Steen Ranch out on Chesnimnus Creek, and the cattle grazed the U.S. Forest Service permit land that adjoined the Steen Ranch. In the spring the cattle were driven up Corral Creek to the Steen place, then gathered up in the fall and "trailed" down, or driven in bunches, to winter on the lower Imnaha.

At that time Kid and Mary Marks were in partnership with Gene and Mildred Marr on a place at Horse Creek, one of the major tributaries of the lower Imnaha. Their place included a house, outbuildings, and Forest Service grazing land.

Oftentimes my husband would brand at Horse Creek. On my days off from the hospital in Enterprise where I worked as an aide, I'd drive the road along the Imnaha, along with my children, and visit Lyman. Let me tell you, I got used to driving that narrow, rim-hugging road, and did it often. I went to brandings and loved seeing the new little calves on the sunny benches.

It was a wonderful place to calve out the cows, and so much warmer than on top.

One day I was driving down the Horse Creek grade with three of my kids, and I saw two folks on horseback far below.

I stopped to chat with them when I got down to the bridge, and the couple turned out to be Kid and Mary Marks. They were both riding Morgan horses. Mary was beautiful, rugged yet refined, tough yet gentle, and so friendly. Kid was one big smile when he found out I was the new cowboy's wife, and the couple took an immediate liking to my children. Since Mary was childless, she always loved children, especially country kids.

One night Lyman had an accident and drove into the Imnaha River. He survived, but the event shook me up. Mary was there to console me and offer advice and sympathy. Not long afterward,

Lyman and I divorced. Mary became a good friend during those hard times.

Four years later, still single, I was doing a lot of outdoor catering. One such job was to cook for the Wallowa County Wranglers, a riding group that once numbered quite a few local horsemen. On this occasion they were camped at the Boundary Campground up Bear Creek, where I did my beef and beans for the group in Dutch ovens in the ground.

The next morning we saddled up and rode up to the Standley guard station. Kid and Mary were the guides for this ride, and they furnished me with a horse, another Morgan. The couple had wonderful horses that were well shod, and handled themselves well in the canyons and on that steep trail. They were sure-footed, calm, dependable horses, and well-broke.

Kid and Mary showed the other riders where to cross Bear Creek, because the trail wasn't marked and you just had to know where it was. Mary had often cooked for pack trips into the mountains, and knew those high mountain trails well. I was impressed with her riding ability, her knowledge of the country, and her common sense to handle any situation that might arise in camp or on the trail. She was my heroine from then on. Thus began a friendship that lasted nearly 40 years, up until she died just shy of her 90th birthday.

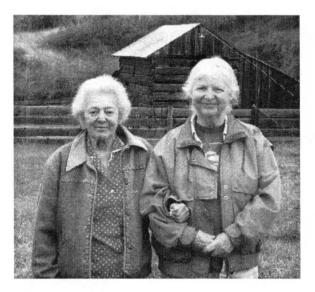

Mary and Janie. (Diane Josephy Peavey photo)

Mary's first diary, 1938.

Diary pages.

3 THE DIARIES

Mary's eyes were wistful as she spoke to me one April morning in the year 2000. I was taking a break from the Imnaha Writers' Retreat, a writing program put on each spring and fall by the literary organization Fishtrap. The retreat is held at a place just across the river from Mary's place, and I'd walked down the road to get some fresh air and visit my old friend.

"Just before I die," Mary said, "I'm going to burn all those darned diaries."

Without thinking, I started to say, "Don't do that!" But then I realized that what Mary was saying could be interpreted to mean two different things. Looking at her through more than 30 years of friendship, I suddenly knew what Mary was trying to tell me. I sensed it was a plea for help in identifying her life.

Mary had been childless. She had spent 67 years on the Imnaha watching her women friends raise their broods. She'd seen their children grow into adulthood and produce children of their own. Perhaps Mary thought herself a failure in a world that holds so much store in bringing children into the world.

Also, I knew, she missed the comfort afforded in old age by one's offspring.

Carefully, I weighed my next words, giving myself time to digest what she had just said. A plan began to form in my mind, one that had peeked through my subconscious many times before. Finally, after a long pause, I spoke.

"Mary," I said, "I should very much like to read your diaries."

"They aren't worth much," she replied. "But you take *em. Please take 'em. I'm not going to keep one any longer. Tired of doin' that."

But I left without taking the diaries.

The next spring, I returned to the retreat, where I continued working on a project I'd been putting together in jerks, stops, and starts. Somehow, my heart wasn't in it. All I could think about was what an incredible life Mary had lived. While I lived next to her for two weeks, I put myself in her skin, and then those diaries began to haunt me. I looked at the awesome canyons surrounding

me, and put Mary in them, riding those steep draws, living in cow camps, working side by side with her husband Kid through all those seasons of her life, doing what had to be done to survive.

At the end of the two-week retreat I drove down Mary's steep driveway to say goodbye. She invited me in, and we got to talking. Mary brought out some old photos of that life I'd been imagining.

One was of a young, beautiful Mary, with dark hair and sparkling Spanish eyes. I got up my nerve and asked, "Mary, I would like very much to write a book about you. I'd love to incorporate you and this place into a story for all the world to read."

Mary's eyes glowed with their former youthful beauty and she smiled.

Then she stood up from her chair by the kitchen table and walked to a hall closet, where she reached on tip-toe to clutch an old worn shoe box.

"Had to put this up high during the flood," she said. "Otherwise it would have been drowned where the water flowed through the livin' room into the kitchen here." She handed me the box, which had been secured with a string.

"Here," she said. "They're yours for as long as you want."

My hands trembled as I took the box. This 83-year-old woman was entrusting me with her life. I gave Mary a hug and left. Driving home was hard, but I promised myself I wouldn't open the box until such time as I could concentrate fully on Mary's handwritten words.

Later that night, leaving the dishes in the sink, I departed to my bedroom office and shut the door. I held the box in my hands and placed it on the desk, then carefully untied the string. Neatly stacked inside were Mary's small five-year diaries, dating from 1938 to 1998, some of which were worn and barely holding together.

The first diary had been a Christmas present — of sorts — from Mary's 13-year-old brother-in-law Elmer. At a Christmas party at the Imnaha Grange, Elmer had drawn the gift with a hook. He didn't want the diary, so he offered it to Mary, who didn't want it either but graciously accepted. The little book had a dark blue textured leather cover softened with use and closed

with a small brass clasp. Each gold-edged page had a day printed at the top, with five ruled sections below, one for each of five years, each given only four lines. I could imagine it and most of the other leather-bound diaries had made long trips in saddle bags as Mary rode those many miles back and forth to the upper cow camps.

Mary used the Palmer method of writing that she had learned in school, so her penmanship was as tidy as the house and routines she would keep. Her numerous entries were penned in ink, with the exception of the first few, which were written in pencil.

Eagerly I read Mary's words. Four lines a day, chronicling not only her life, but an era "on Imnaha." When I next looked at the clock it was 3:00 a.m. Blearily I read the next entry.

> *June 27, 1941 — Laurel and I got up at 3:30 and milked*
> *and went to the Flat so we could go to town. Had a*
> *good time and got home at 8 o'clock.*

Like so many entries, these words only gave the bare facts. When Mary had written she was going to town, that meant she had to get up early, milk six cows, strain the milk, set the pans to cool, eat breakfast, saddle her horse, and ride the three miles from from Harl Butte to Marr Flat, where she and her friend could hitch a ride to town. Mary's life among the Marks family and the canyons would be recorded in only four lines a day, but the real stories would be hidden between Mary's handwritten lines.

Still, I could feel her excitement about going. It was a rare occasion for any canyon person to go to town, and young Mary must have looked forward to the event very much.

As I read, a pattern began to emerge, a pattern of life dictated by the seasons, and a theme that revolved around work. Work filled her days, her husband's days, their family's days, and their neighbors' days, There was also a closeness, a loyalty, a sense of fun, and the indomitable ability to cope with each day as it came.

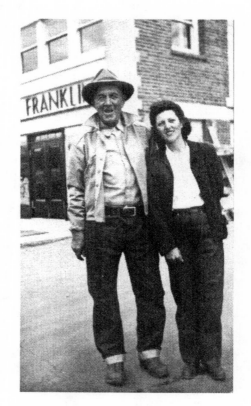

Mary and Dad Andy Heaverne.

4 The Heavernes

My dad met my mom when he was with Buffalo Bill's Wild West Show when it came through Santa Barbara, California.

Buffalo Bill Cody was a myth-maker. Attired in extravagant, colorful trappings that would be copied in Hollywood, Buffalo Bill's cowboys entered arenas from New York to San Francisco on galloping horses, yippee-kiyaying with spurs a-jingling. This showmanship established a cowboy image, but it should not be surprising that many of the stars of those early Wild West shows really were working cowboys who utilized their skills to enhance their roles.

Take Andy Heaverne, for instance. Andy was a member of Buffalo Bill's traveling troupe, billed as a trick and fancy roper when the show rolled into Santa Barbara, California, in the early 1900s. You had to be good to be a trick and fancy roper, and Andy had learned roping just like brushing his teeth while growing up on his dad's place out on the Divide in Wallowa County.

"My dad got acquainted with a pair of Spanish brothers after one of the shows," said Mary. "They were real good with horses. My dad took a liking to them, and one evening they said they wanted to introduce him to their pretty sister, Rosita. I guess it was love at first sight, because my Irish trick-roper father married his señorita in the Mission Santa Barbara and moved her to Oregon. My dad had cattle and land on the Divide here in Wallowa County, so he moved my mom to Joseph."

The small town of Joseph nestles under a huge mountain. Both are named after Chief Joseph of the Nez Perce Indians, who originally inhabited this country. Described by writers of the time as "the last frontier of the West," the town still had boardwalks when Mary grew up there. "Those boards would shake loose of their nails and open up, and you'd have to walk real careful or one would come slappin' you in the face," she remembered.

In that little town Andy and Rosita Heaverne began their life together in a small, wooden-framed house, where Rosita would

Andy Heaverne at the Pendleton Roundup.

give birth to six children. First, in 1913, came Clifford, and two years later Mercedes, who was called Mercy.

Personal tragedy struck the family when, during a terrible windstorm in 1916, a hay feeder sailed through the air and hit little Clifford, ending his short life. Shortly afterward, on May 26, 1917, their third child, Mary, was born. The Heavernes were spared from a larger tragedy when the great influenza epidemic that swept across the world in 1918 passed over their family without incident. Three more children, Alice, Mike, and Pat, followed in steady succession.

A pretty child from the beginning, with her mother's dark Spanish features and her father's Irish eyes, Mary had a mind of

her own. "We'd go to the Catholic Church in Joseph," said Mary, "then step out to run across the street to the Methodist Church where the children were havin' such a good time, eatin' cookies and punch."

But Mary's father Andy was never the same after Clifford's death. Drinking had always been a part of the Wild West shows, and to forget about Clifford, Andy began to drink more heavily. One day he just up and left Rosita with the task of rearing her children alone.

"Times were hard," said Mary. "I looked forward to my dad's infrequent visits. He did contribute to our income the best he could, but he was gone most of the time. When he did come home, he'd tell us stories of his adventures, like the times he packed writer Ernest Hemingway into the Idaho wilds on hunting trips."

Mary remembered her mother as an accomplished home-maker. "Rosita was such a clean person, used lots of Lysol to keep the place clean," Mary recalled. "She'd put a pan of salt-rising bread to rise of a night, then get up in the morning and making bread out of the huge pan of dough. I can just remember her stirrin' up that large pan full of dough the night before. My mother cooked delicious Spanish food, wish I could remember how she made it," said Mary. "She'd make a batch of enchiladas in her kitchen and they were taken to a local restaurant in Enterprise, seven miles away." But Wallowa County was predominately white, and other races were often discriminated against.

"Because mom felt out of place and shy due to her Spanish heritage, her dishes were served to customers who never knew the hands that prepared the food. Mary also remembered how she and her siblings caught all the childhood diseases: whooping cough, scarlet fever, and mumps.

"Mom got the mumps too," she said. "It was very hard for her to take care of us, when she was so sick."

Although Andy was gone, Rosita was close to both her mother and mother-in-law. Olivera, Rosita's mother, had come to Wallowa County to be near her daughter, and Mary remembered how tired her mom would be. She also took care of Andy's mother, Elizabeth Heaverne, who was bedridden. Mary would help by treating her grandmother's bedsores, which got worse when it

was so hot in the summer in Joseph.

One August, Olivera passed away. Her grave had no marker, and Mary always felt badly. Years later, Mary had a marker made and placed over her grandmother's grave. Today Rosita is buried in the Catholic cemetery on the hill above Enterprise, in view of the Wallowa Mountains. Next to her are Olivera, Elizabeth Heaverne, and all of her family except Mercy.

Although life was not easy for her family, Mary and her siblings had a marvelous playground. "Our backyard was the east moraine of Wallowa Lake. My sisters and brothers and I would spend hours playin' amongst the cottonwood trees, irrigation ditches and boulders," said Mary, who was not aware as a child that she was growing up in one of the West's most scenic places.

"I remember the time they re-buried Old Chief Joseph at the foot of Wallowa Lake. There were lots of Indians, and other folks, and a big barbecue. I have a photo taken of me standin' beside the monument."

Early on, Mary developed a love of horses and became a good rider. Oftentimes she and Mercy would ride clear to the Divide, a distance of at least 15 miles from Joseph over rough terrain, to visit friends. Little did Mary know that one day she would be cooking for sheep camps in the canyon of Big Sheep, and that her diary entries would record such places as "Muley" and "Red Rock."

"One time," Mary recalled, "Mercy and I rode to visit a friend on the Divide. We spent the night, then played most of the next day, so it was late when we started home. We made it safely off the Divide, and started up Sheep Creek hill, when it got dark on us. So we just took shelter in an old barn alongside the road, curled up and went to sleep, and at first light we jumped on the old horse and rode home. Mama was pretty worried, and of course, no phones in those days."

In this independent way, Mary would grow up to LIVE the West. She played a role in the West's early settlement that would shatter the myths her father had portrayed in those early Wild West shows.

Clifford, the little boy near steps, at Heaverne house in Joseph, Oregon, where "the sidewalk ended" and Mary was born.

Mary and brother Pat, 1939.

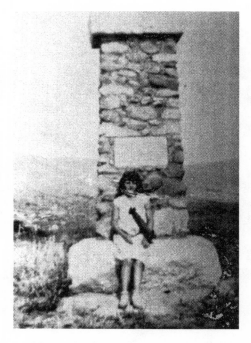

Mary, 12 years old, at Chief Joseph monument near Wallowa Lake.

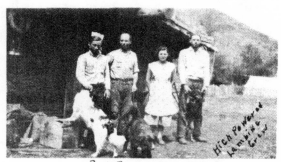

Mary with cooking crew at Red Rock sheep camp, 1936.

5 THE MARKS FAMILY

Mary attended school in Joseph until the seventh grade. That was the extent of her education as far as books were concerned, but the school of life was just beginning to educate her. Because times were tough, Rosita's children left home during adolescence to go out and earn a living. This eased the financial burden on Rosita.

One of Mary's schoolmates had been a boy named Mark Marks, the son of Clem and Ethel Marks, and it was probably through this acquaintance that Mary was offered a job that would change her life. In early 1933, at age 15, Mary was sent to look after Mark's elderly widowed great aunt Eliza Marks, who lived near the mouth of Freezeout Creek. She wasn't the only Marks living on Imnaha.

The Marks family had come a long way to land in Wallowa County. In the 1770s, George and Susannah Marks emigrated from Ireland to America. Two generations later, Bluford and Martha Marks traveled west with their family to Oregon by ox-drawn wagon. It was their son Benjamin who, in 1866, married a Linn County pioneer, Elizabeth Nye, and then in 1889 traveled slowly by team and wagon to eastern Oregon's Wallowa country with 10 children, including young Alfred, born in 1881.

Since most of the land in the valley was already taken, they continued down into the canyons and homesteaded at the mouth of Freezeout Creek, where it empties into the Imnaha River. The Marks family were among the first settlers in that rugged, remote land, and their clan would branch out like the multitude of tributaries that swell the Imnaha.

In her memoirs, Minnie, one of Benjamin and Elizabeth's daughters, recalled that the first winter on Imnaha was spent in a house belonging to the red-headed German twins Theo and Gus Schluer. It wasn't until the next spring that they moved upriver to a spot a quarter mile below the mouth of Freezeout Creek. Living in tents from March on, the family waited it out until Benjamin and his strong sons cleared trees and built a large log house, complete with fireplace.

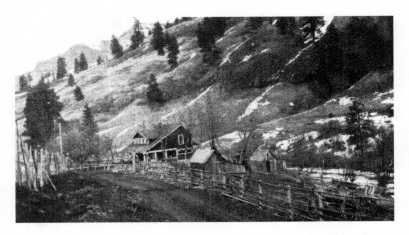

Alfred Marks place — now owned by Gary and Vicky Marks.

Benjamin Marks homestead at the mouth of Freezeout Creek on the Imnaha River.

Uncle Ira and Aunt Louise homestead — now the Driver Place.

Minnie remembered when the family first moved to Imnaha and had to ford the river 24 times between the settlement of Imnaha and their place upriver at the mouth of Freezeout. "Some of those places were deep and awful rough," wrote Minnie. Round trips to Joseph and Enterprise often took five to six days, depending on the weather. Mostly the trips out were made in the fall, when the river water was at its lowest level.

What would become an annual ritual began that first spring, when the family busied itself planting huge gardens, setting out fruit trees and berries. Minnie wrote that they didn't have any canning jars then, so their food was preserved by drying, pickling in crocks, salting, and storing in large, underground root cellars that were dug into the sidehills.

Like other homesteaders, the family raised hogs and chickens, milked cows, and butchered a beef from their range herd when meat was needed. Wild game and fish also supplemented their diet. By 1890 the growing family began running cattle on the Freezeout-Snake River range. In the twenty-first century, their descendants continue to make their living from cattle.

When the Freezeout School was built, Benjamin and Elizabeth's children walked or rode the three miles from their house to school each day. Beginning in 1892, a woman named Mary

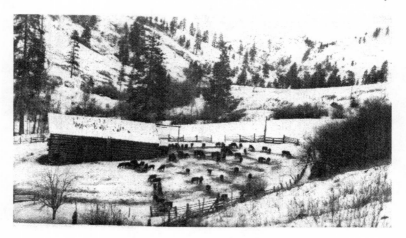

Alfred Marks cattle, Imnaha.

Fleet taught those first lessons. She came from the little town of Flora, 30 miles north of Enterprise. Benjamin was the school clerk, and Mary boarded with the Marks family. In 1894, she took the difficult teacher's exam and received the impressive grade of 91.5, so the Marks children must have been well taught.

Because Benjamin was made of pioneer stock, his talents were many. Among other skills, he was an accomplished blacksmith, and even made his own charcoal. Minnie described how they would cut green wood and split it into blocks eight inches square and two feet long. These were stood on end in a pit, tipi style, one tier surrounding another, until the pile was 16 to 18 feet across. A fire was carefully inserted into the middle and watched over to keep cool enough for the desired results — partly-burned wood that had turned into charcoal. The burning took about three days and nights.

Life was not all work. Winter activities included ice skating, and in summer there were baseball games, fishing, and playing hide and seek among the rock rims. And because Benjamin was a blacksmith, there were plenty of horse shoes to pitch!

Since most of the families in the canyons were large, there were always plenty of contestants for rodeos, where the young people would hone their cowboy skills. If more intellectual stim-

ulation was desired, the school house, and later the Grange Hall, would offer spelling bees, debates, and literaries — events in which people recited poetry, gave readings, and discussed the works of favorite authors of the day. Some literaries got political at times.

Another favorite event for the young men and women was the box social. The girls would fix up a special meal and put it in a decorated box. The boys would bid on the boxes, and the winner would then get to share the meal with its maker. The boys weren't supposed to know who had prepared each box meal, but they had a way of finding out, so sometimes there were bidding wars for a favored girl's meal. The proceeds of the event would go to benefit the Grange.

Elizabeth died at the age of 63, but Benjamin lived until he was 83. Both of them are buried in a small plot across the river and down from the mouth of Freezeout Creek. The site is marked by a weathered, wooden fence and a mother lilac, whose shoots have all but grown over the stone grave markers. Elizabeth loved lilacs, and in the spring this enormous bush and its offspring are covered with massive, fragrant lavender-colored blooms.

A family named Fisk had come to Imnaha and settled in the late 1800s on Imnaha. Being God-fearing, stalwart Christians, the Fisks must have felt like a little band of missionaries landing amongst a bunch of heathens when they encountered the Marks family, who, it seems, not only didn't attend church, but also chewed tobacco, danced, played cards, and carried on in other ways foreign to the church-going Fisks. So it was ironic that Alfred, Benjamin and Elizabeth's fourth son, and now a grown man, took a shine to Mary Fisk — and that she returned the favor. They were married in 1912. As it turned out, two other Marks boys also married Fisk girls. Since Benjamin "Granddad" Marks was the Justice of the Peace for Imnaha, he may have presided at some of his own children's weddings.

After a brief stint living at Waterspout Canyon on the Snake River, a homestead Alfred had filed on in 1909, he and Mary purchased and moved to a home in 1915 above the mouth of Freezeout Creek, where they raised three sons: Clarence or Kid, Earl, and Elmer, who was also called Mike.

The widow Eliza Marks that young Mary Heaverne came to

care for was Benjamin Marks's sister, known to Kid, Earl, and Mike as "Grandma Jensen." In addition to caring for Grandma Jensen, Mary was expected to weed the garden, milk the cow, and hone her housekeeping skills. Mary recalled, "I sure weeded a lot of carrots. They grew extra, fattened the hogs on 'em."

Grandma Jensen taught Mary how to make bread, cook, wash on a scrub board, iron, and clean — and by cleaning she meant right down on her hands and knees, getting into those corners. The floors were scrubbed with homemade soap, soap Grandma Jensen had taught her how to make after convincing Mary she wouldn't get burned by the lye. Mary also learned how to embroider and tat, making fine laces and decorative pieces.

Mary stayed with Grandma Jensen for a year, until the elderly woman's condition became so fragile that she was moved to town in Joseph. Mary then moved in with Mark Mark's parents, Clem and Ethel. Clem, Alfred's younger brother born in 1877, had homesteaded on Snake River just south of Sluice Creek, below Hat Point, in what became known as "Marks Basin." In 1916, he and Ethel moved to a place just up the Freezeout road. Clem was crippled by premature and severe arthritis. His hands, as seen in old photos, were as gnarled as twisted tree limbs. So Ethel had to milk cows, do all the chores, and raise her family, along with caring for an invalid in a wheel chair.

Mary helped around Clem and Ethel's house, until one day an unexpected letter arrived offering to hire Mary on at a sheep operation down on the Snake River. Mary never did learn how the writer of that letter, Celia Titus, got her name.

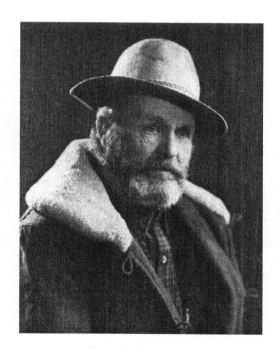

Dick Fisk, photographer.

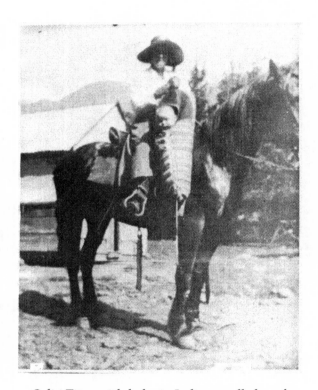

Celia Titus with baby in Indian cradle board.

6 A Month on the Snake River

Celia Titus was a legend on the Snake River. She could do everything a man could do and, besides that, everything a man couldn't do. Celia and her husband, Jack Titus, each had their own livestock operation. He ran his own sheep and cattle, and she ran hers. It was a rather unusual arrangement, but one that seemed to work.

A ferry that had been built in 1891 at Pittsburg Landing, twenty miles downriver from Saddle Creek, was being operated by Jack in October of 1933. He was paid 20 dollars a month by the county government, in addition to collecting fees from passengers on the crossing. Then, by order of the Wallowa County Court, the ferry was discontinued due to lack of funds just the year before Mary arrived.

Like most folks in those rugged surroundings. Jack and Celia found humor in everyday life. They had a son named Bob, and when he was a baby, they put him in one of those Indian cradle boards. When they were working cattle they carried him that way, hung on the saddle. Once they hung baby Bob in his cradle board on a fence post while they cut out some cows, and when they heard him holler, they looked over to see a cow licking his face!

Celia had hired Mary on to come to her operation at Pony Bar, about 6 miles downstream from Saddle Creek and nearly 15 miles upstream from Pittsburg Landing, to cook for her herders and lambing crews.

Mary remembered how cold it was that March in 1934, when she rode up the snowy Freezeout trail to Freezeout Saddle, then down Saddle Creek to the Snake. Accompanied by Mark Marks and his cousin Kid, Mary traveled the long trail downriver to her new job. She made the journey on a newly shod horse that Kid Marks had given Mary to ride.

As a camp cook, Mary soon learned to use the wild yeast that the sheep camps relied on for leavening. "It wasn't called 'sourdough,' it was just called 'yeast,'" said Mary. "We didn't have any stores to run to in the canyons, so this yeast was carefully

guarded and fed." Mary remembered that if the yeast got a little stubborn, you could liven it up with one of those dried yeast cakes. "Don't think you can get 'em these days," said Mary. "We just kept addin' potato water to the yeast jar and kept it goin'. It would just froth up so nice, ready to use for bread."

When cooking with sourdough starter, you must reserve some of the batch so that you can build it back up for the next meal. "But one morning," recalled Mary, "I forgot, and dumped the whole mess in the biscuits So I grabbed me a fruit jar, saddled the horse right quick, and rode downriver to the nearest camp before Celia found out I forgot to save some. Along the way, I passed a boat, and there was a woman on board, a shearing camp cook, and I told her my story. She told me where a camp was where I could get some more yeast."

She rode seven miles, clear down to the mouth of Temperance Creek, where she met the camp cook, who was very kind to her. "I told her I'd done a very foolish thing, and she said it would have to be pretty bad to beat the things she'd done. She said, 'When you do anything stupid, tell me first, and I'll tell you one I did worse.'" Armed with her fruit jar of yeast tied to the back of her saddle, Mary rode alone through the rugged terrain of Hells Canyon, back to Pony Bar in time to cook supper.

Besides cooking, Mary's job was to help Celia with chores. That is, she did chores at first, until one day Celia noticed how good Mary was with a horse. That's when Celia gave Mary a horse to ride. In those canyons you cannot ride just one horse because you'll wear it out, so the horse Celia gave Mary took turns with the one Kid had given her. From then on, Mary worked right alongside Celia herding sheep. She ended up spending more time on horseback than in the camp kitchen.

Although she'd grown up around horses, Mary didn't have experience with other livestock. Celia taught Mary many things about ranch work, and in spite of Mary's inexperience, she learned quickly and became a good hand. That early training would set the tone for her life's work.

Some livestock cooperated less than others. Mary told a story about a milk cow who sucked herself. The cow would lie down to suck her own milk, and Celia decided to put a stop to this bad

habit. "So," recalled Mary, "Celia, she took a knife and cut the cow's tongue, and that stopped her for awhile, but after a few days the tongue healed over, and there was that old cow, layin' there suckin' herself, milky bloody froth comin' out of her mouth. Darndest thing," said Mary.

It was Mary's job to lead that old milk cow to the creek for water. The way to the creek was steep and the cow got ahead of Mary, who pulled so hard the halter broke. Mary hurriedly searched around and grabbed a cinch rope off a pack saddle, one of those with a wooden cinch ring tied on one end, and somehow wrapped it around that old cow. And then the cow got all tangled up in that long rope on that steep hillside and went down. When she got up she was "stifled," or lame. They had to get rid of the cow.

Her employment under Celia would only last a month, but Mary really covered the country — and what country! Years later she recalled how she rode harder during that time than she would ever do again.

"Those Marks boys left me there and rode the long trail back to the mouth of Freezeout, and I spent my days ridin'," said Mary. "Never did so much ridin' in my life, tendin' those sheep. They were scattered up and down those canyons and we had to get them bunched up at night, safe from coyotes."

Mary's horse, the one Kid had given her, threw a shoe before she rode back out on top. She remembered how Celia laughed when that happened. "I can't believe you are sixteen years old and don't know how to shoe a horse," she told Mary. Years later, that tale was still circulating among the inhabitants on Snake River, and told back to her later by one of the Marks boys.

Such was life on Snake River. Young children often learned to shoe a horse before they learned to read. Most of the time their very survival depended on being able to get around in that steep country, which meant on the back of a horse, a horse who was only as good as his feet. And no horse could climb over those rough rocks with bare feet.

Folks continued to ride horses well into their older years. Mary remembered that Celia's mother, who lived on the Wisenor place up Temperance Creek, was still riding in her old age. They

were traveling horseback together one day, when they came to a difficult and dangerous place where Celia's mother, who never wore spurs, asked to borrow one of Mary's so she could better control her horse. So the two of them rode through the bad spot, each one wearing one spur.

Celia had a big roan horse that Mary admired. "I sure did like that roan," recalled Mary, "but Celia never did let me ride it. I'd look at that horse and think, 'You won't let me ride that roan, sister, but you won't be ridin' him forever.'"

In fact, Celia nearly lost her life riding that roan. Mary and Celia were out riding a narrow trail that followed a high cliff above the swift and wide Snake. Celia, who was in the lead, dismounted to open a narrow gate.

"Celia, she was short and pretty round," continued Mary, "and that roan was so big you really had to move fast to get up in the saddle. Well, she got one foot in the stirrup and that horse started moving down the trail with Celia hanging out over that cliff. I was sure she was going to just fall right into the river below. But, as Alfred was fond of saying, 'You never holler WHOA in a bad spot.' Celia didn't, managed to get back on that big roan, and rode right on."

The river presented other dangers as well. Mary remembered the abandoned crossing where Jack used to operate the ferry. The operator would pull the ferry using cables strung across the river. "One night," Mary said, "a bunch of cowboys on the Idaho side got drunk, and came swingin' across what was left of that ferry...just a few cables, as I remember. Don't know how they wasn't killed, or drowned, but they survived."

Lambing season soon ended. In April 1934, a little over a month after arriving and just a month shy of 17, Mary rode out of Snake River by herself, up that long trail to Freezeout Saddle and down to the Imnaha, back to her home with Clem and Ethel Marks. She was riding the horse that Kid Marks had given her.

7 DANCING AND COURTING

During Kid and Mary's courtship there had been much competition between the Marks cousins, Kid and Mark, for her affection. Oftentimes she'd be riding along between the boys, each one trying to favor or impress her with something. But there was never any doubt in her mind which one she would choose for a mate. Mary loved horses, and it was Kid who always provided a shod, well-broke horse for Mary to ride to the dances.

How Mary looked forward to those dances! In fact, Mary liked dancing as much as she liked horses. When she was going to grade school in Joseph, the kids taught themselves to dance out on the playground.

Some of the Imnaha dances were held as far away as the Bridge, but mostly they just had to ride to the old Grange Hall near Grouse Creek, where, Mary remembered, it was Kid's uncle — Minnie's husband Frank Shevlin — who provided the fiddle music.

Mary described that first Grange Hall as "just an old bunkhouse, with wooden floors where the dust jumped out between the cracks as we stomped around. Sure was a lot of fun, and there were always plenty of boys to dance with."

Recalling dances at the Bridge, Mary said they rode horseback to get there, danced till daylight, then saddled up and rode a few miles upriver to eat breakfast at Vern Warnock's place on the way home. If it was bad weather they could rest, but if it was sunny they'd have to work that next day, no matter how tired they were. "Didn't matter if you were so tired your feet felt like they was still doin' the Chicken Scratch dance, you had to work, to pay the fiddler."

"It was hard to keep your feet still when you heard that fiddle music," recalled Mary. "Mostly we danced schottisches, reels, and quadrilles." The polka was another dance she liked. Kid called the quadrilles, and while he did, Mark danced with Mary. But it was Kid who got the last dance.

Newlyweds Kid and Mary in snow at the Jensen place.

Lou Warnock homestead, Mary and Kid's first home, 2001 — since moved. (Janie Tippett photo)

8 KID AND MARY GET HITCHED

It's no surprise that Mary, an independent-minded young woman, got married the way she wanted to. It might just have happened like this...

"I just think it'd be wonderful if we could have a double wedding," said Aunt Katie, Mama Marks's sister. Seventeen-year-old Mary didn't think it would be so wonderful. She just wanted to get married, get it over with, and go on with her life on Imnaha. But Aunt Katie kept on and on. "We could have the two ceremonies performed in Joseph, then put on a big dinner afterwards."

Mary's chum Lucille Keeler was going to marry Tom Rayburn, and Aunt Katie just loved planning big doin's. "That way," said Katie, "we'd only have one dinner to prepare."

Mary slipped out the back porch door and sat down on the chopping block and thought back on her time with Grandma Jensen, with Celia Titus, and with the whole Marks clan. Ever since she'd left home with only a seventh-grade education, it seemed someone was always making plans for her, thought Mary, contemplating her future while sitting in the summer sunshine of a hot August morning.

It's time I made some of my own plans, she mused, and with that she marched back into the kitchen and stated in a strong voice, "No."

"No what?" replied Katie, and the question was silently mirrored in the eyes of the other Marks women, their coffee cups clattering to the table all at once.

Mary's Spanish eyes glittered as she tossed her dark, curly hair in a defiant gesture. "No," she repeated, "I don't want a double wedding," and she left them again to march out the door.

If she was old enough to marry Kid Marks, she was old enough to make up her own mind. That night she and Kid made their plans. Mary told Kid, "No way am I going to go through with Aunt Katie's plans, let's just run off."

"How?" said Kid, "I don't have anything to drive."

"Well, then," said Mary, "borrow someone's rig."

So Kid got on his horse and rode off to his cousin Casey

Denny's place and convinced Casey to borrow his brother Jack's car. The Great Depression was still on, and cars were few and far between on Imnaha in 1934, although people on Imnaha grew their own food and didn't feel the pinch as much as city folks did.

Finally it was all set up. Cousin Casey would drive them in the borrowed touring car to get hitched. Between the two of them Kid and Mary had enough money to pay a preacher and buy gas. On that hot August morning in the year 1934, Mary was up long before dawn, dressed in her clean blouse and skirt, listening for the sound of that car. And soon it chugged up the road, leaving a cloud of dust in its wake.

In those early years the roads leading out of the county were all unpaved, dusty, bumpy affairs that shook up the hardiest of travelers. And Mary, Kid, and Casey traveled those old wagon roads clear to Waitsburg, Washington, over 200 miles away. When asked why they chose to go so far for a preacher, Mary chuckled, "To get as far away from Aunt Katie as possible. We ran away.

The only ones who knew we were going was Kid's folks. I figured I'd only get married once, and wanted it done right."

Living in the canyons had given Casey lots of practice driving curvy roads, but when it came to negotiating the steep grade that wound down Paradise Ridge to the Grande Ronde River, any driver would have a tough time. They crossed the river on the old bridge at the mouth of Deer Creek, a bridge which washed away in the winter of '48-'49 and was never rebuilt. Then they wound their way up the other side on the crude, rutty, dusty road of Shumaker Grade.

It was mid-summer, the hottest time of year, and the touring car heated up climbing that long grade and vapor-locked, a common occurrence in those days. Vapor lock is caused when the gas heats up and the vapors block the flow of gas to the carburetor, To fix it, water was poured over the gas line, which cooled the gas and unlocked the vapor. But if one had no water, it took a long time on a hot day to let the gas cool enough to unlock the vapor caused by the heat. Casey knew about vapor lock, and always carried a spare can of water for just such emergencies, so in this slow way they made their way to the top.

After the trio rattled their way into the small settlement of

Asotin, Washington, Kid and Mary purchased their marriage license. From there they drove west until they reached Waitsburg. The small town, surrounded by golden grain nearly ready to harvest, shimmered in the August heat.

Mary and Kid found the preacher living in a modest little house with his young wife and baby. "They were awful nice, took pity on us," Mary remembered. "Their house was spotless and the baby played in the crib, waving its hands and feet."

The young preacher smiled kindly at the young bride and groom, both covered with a thick layer of dust. He invited them into his home, whereupon the wife fixed them something to eat while Mary held the preacher's baby in her arms. After Mary helped with the dishes, the preacher got out his Bible, and stood before them in the parlor. Casey and his wife, with the baby now back in her arms, were the only witnesses to the brief wedding ceremony. Twenty-year-old Kid kissed his seventeen-year-old bride, and they were man and wife.

Mary recalled that the preacher "just looked at us scraggly kids and hardly charged us anything." Kid paid the man with some crumpled bills and they left. Several months later the preacher and his wife wrote Mary and Kid a nice letter, asking how they were doing. And years later, Mary would be picking huckleberries near Harl Butte and meet up with a woman who said she and her husband were married by that same preacher!

They spent their wedding night in a road house there in Waitsburg. Casey was in one room, and she and Kid were next door. The next morning they arose early so they could return to Imnaha before nightfall. All that long, hot day the sun burned down on the trio, and of course that was long before air-conditioning. So they had all the windows open, which meant they breathed in great gulps of dust as they bounced and bumped their way over ruts and descended those canyons again, the tired old car frequently breaking down. Years later Mary would recall how "we pushed and shoved more than rode home." When they were at their wits' end, the driver of the Enterprise to Lewiston stage line stopped his vehicle to help them get going again.

When the young couple finally did return to their own canyon "all married," there remained the problem of where they would

live. Kid's dad Alfred invited them to live with the family, helping around the home place until they found a place of their own.

Thus Mary began a new life that next August morning, a life that wouldn't change a whole lot over the next 70 years. Her pretty eyes flashed dark and lovely, and her new husband admired her pretty arms and hands, hands that would scrub, bake, train colts, pitch hay, drive derrick, harrow, can, garden, and lead a pack string. But, sadly, hands and arms that would never hold a baby of Mary's own.

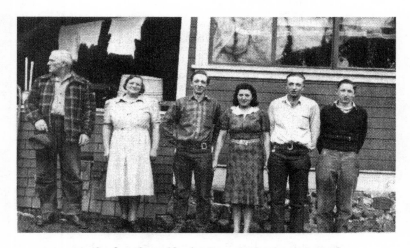

Marks family: Alfred, Mary, Kid, Elmer & Earl.

9 EARLY DAYS OF MARRIAGE

Mary learned more about Kid after he became her husband, and much of that knowledge was gleaned from her mother-in-law. After the young couple returned from their wedding trip, they settled in with Kid's folks as easily as if Mary had been raised in that family of three boys. An early photo taken of the family shows Mary standing between them, as if she'd always been there.

Having another female in the household must have been good for Kid's mom, in spite of the occasional confusion of having two women named Mary Marks living under one roof She always treated Mary kindly, for, as Mary said, "I was like the daughter Mama Marks never had. She was an angel."

Kid's family was now Mary's family, and because of her own parents' separation she welcomed the sense of security provided by the Marks family. Over shelling peas or peeling apples, Mama Marks would tell Mary stories, like how Jennie Blevans, the midwife, delivered Kid right there in the house at the mouth of Freezeout Creek. And how, when he was just a wee one, they moved to Waterspout Canyon along the Snake River, a place with lots of rattlesnakes.

"Alfred's dad and two of his brothers were in a partnership there, raising cattle. It was a wild and lonely place," recalled Mary. "Mama Marks told me that in order to keep Kid from wandering off, she used to tie him to a tree. The place they lived in was just a shanty, and she was worried about the snakes and her baby, so when Kid was three they moved back to the Imnaha, where Kid's brothers were born." And on the Imnaha is where the family stayed.

During that first winter when Kid and Mary were living with his folks, the two brothers, Earl and Elmer, were still at home, too. "Mama Marks told me about when Karl was little and riding his horse down to the Freezeout School," remembered Mary. "She'd say, 'Now Earl, you just walk that horse, don't run.' And of course the minute little Earl was out of sight he galloped all the way to school. 'I knew,' she said, 'because all the neighbors living along the way let me know about it.' "

Newlywed Mary's days were too busy to be feeling sorry for herself for not having a home of her own. However, she often thought about how nice it would be, just the two of them, setting up housekeeping one day.

Later on that winter, Mary's dreams came true. Lou Warnock's old homestead became available to them. On a nearby west-facing bench, Lou had "proved up," and done some farming. The homestead was just a crude, one-room board shack perched halfway up the opposite canyon, across the river from Kid's folks' house. But Mary was excited. She would have a home of her own.

Access to the place was gained by a rough, rocky wagon road that wound around the benches above the eastern side of the river. Or, if you wanted to walk down the canyon, you could cross a swinging, narrow footbridge leading to Alfred and Mary's place across the Imnaha. A good spring downhill from the shack provided clear water for house use, and from the one window over the dry sink, Mary could gaze down at the river winding below the steep canyons that walled her in on either side.

Mary remembered, "The winter of '34-'35 was a real dilly. The wind blew between the cracks, and the old wood stove gulped enough wood to fill a barn." But Mary and Kid settled in. Even though the young couple faced years of hardscrabble existence, they were young and strong, and they were in their own home.

Many memories were made there, like the day Mary got her new wood cookstove. She stood outside, waiting anxiously as the sweaty team of horses made its way up the hill, pulling the wagon with her stove roped down on the back.

"When Kid and Alfred carried the stove in and assembled all the lids, there were two missing," Mary told me. "Alfred just said, 'Whoops! Guess they just rattled off and got lost.' I was near tears. I'd waited so long for a good stove." She'd looked forward to cooking supper that very night on it. Without all the lids the thing would smoke, and she wouldn't be able to use it. Considering how long it took to get this stove after it had been ordered, she knew lids would take forever.

"Then Alfred began to laugh," Mary continued. " 'Well, lookee here,' he said, and produced the missing lids from the folds of his large jacket pockets."

This type of kidding, almost cruel in a way, provided entertainment for the canyon menfolk at the expense of some unsuspecting person, often a woman. Sometimes the pranks and jokes didn't seem very humorous to the victim, but young Mary learned early on that it didn't mean they didn't love you, it was just their way.

"Alfred, he had a great sense of humor and fun, always kidding someone," recalled Mary. "He'd ask, 'Did you ever hear the story of the empty bucket?' When someone answered, 'No,' he'd say, 'There wasn't anything in it.'"

Kid on Morgan horse at supply cabin at Uncle Joe's (Benjamin Marks) place.

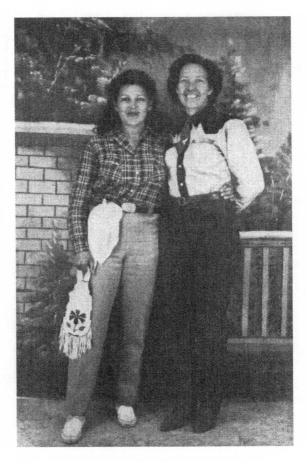

Mary with beaded doeskin bag, and Inez Prout, 1947.

Mary's first home, moved to the old Jensen place.

Log trough.

10 ALL IN A WEEK'S WORK

January 1, 1938
Spent the day at Clem Marks' playing cards.

Thus Mary neatly penciled the beginning entry in her first diary. She was 20 years old and, having lived with the Marks clan since she was 15, was pretty-well ingrained in their lifestyle. Playing cards to pass the long winter hours was a favorite pastime on Imnaha — when folks weren't busy working.

Still childless, Mary was able to be outside helping Kid with all of the ranch chores, as is shown by her entry two days later: "Kid and I put in a trough next to the rims, sure was nice and warm up there."

"Putting in a trough" took considerable skill, patience, and a practiced hand. After a suitable tree was felled, it was burned out in the middle and the fire extinguished before it burned all the way through. Then one had to spend hours chipping away, smoothing the hollowed out log so it would be deep enough to hold water, yet not so thin-bottomed as to begin to rot and leak.

If timber was handy to the spring and the ground was reasonably level, the log could be hollowed out near the site. But often as not, since the country stood on end, the troughs had to be packed by mules up steep canyon sides to the springs. They were placed downhill from the spring, where the water would be piped into them. Both livestock and wildlife used the troughs. Many of the steep canyon sides would never be grazed, especially in dry seasons, if it weren't for those watering troughs. Traveling all the way down to the river for a drink took up too much of the cattle's energy.

Today it is rare to come upon one of the old log watering troughs, but a few still survive, mostly forgotten or replaced by metal ones. Covered in moss, hidden from view, surrounded by overgrown thickets, these relics of the past continue to hold water and attest to the workmanship of men like Kid Marks. So when Mary simply wrote they "put in a trough," there is a story here, a story taken for granted by the canyon folk, who accomplished these tasks on an everyday basis.

Kid had a reputation with an axe. Not only was he adept at hollowing out logs for watering troughs and salt licks but, as local folks remember, he left signature trail blazes. The old stock drives would be marked with blazes on the trees, and Kid, who always kept his axe sharpened, made such a perfect chip or blaze on the bark of a tree, everyone knew it was his mark.

One morning Mary noticed a quietness fall upon the forest where Kid had been chipping away at a log trough. She realized she couldn't hear the familiar rhythmic sound of the axe. Then she spotted her husband, several feet away from the log, sound asleep.

A wave of pity went through her. She felt sorry for him, as he'd been working at the trough all morning. Mary picked up the axe and began chipping short strokes of wood away, thinking Kid would appreciate her help when he woke up and found the task finished.

Mary's strokes weren't as sure as Kid's, her swipes with the axe not as calculated. Nevertheless Mary continued on until she thought the log looked just right. She took one more lick with the axe to smooth up the bottom. But Mary's axe bit too deep, and with despair she realized she'd cut a clean swipe clear through the log.

Remembering that unhappy moment, Mary said, "Somehow Kid sensed something was wrong, and chose that moment to wake up."

As he stared down at the gaping hole chopped in the log. Kid became furious and began to yell at Mary, until one of the cowboys working in a nearby corral heard the ruckus.

"He come over to where we were," said Mary. " 'Now Kid,' he said, 'don't you go getting upset at Mary, she was just tryin' to help.' And I was."

Mary had so many lessons to learn, and each one took its toll on her. But she learned well, rarely repeated a mistake, and was far from helpless. Although she couldn't help feeling bad about the log trough, Mary said, "I didn't have to stick around. I had a horse."

More than once, if Mary felt she wasn't treated fairly, she simply got on her horse and rode away.

Take the fence building incident. Fences on the Imnaha march straight up steep hillsides, and they don't build themselves. In a place where just the act of standing upright is a challenge, men and women built fences to last. Fence material, wire, and posts were all packed up on the backs of horses or mules, and everything was built by hand.

In places where the soil is thin and rocky, fence posts can't be sunk in the ground, so rock jacks act as support for the fence. Building rock jacks is one tough job, requiring both strength and skill. First, wooden posts are fashioned into a sort of tripod affair with a brace at the bottom, which is then filled with rocks to anchor it. Depending on where the fence is built, rocks must be lifted and carried considerable distances.

Stays or small posts, held up by barbed wire, stabilize the fence between rock jacks. Miles of fence built in this fashion march up incredibly steep canyon-sides.

Once Mary led a pack horse way up under a rim so she could help Kid stretch and staple barbed wire to a corner rock jack. Seeing Kid unload the roll of wire on a steep incline, Mary yelled, "Don't let that wire get away or it'll roll clear to the bottom." Kid never did pay much attention to anything Mary said, and sure enough, "there went that bunch of wire, skittering down the canyon, gathering speed as it went. I was so disgusted, I jumped back on my horse and rode down home. Darned if I was going to be the one to go down there and bring it back. I told Kid that would happen."

Kid must have fetched the wire, because today that fence is still there, straight as a die, ending in sky, a testament to those hard-working fence builders, who not only built the fences but hand-split all those posts and stays.

At other times, Mary stood her ground. Out at cow camp, it was the men's job to split wood for the cook. One time, no one had split Mary's wood, and when 15 starving cowboys came back to camp, there was Mary, sitting with her arms crossed, the axe stuck in the middle of the table, and no food cooked. The men went out and split wood.

On January 4th, Mary wrote two lines: "Kid and Earl hauled hay from the Lambert place." Here again, these few lines can't

convey to the reader all that entailed. Horses had to be fed, groomed, harnessed, and hitched to a hay wagon, and the team driven to the Lambert place, often as not fording creeks and the river itself, which always presented obstacles. Hay was not baled in those days, it was stacked. Therefore Kid and Mary would have used pitchforks to toss the hay onto the wagon. This was an art in itself, as the hay had to be tromped down and the stack made sturdy enough so as to withstand the bumpy ride back to the Marks barn.

On January 5th, Mary noted, "I stayed home. Kid went hunting, and Earl and Walter (Marks) spent the evening." Mary would have been in her tiny little shack of a house, perched halfway up a canyon. Kid would have been hunting for some sort of wild meat, most likely venison. There were no seasonal hunting restrictions for people in the canyons. Wild game was plentiful in those days, and in January there was no problem keeping meat from spoiling.

Mary's house would have been crowded but cozy, the men talking around the kitchen table over coffee she poured.

And Mary understood "man talk." She understood when they discussed hunting, building fence, the price of cattle, and breaking horses, because she worked right alongside her young husband performing all of these tasks. And she was still expected to do the housework and cook three meals a day for hungry cowboys.

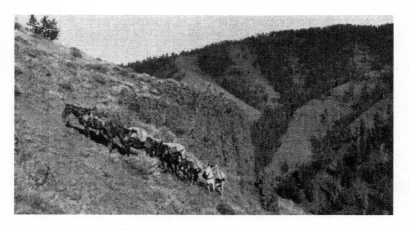

Pack string on a steep canyon trail.

11 VISITING

Sis and I went over after the mail, which was none.

Mary's sister Alice had come for an extended visit that January of 1938. In a community without phones, frequent visiting combated loneliness and relayed the news. One can feel the disappointment in Mary's words on finding no mail. Perhaps she hoped for a letter from her mother, or from her father, whom she adored but rarely saw.

The arrival of the mail was always a much looked-forward-to occasion. It was delivered, only on certain days of the week, to a homemade box that resembled a miniature one-room cabin, complete with a roof to shed the snow. The "cabin" was supported by a rock jack, a square wooden crib filled with rocks to stabilize fence lines. Since the mailbox was situated along the main road, Mary had to walk down the steep trail and cross the narrow swinging bridge to Kid's folks' place, where Kid and Mary's mail was delivered along with that of the elder Marks.

The mail was delivered by Murat Blevans, who lived just upriver with his wife Jennie. One time I quizzed Mary about them. "How did Murat get a name like that?" I asked.

"I always heard he named himself," said Mary. "There were always lots of stories about him. One I remember is once when he was in charge of delivering the upriver mail, there came a box from a mail order catalog. Of course everything was all in the open air, as the mail was delivered in a horse-drawn buggy in those days, and when it commenced to rain, Murat was afraid it would get wet, so he sat on it. By the time Murat delivered the box to the lady who had ordered her fancy new Easter bonnet, it was pretty well smashed," laughed Mary.

"Murat, he was pretty stingy," she continued. "It was said he didn't shave his kindling with his knife at night, for fear someone else would use his work to start their own fire. He wanted to make sure it was him who used it."

Mary recalled Jennie well. "Yes, I knew her, everyone did back then. She was the local midwife, she helped bring lots of

babies into the world, including Kid." And Jennie and Mary had something else in common — a connection with Indian women.

As a child, Mary had established a close friendship with Martha Hill, a full-blooded Nez Perce woman who took a liking to her. Martha, along with a handful of other Nez Perce women, would come to Wallowa County each summer to trade beaded goods for deer skins. "The others didn't always come," recalled Mary. "But Martha and one other woman came every year."

Martha rented Rosita's pasture on the outskirts of Joseph at the base of the Wallowa Lake moraine, where she grazed her horse and pitched her tepee. Mary would come up with an occasional deer skin to trade, but one gets the feeling Martha did more giving than trading with the little girl with the dark Spanish eyes.

Mary once gave me a yellowed clipping from the *Wallowa County Chieftain* that she had found in her Aunt Ann's belongings after she died. The clipping, from June 28, 1934, was fragile and fragmented, with the rainfall for Joseph, Enterprise, and Wallowa recorded on the back.

On the front, the clipping read, "For many years three Indian women came together each summer to the Imnaha river, Emma Johnson, Phoebe Lowery and Matilda Lindsay. The two former were sisters and the latter a friend. Settlers of Imnaha will recall them as elderly ladies even thirty' years ago." If you go back another 30 years that meant those three sisters came to the Imnaha around 1904. The clipping continued,

> *They would appear each July with saddle and pack ponies, camping here and there along the river, buying deer hides and trading in gloves, moccasins and other beaded articles.*

> *They could talk English fairly well, were friendly and cheerful at all times.*

> *Occasionally visiting other parts of the county, their trading territory seemed chiefly the Imnaha river where they usually stayed until late fall. For 15 summers in*

succession these women camped on the river bank on the ranch of Murat Blevans, where they were extended every courtesy by Murat and Jennie Blevans.

During the years a feeling of confidence and friendship grew between these lonely Nez Perce women and Mrs. Blevans. They told much of their early life. They told of being with Chief Joseph on the long, terrible race for life when General Howard followed them through Idaho and Montana almost to the Canadian line in 1876. They told of Emma and Phoebe's father being killed by soldiers. They told of a troop of cavalry charging through their camp, knocking down tepees and killing several women and children, and of being all rounded up and put on a reservation where there were "no deer and no fish."

They said Chief Joseph thought when he made his last stop that he had crossed the line and was safe within Canadian territory, whereas he really lacked 20 miles of reaching the line.

Six years ago these ladies made their last horseback trip to the Imnaha. They were growing old and feeble; they knew it was the last time they would camp by the sparkling water, when they said goodbye to Mrs. Blevans they shed tears and were sad. So they came no more and soon the Blevans family moved out to Joseph.

As a sequel to the story Monday June 25, just before noon a large shiny car stopped before the Blevans home in Joseph. Within it were Emma Johnson and Matilda Lindsay. It was driven by a nephew, a Carlisle graduate by the name of Jesse Paul. Emma told of the recent death of her sister, Phoebe, and Mr. Paul, in faultless English, related how the two remaining women of 80 or thereabouts longed to return once more to Wallowa and the Imnaha, so he had decided to bring them by car and take them wherever they wished.

> *They had already been to the Imnaha, finding the Ble-*
> *vans family gone. They were given a warm welcome*
> *and remained to dinner. Then another and probably a*
> *final farewell was said.*

Like Emma, Phoebe, and Matilda, Martha Hill continued to return to Wallowa County, and remained lifelong friends with Mary. After Martha's death, her nephew appeared unexpectedly one day at Mary's door at Freezeout with a gift for her. Mary was gone, but Kid was there. The nephew wouldn't leave the gift with Kid, instead asking when Mary would be back. Kid told him, and later the nephew returned to present Mary with two beautiful beaded purses and a pair of moccasins, saying Martha had ordered him to give them to Mary in person.

"Make sure Mary gets them," Martha had requested.

Mary, in turn, later gave those wonderful gifts to the Wallowa County Museum.

12 CHORES

On January 9, Mary penned,

> *We went to the Bridge and stopped at Kate and Will Wilde's, and then spent the afternoon at Clem's. We washed today and John (Alice's husband) came up, also spent the night with us.*

Washing was a huge undertaking. Water had to be heated on a wood stove in large galvanized tubs, one for sudsing and one for rinsing. Mary would shave a bar of home-made soap into the sudsing tub, then bend to the task of scrubbing dirty jeans and sweat-soaked shirts across a scrub board. She would rinse them, then wring them out on a cumbersome hand-crank wringer. The wringer never quite got all the water out, and the clothes were heavy and dripping when they came out. If the weather was clear or windy, the clothes could be fastened with wooden pins to a large clothesline to dry. Otherwise the overalls, work shirts, flannel sheets, and such would have to be draped on lines strung over the wood heating stove. Oftentimes Mary would hang out the wash on a cold winter day, and the clothes would freeze stiff. Then she'd carry them into the cabin and let them thaw out.

Eventually Kid got her one of those miserable gas-powered washing machines. When Kid was around, of course, it worked fine, but when he was off riding the thing wouldn't start, and Mary had a heck of a time. "One thing," she said, "I sure learned to cuss."

During the summer months, once the clothes were hung out to dry, Mary often saddled her horse and rode with the men to "salt up the ridge." That didn't mean that she literally salted the ridge, but rather that she loaded two heavy chunks of salt wrapped in burlap bags onto a pack horse or mule, and packed it up to the ridge where it would be available to wandering cattle that grazed their way to what were known as the "salt grounds." Sometimes they would pack loose, coarse salt in 50 pound bags, putting three bags — 150 pounds — on a mule. In Kid and Mary's case the salt was fed in hollowed-out logs that served that purpose

Kid and Mary with cross-cut saw.

for many years. Porcupines also love salt and would gnaw some of the troughs clear through, even after the salt was gone.

Salt houses were important to cattlemen. They were usually propped up by large rocks so the salt wouldn't draw moisture from the ground. Most were built of galvanized tin to prevent leaks during the frequent snow and rain storms. Usually several ranches went together to share a salt house, which could store large amounts of salt. Many ranchers, like Kid and Mary, purchased mine salt, which was shipped from Salt Lake.

Mary noted the next day, Tuesday, that while she, Kid, and John rode up the river, Alice stayed home and ironed. Mondays were wash days; Tuesdays you ironed. Many a dish towel was embroidered with the days of the week depicting various household duties being performed by a bluebird or young maiden.

Far from an easy task, ironing was a major undertaking, and Alice probably was glad to have the cabin to herself. The "sadirons," pointed at both ends, were heated on the range top, then wooden handles were fastened on so one could iron. Mary recalled that they usually had three sadirons on the stove so you could always have a hot one, as the irons cooled off pretty fast. All you had to do was change the handle from the cold one to the hot one, and keep on ironing. It was quite a trick to keep from scorching white things.

On the 13th, "Kid and John sawed wood. Sis and I stayed home." In the dead of winter much wood was consumed, not only for cooking but for heating as well. Sawing wood entailed more hard labor. Usually trees were felled and drug or hauled to the ranch houses, where they would be stacked until someone got around to sawing them.

Before the early settlers acquired gasoline-powered circular buzz saws, the logs had to be cut into stove lengths by using a long cross-cut saw. This required the well-coordinated labor of two persons, one on each end. Mary was to serve her time on one end of a cross-cut saw, and she wasn't sorry when the family purchased a buzz saw. Of course, in the even more remote cow camps, there weren't any buzz saws, because they were too big and heavy to haul. Mary had to pull the long cross-cut blade back and forth with Kid, sawing the logs into chunks. Then the chunks of wood had to be split into different sizes, smaller ones for the cook stove, larger ones for the heating stove.

Original Lookout Mt. cow camp, from a painting.

Mule and stone boat at Harl Butte.

13 COW CAMPS ON TOP

Early on the Marr Flat Grazing Association was formed by several local ranchers, and cow camps were built below Harl Butte, nearby at Marr Flat, and farther south at a place called Mahogany. The association consisted of several ranchers who had grazing permits in the National Forests, which allowed them to run cattle from late spring until late autumn.

Crude log affairs, the cow camps housed cowboys who moved cattle, packed salt, and maintained fences from spring through late fall. There wasn't even a cabin at Mahogany at first, so folks just camped in a tent when they stayed there. The camp on Marr Flat no longer exists, and its name — "Marr Flat Cow Camp" — has become attached to the nearby camp at Harl Butte. But in Mary's day, Marr Flat Cow Camp was on Marr Flat, Mahogany was known as the "upper camp," and the camp at Harl Butte was called "lower camp."

In 1935, the summer after they were married, Mary and Kid lived in an old cabin, built of rough lumber, at the Marr Flat Cow Camp. Kid and Mary had the responsibility of caretaking all the cattle that summered up there, not just their own. This later led to their being hired as paid managers for the Marr Flat Grazing Association, a job they held for many years. The association paid Kid and Mary to maintain fences and salt the cattle, and provided housing at the various camps.

Conditions were rustic. During the winter of 1935-1936, snow caved in the Marr Flat cabin, and the following summer they had to live in a saddle shed until the cowboys cut poles and built a new cabin.

Although Kid kept his axes sharp, for the most part he and Mary had to work with old broken-down tools at the cow camps. She remembered being on one end of a dull cross-cut saw when they were sawing a doorway, and Kid gave her heck, as the opening was crooked. Mary got mad and rode off through thirty miles of unfamiliar country. Kid tracked her all the way home. They made up, but the saw was doomed.

"We left that old saw down in Squaw Creek," remembered

Mary, "so we would never have to use it again."

Life in cow camp could be exciting in other ways, too. Mary recalled an incident that happened on one of their numerous trips from the canyon to the camps up on top. Those old cabins were infested with mice, so Kid and Mary decided they needed a way to transport cats to the camps.

"Well," began Mary, "Kid he built this little box with a screen on top, and then when it came time to catch them cats, they made themselves REAL scarce, they just seemed to know when was time. So Kid, he would call, 'Here, kitty kitty kitty,' trying to entice 'em. Finally, one by one, he had 'em captured and placed in the box. It was set on top of the pack mule's load. Then, halfway up the trail, it began to rain, then hail, and those cats were half drowned, and so were we.

"When we got to camp, Kid, he let those wet cats out and one jumped up on the rafters and fell down, then kept goin' around and around until it was pretty dizzy," Mary said. "That cat came out of it, but it got to be such a pain takin' them cats up and back, we finally gave it up."

Cow camps provided yet another venue for practical jokes. Once when Mary was cooking up at the Marr Mat Cow Camp, she was needing some water to thin down the gravy. She had run a bit short of canned milk and needed to stretch the gravy so it would serve several extra cowboys. So she sent a couple of the younger boys to the spring for some fresh water.

When they returned with the pail of water, they had smirks on their faces, but Mary didn't think much of it, until she began stirring the water into the flour mixture, and then noticed these slimy lumps in her gravy. Horrified, Mary lifted one of the squirming lumps out, only to discover they were polly-wogs.

"I could of killed those boys, they was always playin' tricks on somebody." Nothing would do but to throw the whole mess out and begin again, this time without good meat drippings. So she fried some bacon and used that for the basis of her next batch of watered-down gravy.

Kid and Mary spent from May until November on top, although there was a lot of riding back and forth between the cow camps and their home on the Imnaha in order to keep up with

the garden, chores around the house, and haying. When Mary and Kid rode down to the old place "on the river" it was eight miles by horseback, and they did that frequently, usually riding down Chalk Creek, Grouse Creek, or Indian Creek.

When moving from place to place, Mary had the job of driving the old milk cow — a job she detested, as the cow refused to drive. One entry notes: "Came up to camp. We had one hell of a time with the old Jersey cow, calf, and bull." The milk cow would "brush up." She'd go under a thorn bush and sulk, because she didn't want to travel those steep trails on a hot day. And bulls were notorious for not wanting to be driven anywhere.

Perhaps Mary's experience years earlier with Celia Titus's milk cow had trained her well, because a local cowboy once said in tribute that "nobody but Mary Marks can take a milk cow up Grouse Creek. She's the only one." Mary recalled she did a lot of cussing. She just had to beat the animal every inch of the way, unless the old milk cow could see the other cows topping out near Marr Flat, and then she'd go right along. Mary said, "If I hit it just right, and the cow would see the others, we had it made, but how I hated that job!"

By November the cattle had been gathered and brought down to the canyons for the winter. Hunting season was over, canning was over, and butchering beef was over. Meat had been canned and sauerkraut was fermenting in the crocks by the time Thanksgiving rolled around.

Screened cooling cupboard.

Harl Butte cow camp.

Harl Butte cow camp — older cabin.

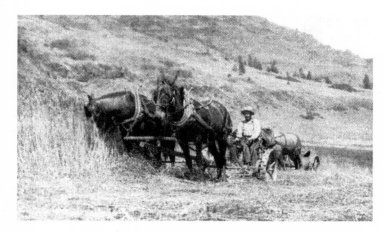

Horse haying the Marks place. (Dick Fisk photo)

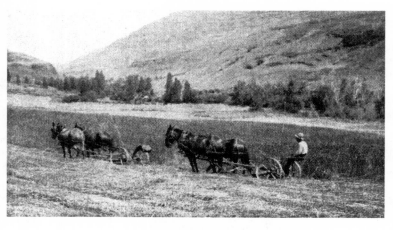

Horse haying in Imnaha.

14 HORSES

July 17, 1938, Harl Butte Cow Camp
Shod horses and drug in some logs. Kid rode the colts.
They didn't buck much.

During the winters, when they weren't needed for working cattle or moving camp, horses were left out to fend for themselves. Abundant grass, especially the native bunch grasses, lay buried under the snow, waiting for horses' hooves to paw through. High in the nutrients necessary for horse health, native bunch grasses sustained ranch horses through the cold months just as they sustained the herds of Nez Perce horses before them.

Mary always worried about her horses during the winter months, and well she might, for horses were essential to their work the rest of the year, like the July day they "drug logs." Mahogany, Grouse Creek, Gumboot, Nieman Butte, Marr Flat, Big Sheep — all those vast areas of forest, high mountain meadows, flats, buttes, canyons, and creeks — were places they traversed by horse, salting, riding for cattle, building fence, or visiting. At the end of each day the couple would return to one of the four cow camps scattered from Harl Butte to Lookout Mountain. Kid and Mary grew to know every landmark in that country, every mood of the changing seasons, and every habit of the cattle they tended.

Of course, those horses needed care. Shoeing horses was a back-breaking job. First, the hooves had to be trimmed and rasped down before the shoe could be fitted to the hoof. Not all horses stood well while being shod. Some would lean on you, while others would fidget or try to kick, or hop up and down. Others wouldn't allow their feet to be picked up. And all the while you had to be stooped over in this unnatural position, holding a horse's leg across your knee. One slip while you were hammering in the horseshoe nails and you'd end up with a sliced gash in your leg. After the tap-tap-tapping required to hammer the horseshoe nails into the holes of the horseshoe and thence into the horse's hard hoof, you had to rasp and smooth off the hoof close to the shoe. After putting shoes on four hooves, a man was ready to

collapse, not to mention a woman. But, thanks to Celia Titus, Mary could shoe her own horse with the best of men.

As if that weren't enough that day, Mary, on top of her cooking duties, "drug logs." Astride her horse, Mary would use a rope dallied around her saddle horn to drag felled logs to a pile. Logs were used for corrals, cut into different lengths for fire wood, split for fence material, and used to rebuild their cabin. All this was taking place on a Sunday, which was just another work day in cow camp.

Meanwhile Kid was busy "starting" colts — beginning the process of breaking them to ride. Once a colt is started it should be ridden every day, so the young horse becomes adjusted to a rider on its back and the feel of the bit in its mouth. There was much for a colt to learn, and repetition was very important when training cow horses. It was imperative that a horse know about the canyons, where the placement of their feet on a rocky, steep trail might make the difference between life and death for both rider and horse.

The next day Mary continued her diary entries: "On Monday the boys went after logs. I washed and Earl went home." One less to cook for.

On Tuesday, while the boys hauled more logs, Mary rode clear to Elmer Warnock's on the Imnaha River, a 15-mile round trip, for a carpenter's level the boys needed for rebuilding the old cabin. Mary simply noted it was a "hot trip." The boys continued hauling for a couple more days, and then things really heated up.

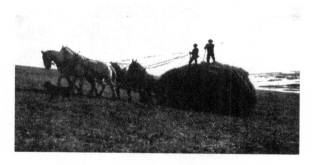

Haying in Idaho on ground much like Imnaha. (Dick Fisk photo)

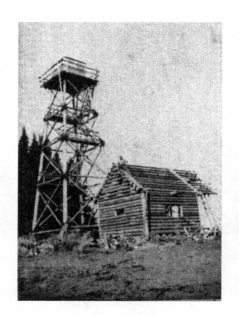

Fire tower, 1930s.

15 FIRE

July 21
I went to the river. The boys went on a fire.

July, when thunderstorms would oftentimes sweep the high country, was the beginning of fire season. Lightning would ignite a pitchy log and there'd be a fire. When the boys got on a fire, they put it out with wet gunny sacks and shovels. Meanwhile, life and work went on.

July 22: "I came back from the river. The boys hauled logs and fought fire all night." The next day, Mary returned to Imnaha to take a wagon home and "went up the ridge and salted." Fires or no fires, they rode for miles to salt the scattered cattle in country so rough and wild one simply had to know the country or get lost.

On Sunday the 24th, "The boys worked on the cabin all day. I came to the river in the evening." I suppose Mary needed to water her garden, as well as tend to other daily chores. Each round trip meant sixteen miles of steep riding. I can picture Mary riding down the canyon trails all alone on a summer evening, after the sun had slipped over the Wallowas to the west, the shadows following her down the creek.

But even home had its dangers. On Monday, "Killed a big rattler at the house, under the porch." And the next day, July 26th: "Started to cook for Earl and the house caught fire. We were sure scared. Kid and Barney came down." That was all she wrote, but I got the rest of the story.

Kid was gone and Earl was plowing the field, holding onto the reins and guiding a horse that pulled a single plow to turn up furrows and prepare the soil for planting.

"It was about noon," said Mary, "and I had the stove fired up and was cooking a big stew, when Earl, he ran in the front door. 'Mary!' he yelled, 'The roof's on fire!' He handed me a couple of buckets and shinnied up on the roof while I fetched water."

Apparently the flue had caught fire and a spark ignited the dry shingles. Hurrying, Mary ran down to the spring, dipped the buckets full, and with water slopping all over her, climbed back

to the house. Earl took the buckets and doused the flames, which were eating into the shingle roof.

"Earl called, 'Go for more!'" said Mary. "I ran up and down that hill with buckets of water until Earl announced that the fire was under control, but from sliding up and down over those rough shingles, he'd worn the seat plumb out of his pants."

Kid later showed up for dinner, having missed the excitement.

One Saturday morning in August, the peak of the fire season in the canyons and high forests, young Mary was sweeping out the cow camp cabin, "settin' things in order," as she often described it. Since Kid and Earl had ridden over to Marr Flat to bring back a horse, Mary decided to ride up to Harl Butte. Eva would be there, she thought.

Eva lived at Harl Butte Lookout with her husband, Albert, and it was important for them to man the tower around the clock. This lonely life was made bearable for Eva by the closeness of Kid and Mary's cow camp, and Mary's friendship. For her part, Mary often craved female companionship, and always noted in her diaries how she missed having a guest around after they left. It's not a wonder Mary looked forward to the times when Eva and her husband rode down to load their cans with water from the cow camp spring.

It provided an excuse for the couple to stay for supper, and then Mary and Eva could visit over washing the dishes, without the men listening in on their conversations. It gave the two women a chance to share "woman talk." Mary liked Eva, but didn't think much of that husband of hers. Mary suspected...no, she *knew*...Albert was mean to her. Eva needed Mary's friendship.

So Mary saddled her horse. It was only a short ride from cow camp up to Harl Butte, and once on top Mary could look out over the vastness of the country she lived in. She spent most of the day with her friend, sipping coffee, talking, and going for a long walk around the lookout. When Mary rode into the cow camp corral that afternoon, the sun had already disappeared behind the distant Wallowas. Then it was back to the routine. Mary was alone in the cabin, the rest having left for a funeral, and the next day the "mob came back and I started cooking again. Washed too."

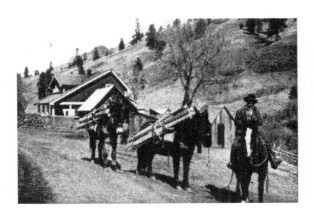

Fencing material on mules.

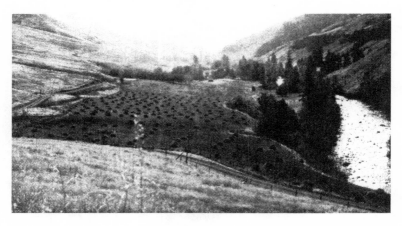

Ross Leslie place, today Lyman Goucher's — note the round shocks of hay. (Dick Fisk photo)

16 HAYING, COOKING, AND CANNING

August 6, 1938
We cooked and canned and roasted.

Mary and Kid had been married for four years. She was 21, young and strong and full of life, a life that was full of work, and between the haying, cooking, and canning, there was plenty of it to go around. It was August on Imnaha and "sure hot as hell," as Mary noted in her diary. Just a few days earlier, she'd written, "We are at the folks and the boys are haying...We came back home and worked till noon and it rained us out...It rained so hard, we couldn't work today. Lightning set a fire over in the next canyon...Kid mowed hay...Cooked for hay hands."

Mowing hay was a lovely sight to see. A team of horses hitched to a mower, the rye quivering, then falling to the sickle. The steady plodding of the horses, the rhythm of it all, the freshly cut hay lying in fragrant rows next to the tall uncut hay. The man perched on the cast-iron seat, reins in hand, calling "gee" and "haw" up and down the rows, raising and lowering the sickle bar to begin another swath down the field. The scissor-like sound of the mower teeth as the horses pulled the mower up and down those steep canyon sides.

Oftentimes the mower would cut into a rock and break some teeth, and then the slow process of replacing the mower blades would ensue. Mostly, though, the fields planted to hay were bottom lands, small in size and picked clean of rocks—another task requiring patience and strength. All of the fields were small, at best, in the Imnaha canyon.

Mary always worried when one of her "boys" was out there farming an extremely steep hillside, especially later, when those primitive early tractors replaced the horses. She'd watch out her window, and pray that they wouldn't roll over.

Benches provided more small spaces to raise hay or grain. Mostly the ranchers raised hay, as they needed it to feed their livestock during the winter months. Sometimes a grain crop would be raised, and of course some of the bottoms were irrigated by gravity or by pumping water from the river with gas-powered

motors whenever the landowner had water rights that came with the property.

In order to cure, the hay had to be dry so haying was always threatened with summer thunderstorms. But when the weather was hot, it was terribly hot. Men and boys drank gallons of water, and their shirts were soaked with sweat. The Marks boys continued with the haying, traveling from ranch to ranch, helping each other. They'd finish one field and go on to the next, and Mary always went along to help with the cooking.

"We cooked and canned and roasted," wrote Mary in her journal. "We picked berries at Vertie's and stoled Louise's apricots... sure hell to pay over the apricots."

Cooking for hay hands was a huge task involving biscuits, gravy, fried venison or beef steaks, a vegetable or two, and always some sort of fruit cobbler or pie for dessert. There would be gallons of lemonade and coffee. Of course, all that cooking created piles of dishes to be washed and dried with flour-sack dishtowels. The big meal was at noon, and a lighter snack of leftovers was served at night. Breakfasts were substantial and often included steak, eggs, pancakes, fried potatoes, and lots of jams and jellies or canned fruit.

Canning season, beginning with apricots, always took place during this hottest time of the year. Mary would fire up her wood cookstove, place the large, 14-quart copper boiler on top, fill it with water, place her jars of apricots inside, and put the lid on. The fire had to be fed to keep the water boiling. The temperature, already hot outside, rose proportionately inside. I can envision Mary wiping the sweat off her brow and longing for the breezes that sweep down the canyon when the sun sank over the rim rocks.

Mary and the other Marks women never let anything go to waste. The very ripest fruit was used for jams, where chunks of the sweet, golden fruit simmered slowly in a large kettle with sugar until thick. Referred to as apricot butter, this delicious concoction was spread thickly on biscuits or hotcakes, but that wasn't all. Mary recalled, "Kid's brother Earl, he just loved apricot butter on ice cream."

On top of all this canning on the river, Mary would often

saddle her horse in the evening, ride the eight miles to the cow camps on top, and tend to things up there—then ride back the next morning to feed hay hands.

Pretty soon everything began to ripen at once: "Cooked for hay hands...picked strawberries in the afternoon...also got dill at Vaunie's and beans at Aunt Ann's...we pickled and beaned all day. Sure a hot mess."

Then the blackberries got ripe.

Berry picking and canning continued, in prodigious quantities. One year Mary wrote, "Went to Kelsey's and picked peaches. Canned 39 qts. Also got tomatoes." And the next day, "Canned 51 qts of tomatoes, also made jam out of peaches and tomatoes." But Mary did see that she got in a little well-earned diversion on those long, hot days of canning over a wood cookstove: she went swimming in the river, which must have been very refreshing.

Meanwhile, the haying continued. "Today they finished shocking, moved to John's in the afternoon." Shocking was another back-breaker. Using a buck rake, which was pulled by a horse, the hay would have already been raked into long rows referred to as windrows. Then, using pitchforks, the men and boys forked the hay that lay in the windrows into small, even heaps, or shocks.

Soon, "the boys finished the big stack." The shocks cured in the sun and were later forked by hand into a hay wagon pulled by a team of horses, and hauled to a nearby barn or stacked loose in a field to feed for winter. Stacking hay was an art in itself, and had to be done just right so the hay wouldn't blow away in the wind, and would maintain an even shape to shed water until it was ready to be fed. After staying with Kid's folks to help them, Mary and Kid moved back to their home to put up their own hay.

Mary (standing) and Bess Walker hunting at Mahogany cow camp.

17 HUCKLEBERRIES

August 24, 1938
Went huckleberrying again, had swell luck! Got eight
gallons between us.

The day before, on August 23, Mary wrote, "The girls and I went huckleberrying. No luck — gosh darn it! We got back in time to cook supper of course." But 1938 turned out to be a good huckleberry year, and Mary had learned early on where the best patches grew. Knowledge like that was automatically acquired when one married into the Marks family. The 24th turned out better, and I could imagine the scene...

Mary's brother Pat and his wife Rita were visiting. Mary and Rita had risen early to cook for the boys, do up the dishes, sweep the cabin, and mix the sourdough. Then they gathered up their berry buckets. It was already mid-morning when they dismounted their horses, removed their bridles, and hobbled them before turning them loose in a small clearing to graze.

This was Mary's favorite time of year, and one of the few times she could escape a man's world and talk girl talk with her friend. Soon they were conversing and picking with such enthusiasm they completely lost track of the time. Because they'd eaten a big breakfast of hot cakes, bacon, eggs, and coffee, and because now and then they'd pop a berry into their mouths, hunger didn't remind them it was well past noon.

But the sun did. Living most of her life outside, Mary was very much aware of its position, and it was the shadows growing longer in the timbered draw that drew her attention to the passing time. Rita, who had found a bigger patch, had disappeared from Mary's sight. Thirsty from her efforts, Mary made her way to a nearby creek to bend down, cup her hands, and drink. Then she called for Rita, who stumbled out of a thick huckleberry patch carrying yet another full pail of purple berries.

"Eight gallons!" cheered Mary.

But now they had to figure out how to carry that many berries on their horses. Rita mounted first, and Mary handed her one of the larger pails, then Mary hung the other pail on a pine limb.

After she was safely in the saddle she rode over and slid the pail off, and away they went back to the cow camp cabin.

As they rode up to the corral, Kid was there to take their pails and unsaddle their horses. Good thing, as it was past time to set the sourdough biscuits to rise. Kid also had the fire going in the blue enamel wood cookstove, which felt good, because at that altitude an evening chill had already settled around Harl Butte.

The boys had been busy gathering cattle. They would start some of them to town the next morning. As Mary and Rita began supper they enjoyed listening to the menfolk recount the day's events.

"Earl Warnock got bucked off," chuckled one. "Cattle buyer is bringing his wife out tomorrow," said Kid. More mouths to feed, thought Mary, and wondered how she would have time to can the huckleberries and cook too, especially since Rita could only stay until the berries were canned.

At the end of her long day, Mary sat herself down on a crude cow camp chair, faithfully took up her pen, and by the light of a kerosene lamp made her entry: "Went huckleberrying again, had swell luck! Got eight gallons between us." And the next day, "The girl left me today after we got our huckleberries canned. We canned 20 qts."

Mary said she usually baked a couple of fresh pies too. And in the winter, "it was sure good to open one of those jars and make a pie."

I cooked and the cowboys came up to ride.

That simple sentence said it all. Kid and Mary were at Harl
Butte Cow Camp, one of the few cow camps that is still in use
_____ there almost every fall — until 2004, when
_____ or the cowboys who came to ride.

_____ e meals and bake pies, even in the later
_____ arnock and I helped with the rest of the

_____ s a cook had spread over the countryside,
_____ from town often appeared just at meal
_____ nave to do was say, "Well, we're goin' up
_____ next day here would come these people
_____ a home-cooked meal. Seems folks were
_____ d of simple life, so Mary and Kid always
_____ er they went. In a country where miles
_____ was more than customary to offer food —
_____ you did.
_____ ainstay, and it took a lot of venison to feed
_____ steaks would be dredged in flour, fried in
_____ kept warm in the warming oven over the
_____ r was added to the drippings in the cast-
_____ enerous amount of cow's milk gradually
_____ ious "milk gravy." No meal was complete
_____ Mary would open a jar of home-canned
_____ oes, and bake biscuits to go with her meals.
_____ ake huckleberry, apple, apricot, and peach
_____ ed her pies.
_____ 1938, after a few years of working in the
_____ s imaginable, Mary put her foot down at
_____ . She remembered, "I told 'em to fix me a
_____ ildn't cook." That remark forced the boys
_____ ok at the conditions Mary was working in.
_____ e old log cabin was falling down around
_____ uilding a new one.

Of course, in the meantime, this meant Mary just had to cook for even more boys, including the fence builders and carpenters who were working on the new log cabin. But as summer waned, the big moment approached. On Friday, August 26, two men went to town after a heating stove for the new cabin. "Thank goodness," said Mary, "I was finally getting out of that dump."

On the 27th, "We moved into the new cabin," wrote Mary, "just in time for the fall ride," when she would be cooking for over 20 cowboys. On Sunday, August 28, Mary noted in her diary that she "cooked for buckeroos, cattle buyers came out, the boys shot two bears."

During supper there wasn't much talk. Eating was a serious matter for hungry cowboys and all they'd utter was "pass the butter and biscuits," or "I'll have another helping of spuds and gravy please."

The cattle buyer must have stuck around, for on Wednesday, noted Mary, "Cattle buyer and wife were here for dinner. 18 to cook for."

September marked a time when the accumulated cattle, belonging to several outfits, were trailed a good 20 miles all the way to the railroad in Joseph. From there they were shipped to market or shipped back East, depending on how heavy they were. Wallowa County had a reputation for good beef because the cattle were fattened on good grass.

Mary split her time between the cow camps on top and making preparations for winter down in the canyon. On September 4, she was along the Imnaha, helping Mama Marks can peaches, only to ride back up on top that evening. It was after dark when Mary penned in her diary, "Nearly froze, as my coat was in the pack."

On Tuesday Mary stayed in camp and cooked. "People coming and going," she jotted. "Rained most of the day. Wayne (Kid's cousin), Elmer and Charles came up after their steers." Mary saw Eva again, as she and Albert came after some firewood. Early fall in the high country meant frosty mornings, and the couple needed wood for their stove. Mary noticed Kid looking at the wood pile and knew one of these days they'd have to hitch up the team and haul in a load of logs to be cut up later for stove wood.

It could snow most any day now.

On Thursday the boys started to Joseph with more cattle, driving them all day, making camp, then delivering them to the railroad in Joseph the next day. Mary would have been busy preparing food for the trail, boiling eggs, baking bread, and stowing canned venison, fruit and cookies in the pack boxes.

While the men were gone, Mary washed, which was, at cow camp, an ordeal in itself, but at least she didn't have to cook for twenty people. All the water had to be carried from the spring into the cabin, heated on the wood stove, and then carried out again to fill the tub. She'd pin the wet clothes on an old telephone wire, strung between two pine trees, that served as the cow camp clothesline.

When the men returned, loaded on one of the pack mules was enough window glass for the new cabin. Now Mary would have clean windows to look out at her world.

On Sunday, September 11, Mary "didn't do much except put in window glasses." After the glass was installed, she "went to the river in the evening," which, of course, meant another steep eight mile trip down Chalk Creek. But it was a trail that was as familiar to Mary as the one that led to their outhouse.

That next day Mary noted that they "brought the car around." Anything with four wheels and a motor was referred to as a car, even if it was a truck. In this case the "car" was an old Ford pickup Kid had bought from his dad. They would have had to drive the old Ford downriver to the Bridge, then on a primitive road up one of the side canyons that eventually led to Harl Butte.

In that rough country, both cars and horses could be dangerous, although if no one got hurt, getting bucked might simply be cause for teasing. On September 14, Mary wrote, "The brown mare bucked Kid off. (Ha! Ha!)" She was still considered a bride in 1938, and often the butt of jokes herself, her lessons hard-learned. It wasn't often she could laugh at someone else's expense, especially her husband, and especially since Kid always gave her a bad time about riding that mare, too.

Sometimes it wasn't so funny, however. Mary would ride anything, and once she had a colt going really good and took him up the trail to the top in steep country. He was going along just

fine for awhile and then he bucked Mary off in a bad place. Kid thought she was dead. And during one dismal period in 1939, not only did Kid and Mary get "wet as heck coming back from the dance on Imnaha," but "Kid wrecked his dad's car, and old Socks bucked him off."

The following day, September 15, Mary was elected to drive two cowboys, "Shorty" and "Stubby," home, while the others stayed to round up some bulls. As the days shortened Mary's riding increased, and on September 20 she noted in her diary, "Kid, Earl and I rode Big Sheep. Sure was a long, hot job." Not one to mince words, Mary wrote a few days later, "Kid and I rode Grouse Creek, sure a hell of a job." Grouse Creek is brushy, steep, and full of rims. And since Earl, Elmer and Will had ridden back to the river, she and Kid had gathered the cattle by themselves.

It was buck season, and Mary noted around the same time that "Kid packed out a deer." Not all the deer they packed out were for themselves. On Saturday the 24th, Kid and Mary packed one out for Art Collingsworth. They got paid $5.00. Hunters from town would come up to Harl Butte or Marr Flat to hunt, and invariably Kid and Mary would have to pack their deer out of steep, impossible situations. Five dollars seems a pretty paltry fee to us, but in those days it was a lot of money.

When Tuesday rolled around, Mary packed her gear and rode to the river again just in time to pick pears. That same afternoon she stoked up the wood stove and soon had quarts of pears stacked in a large copper boiler, steaming away in her hot little kitchen. Since it was canning season she stayed "on the river" and drove to the Bridge after tomatoes. During this time Mary was getting ready to move back into the house from cow camp, which meant she had to spend time cleaning as well. All in a day's work.

When Mary returned to cow camp, she took some of those tomatoes to her friend Eva at the fire tower, tomatoes she'd carefully packed into boxes that had been carried up that steep trail on the back of a mule. The next day she helped Eva can them. Now that was friendship!

Meanwhile, Kid and Albert were "on a fire." Mary noted that when the men came in at 2:30 in the morning, she and Eva had to "get up and get supper for the big bums." On October 3rd, Mary

finished packing, and the next day she and Kid moved back home in the "car."

There was always so much to do. Mary picked and canned ground cherry preserves. The next morning, while Kid and Earl went back to camp after the horses, Mary helped Kid's mom can prune plums. Then she helped the folks can their beef.

Kid and Mary's fruit, canned meats, cabbages, sauerkraut, apples, potatoes, squash and onions were stored in a root cellar located on the old Marks homestead. The original root cellar was dug into the side of a bank and rocked up with a wooden door. Mary once took me into the cellar, and it was like we'd stepped down into time and peeled away the layer of years. Comingled odors assailed my nostrils — onion, apple, the earthy smell of potatoes, and somehow the preserved feeling of autumn on Imnaha. Neat rows of canned venison, elk and beef, of chicken broth, pickled beets and corn relish, of ground cherry preserves, mincemeat, and tomato preserves, of pear butter and apple sauce lined the wooden shelves. Their isolated lifestyle demanded that hoards of food be put by for winter, and the Marks family believed in preserving everything that was in season.

The onset of winter didn't necessarily mean the end of "cattle drives." One Christmas Eve Mary noted, "Kid and Lou got in about four o'clock, found lots of snow on top and the cow wasn't ours. They took her to the river." No doubt a cow had been spotted up on Freezeout Ridge by a neighbor who thought it belonged to Kid and Mary. When cows are your livelihood, a missing cow is important, and because those on the river looked out after themselves, Kid and Lou spent Christmas Eve riding under snowy rims and down the steep trail from Freezeout Saddle, driving a cow that belonged to someone else. Someday a neighbor would do the same for them.

Up in the Harle Butte country, Mrs. Jack Walker and Mrs. Kid Marks shooed their husbands out of camp after a load of wood. The ladies then went out and brought back a three-point buck, shot Mrs. Walker.

Newspaper clipping about Mary and Bess hunting.

19 THAT HOG MESS

November 29, 1938
Thank God we finished with that hog mess.

Hog meat was very versatile, and became a mainstay of the early settlers' diets. Hogs provided fresh pork and lard for baking. Huge amounts of hog meat were canned and stored for winter. Great hams and sides of bacon were cured and smoked in smoke houses, and sausage was preserved in lard. Root cellars kept these cured meats cool in summer.

Mary didn't especially enjoy hog butchering, but like so many other seasonal jobs, it had to be done. It was a tradition that sustained them all winter. She noted in her diaries year after year how glad she was when the "hog mess" was cleaned up, for the entire process lasted several days, and it was Mary and the other Marks women who were left with the massive cleanup.

As Mary described the butchering, I could see the scene before me...

The scraggly cottonwoods that grew alongside the river were losing their leaves. Each new gust of November wind sent showers of them wafting down to float upon the clear cold waters of the Imnaha.

Up high, the rims were dusted with the season's first snows, and the rattlesnakes and bears had been seeking out their winter lairs. Frost clung to the shaded north-facing slopes, or "norths," and rimmed the bottoms.

Clouds of steam erupted from a large vat of boiling water. A wood fire crackled below. Puffs of vaporous breath escaped the men's nostrils as they rolled up their sleeves to grab the first stuck hog by the hind feet. Earl Warnock came up to slit the throat so it could bleed out good. "Don't they look awful when they die?" he asked, and Mary agreed, shuddering at the thought. But she would toughen over the years to the task, and become as good as the men at butchering. In the not-too-distant future Mary would be shooting and field dressing her own buck deer and elk.

The entire Marks family had turned out for the hog butchering. Together they heaved the dead hog above the vat of boiling water,

and then once, twice, three times they submerged the carcass. It was hot, heavy work, and they grunted as they used ropes to raise and lower the hog, then hung the steaming carcass from a long meat pole that was supported between two trees.

Several men and boys went to work scraping the hair, using round metal hog scrapers with wooden handles. It was a good scald, and the hair came off easily. When there wasn't a good scald, it was like plucking chickens that had been dipped in tepid water.

The scraped hog chilled rapidly in the cold morning air and soon another fellow was gutting out the entrails. Then others relatives began to cut off the leaf lard, the layers under the loin, and place it in large pans to carry in to the women, who were waiting to render the lard in large, cast iron kettles in the oven.

That was just the beginning. When the lard melted down, there would be "cracklin's" floating on top. Mary would scoop these up with a slotted spoon and drain them on towels. Sometimes the youngsters would sprinkle cinnamon and sugar on the cracklin's, and other times they were simply salted and eaten like potato chips. Oftentimes, too, Mary helped the older women prepare pickled pigs' feet. The skin was peeled from the feet, which would then swim in a tangy, glutinous mixture that was stored in crocks or gallon jars.

Mary remembered the days they ground the sausage, using a hand grinder to crank around and around until all the meat was ground up with some of the fat. "That part was work," she recalled, "but mostly fun, because we'd do it at Uncle Joe's. He had the sausage grinder at his place. We'd mix in the sage, salt and pepper. We used Aunt Ann's sage; she grew it. Then we had to can all that sausage." Mary scratched her head, "Don't remember if we put any liquid in or not, but it sure was good. Kid, he put brown sugar in when the hams and slabs of bacon were rubbed with salt and salted down, before they were hung in the smoke house. Everyone had a smoke house."

Mary recalled the pungent odor of sage when it was mixed with the sausage, and the scent of apple wood smoke on the massive hams and sides of bacon. "I remember that wonderful smell. We used apple wood saved from prunin' the orchards and

from the apple trees that died. Some of us would have to feed the fire, just keep it smolderin', so the smoke would go up into the hams and bacon. Aunt Ann made sure we did it right. We ate the ribs and tenderloin fresh, and I remember cannin' some of the tenderloin too. We used a lot of half gallon jars, that way we saved on lids. It took a lot of meat to fill one of those jars. It was a lot of work doin' up those hogs."

On top of the hog mess, Mary would help the other women cook for these gatherings. That meant peeling potatoes, frying meat, stirring gravy, baking rolls, simmering beans, cooking vegetables, and baking huge apple sheet cakes and squash pies.

It's not a wonder Mary would write at the end of the day, "Thank God, we finished with that hog mess."

20 Spring in the Sheep Camps

April 20, 1939
Jimmy Huffman came after lambs, and rolled and
killed his horse.

When she was twenty-two, Mary and her brother Pat cooked
for a sheep camp owned by a fellow named Gaulkie. This partic-
ular camp was situated up Big Sheep Creek at a place called Red
Rock. The country up Big Sheep was full of steep rims, and over
the years many horses lost their footing and fell to their deaths
below. Thus the term "rolled" his horse.

It was lambing time at Red Rock, and in those large sheep
operations twins or even triplets would sometimes be born to
ewes who didn't have enough milk. Oftentimes an old ewe would
die during lambing. The lambs without mothers were called
"bummers," and were bottle-fed, given away, or sold to people like
Jimmy Huffman. The Huffmans lived on the Divide.

Mary and Pat worked for Gaulkie for three years, earning
extra income by helping pack salt to the sheep and cooking for
the extra hands hired on during lambing. Examining a photo of
herself and Pat standing outside the cook tent, Mary pointed to
the bench which held a wash basin for the men to wash up before
eating. "See the scrub board leanin' there?" said Mary. "That's
how we washed our clothes."

The first sheep camp up Big Sheep was set up at a place called
Muley. The lambs started coming around March, and Kid couldn't
help because it was time to begin farming on the river. But he
always saddled up a pack horse or two for Mary and Pat and
transported their gear to the camps. From the river, they would
ride up Indian Creek and drop right down the other side into
Muley. After Kid delivered his wife safely, he'd lead her horse
home.

Mary recalled the time when "we was moving camp from
Muley to Red Rock. Kid had built me a bed frame to put my bed
roll on, so I wouldn't have to sleep on the cold floor. The pack
string was crossin' the crick, which was pretty high with snow
melt, and the bed Kid made me fell off the mule and went into the

crick. Nothing we could do. At least we saved the bedroll. But later, Kid, he returned with his horse and fished out my bed."

Mary said the sheep were kept away from the tent, but between cooking duties she'd often walk up the hill to see the little lambs. "I just loved seein' all those little lambs," she said. Later, the band of sheep would be driven to the Divide where there was a large shearing plant. "Don't suppose there's anyone alive now that can remember where that was," wondered Mary. She thought Gaulkie summered his sheep out north of Enterprise.

Once, at the Red Rock camp, some brush got caught in the creek and dammed it up. When it washed out, the creek downstream rose quickly, and one of the herders warned Mary to leave. She got out just in time. "The place got really wet, and Gaulkie had just come from town with groceries like flour, sugar and beans. It all got just soaked, and he had to ride clear back to town for more supplies."

Another time Mary remembered building a fire outside the camp on dry ground where she cooked breakfast. Bacon and eggs, but no bread, as she had no flour. She said Gaulkie's wife did most of the bread baking, since there were so many to cook for and they used a lot of bread to make sandwiches. Mary remembered the pot-bellied stove at the Red Rock camp. "It had four lids and two stove pipes that ran up to a small oven, just a little one, but I could bake custard pies in there. Years later, I rode back up Big Sheep to that camp and that old stove, it was just rusted apart."

When Mary's services were no longer needed, here would come Kid on horseback, leading her horse and a pack mule, to fetch her home again. "Home" for the summer and fall would be the cabin at Harl Butte Cow Camp.

Often Mary talked about the old sheep drives and how Harley Tucker's dad used to run sheep on the Divide. Though there weren't exactly "range wars," there were quite a few disputes over grazing in those days. "The ranchers put up signs marking where the sheep drives would go. Cows weren't supposed to go where the sheep grazed," said Mary. "If they did, it wasn't a problem: we just sicced the dogs on them cows."

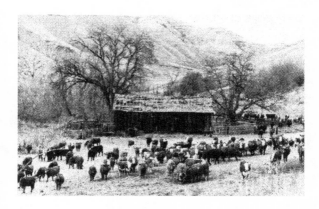

Cattle at Camp Creek — this barn used to be the dance hall.

21 GRANGE DANCES

I'm sleepy after the dance.

On an April day in 2001, Mary reminisced with me about the dances they used to have, and about all the characters who made them so lively. "The first Grange dance on Imnaha was held upriver in Elmer Warnock's old house," Mary remembered. "We had great times there. It was big enough for two sets of quadrilles, and a little kitchen was built on."

The first Grange Hall was built in 1942 on Alfred's property. Kid's mother Mary played the piano, and Elmer Warnock and Frank Shevlin played the violin. Another musician was Muriel Warnock, who worked hard all day being a mother, cooking and such. She'd come to the dances and, together with Mary, would "chord" the piano. Verne Colvin was another good fiddle player, and later Tom Rayburn played the first guitar she could remember down there. It didn't matter how hard those people worked during the day, they'd always take time out to play at night for those dances, which lasted until midnight.

"One night," remembered Mary, "several young fellers felt frisky and put a whole can of pepper on the stove, and it just run everyone out of the hall. I wasn't a member yet, when those boys put the pepper on the stove, but I remember what happened because I was going out to the kitchen to put the coffee to boil. Billy Warnock, Jack Grader and Wayne Marks were three of the fellers who stirred up the fun."

Alfred, Charley, and Uncle Ira — all Marks men — called those first dances, but in later years Kid did the calling. "Kid, he was good at it, he knew it so well, having listened to those calls and music since he was a baby. When we'd get all tangled up out there on the floor, here'd come Kid and get us straightened out, never missing a beat!"

Mary recalled that A.L. Duckett was the main person to get the dance hall going at Imnaha. "We had some wonderful times there. It was just an old barn up Camp Creek. A bunch of us got in and cleaned it all out. The wood floor was pretty rough. The place was inhabited by a bunch of wood rats and I remember we

would be dancin' away and look up to see them buggers leapin' from rafter to rafter.

"Rowena, A.L.s wife, she was in charge of the sandwich makin' and we'd dance 'til midnight and she would bring out these wonderful sandwiches and something to drink. Lots of coffee to keep us a-goin'. We had to ride horses back upriver that night and work the next day.

"I can still taste Rowena's sandwiches. We all helped with them, although she was in charge. You know in those days the cheapest sandwich was baloney. It came in those long rolls. So as not to get tired of it, we disguised the baloney in several ways. The most popular method was to grind it up with one of those old hand grinders, add pickle and mayonnaise, and spread it on the bread. Most of the time folks didn't know what they were eatin'."

Mary remembered when this old cowboy came through the line "all likkered up" and asked what kind of sandwiches they had.

"Rowena replied two kinds, chicken and baloney. She had run out of waxed paper to wrap them in so had used paper napkins. The ones wrapped in white napkins are baloney,' she told him, 'and the ones wrapped in pink are chicken.' "

Eagerly the old fellow grabbed one of the pink wrapped sandwiches, and started going around grinning at everyone that the pink ones were chicken sandwiches and he'd got one. Rowena just smiled, knowing all of them were baloney.

"That old cowboy had enough whiskey in him he never even noticed. We women got a laugh out of that one," smiled Mary.

One time A.L. Duckett asked why didn't they serve pie. Up until then the women had been baking cakes for the dances, but after that they began to making pies. Of course, upriver, pies had been made by the Grange women for years, and some say that there have never been finer pies in Wallowa County than those baked by the Imnaha Grange ladies.

"Another time, at one of those dances up Camp Creek, I remember Cody Dotson and his wife came to the dance, and they had this little baby boy. Cody's wife was dancin' and Cody wanted to dance too, but had to hold the baby. So he seen Lou Warnock,

who was this old bachelor, standin' over by himself, and he asked Lou if he would be so kind as to hold their baby while he danced with his wife. Reluctantly old Lou took the baby and stood there watchin' everyone dance, and the baby was plumb happy. But pretty soon Lou looked very uncomfortable, and taking note of this change Cody and his wife danced over to where Lou was standin', holdin' the baby out away from him. It seemed the little feller had wet his pants, and the moisture had seeped down all over poor old Lou. I still chuckle to this day, when I think about that," said Mary.

They had some wonderful dances at the Grange and later at the Bridge, but then folks from on top got wind of the good times and began coming down.

"Only thing was, the whiskey they brought with them flowed as freely as the river," said Mary, "and some bad fights erupted, mainly over a girl. One night a feller got pretty full of whiskey, and it went to his head and he broke a whiskey bottle over a rock and held it to another feller's throat. That ended the dances at the Bridge. Too bad, because we sure had some good times."

The dances continued upriver at the Grange Hall. Mary's diaries are full of accounts of attending those dances. It was something she really looked forward to, and the next day she always noted, "Sleepy after the dance." But when bad weather or work kept her away, she noted her disappointment: "Lonely, old Saturday night, couldn't go to the dance."

Uncle Ira's garage as it stands today.

22 Whoa!

Many of Mary's diary entries are sprinkled with anecdotes involving Uncle Ira and his wife Louise. They had homesteaded on a piece of property just up and across the river from where Mary lived most of her life. The river makes a bend there, and enough bottom land allowed for a small house, a barn, a garden, and an outhouse before the canyon rose above them. Because the house was located across the river from the main road, access to their place was gained via a crude footbridge that spanned the Imnaha at a spot just before the bend.

Over the years many swinging bridges were built to replace others that were swept away in spring floods. The only time a motorized vehicle could be brought over was when the water was low in the fall or late summer. Altered somewhat by the flood of 1997, the river still makes a bend there, and a pair of dippers returns each spring to a nest made of mud adhered to a large rock that rises above the river.

Aunt Louise and Mary were cut from the same cloth. Every so often, the river would freeze over in winter and the men (Kid and Ira) told the women not to cross over to visit. "Too dangerous for you womenfolk, might break through the ice," they said.

But, as Mary remembered, "when the river wasn't frozen we had to walk up the road and over the swingin' bridge, so crossin' over the ice saved a lot of time. As soon as the men were out of sight, here'd come Aunt Louise, pussy footin' across the ice, a freshly-baked cake held high above her head. She'd say, 'Put the coffee on, Mary, here I come!'" And then the two women would visit and tat, embroider, or work on their rugs, after which they would indulge themselves in Louise's famous chocolate cake. Louise had chickens and fresh eggs, and Mary and Kid always had a milk cow, so Louise's cakes were always high and moist.

Of course, if the men returned, Louise would walk back home by the road. "The men never caught on," recalled Mary.

And Mary would tell the story of Aunt Louise up on the hillside raking hay, when Uncle Ira hollered up, "Louise, your rows are crooked, make straight rows." The tiny areas of hillside

that were farmed were so terribly steep, just managing to stay upright was an ongoing challenge in itself, aside from creating straight rows. Louise replied, "You just come up here and rake yourself then," and with that she let go of the horse's reins and headed for the house. Mary said she learned from Aunt Louise how to do that, and whenever Kid criticized the way she did a job, she simply headed for the house or the hills.

Today the old horse-drawn farm equipment has sunk into the ground, and oftentimes you can find parts of rakes used to hold up rock jacks or fences. The fences, built with pride and patched many times over the years, still stand.

Mary recalled that Ira and Louise's little house contained a small kitchen, a front room, and two small bedrooms. There was no electricity. The house was heated with a small wood stove, and Aunt Louise cooked on a wood range. There was a small barn on the flat near the river, an old log root collar (used as a wood shed today), and many fruit trees which still bear pears, apples, and plums.

Shortly before Uncle Ira purchased his first car—a Ford Model T coupe—he built himself a garage out along the road, backed up against the river. All Uncle Ira had driven prior to the new car was a team of horses, and when he wanted his team to stop he simply hollered "Whoa!" Not really having had much instruction on driving his new car, and insisting he'd get the hang of it by himself, Uncle Ira climbed in behind the steering wheel for his first run and putt-putted upriver, turned around in a wide spot, and drove back to the garage. He pulled into the driveway, aimed for the middle of the small garage, pulled in just fine, and then, of course, hollered "Whoa!" At which point the car, with Uncle Ira still at the wheel, drove right through the back of the garage and straight into the river!

As time went on, Uncle Ira suffered a stroke, so the couple moved to Enterprise. Aunt Louise always longed to return to their home along the river and, after his death several years later, though she did manage to plant a garden down there for a couple of years, but she never did move back. After several twists and turns, the place eventually was sold to a doctor in Joseph, Dr. Blackburn, who burned down the little house that was the

original homestead and built the log home that still stands today. Inside the new house is a small framed black and white print of the original homestead house, the barn near the bend in the river, and a large garden with tall stalks of that good Imnaha corn.

When Dr. Blackburn retired, he sold the place, along with his practice, to Dr. Mike Driver. Starting in 2000, Dr. Driver and his wife Kathleen have made the house available during the months of April and October for the Fishtrap Writers' Retreat. Fittingly, the bulk of this book was written during those writers' retreats. If you ever go to the retreat, just before you reach the modern swinging foot bridge that is still the only access to the place, you'll see an old weathered shack. Uncle Ira's garage has withstood the years, and you can still see where it had to be patched up at the far end, the day Uncle Ira hollered "Whoa!"

23 PALLETTE RANCHO

Drove cattle to the Pallette Rancho.

Mary came to the canyons in 1933, and four years later a movie actor by the name of Eugene Pallette decided to purchase a ranch upriver from where she and the Marks clan lived. During the late 1930s and into the 40s Mary often wrote about or described Pallette and his vast holdings. "Most people thought he was a bit strange, but I liked him, he was always nice to me," recalled Mary years later.

Mary said she remembered him having blue eyes, brown hair, and standing about 5 foot 9. The May 14, 1944 Sunday edition of *The Oregonian* said,

> *Eugene Pallette said he came into the movies to avoid starvation working as an extra in the old Nester Film Company 30 years ago. Got the job because he could ride a horse. He weighed only 125 pounds then, wringing wet, an accomplishment acquired during the school days at Culver Military Academy. After two years out for air corps service, he returned to films and gained his fame and weight. Latter now at 230 pounds.*

"I remember once when Kid and I rode up to the Pallette place, and Kid left me waitin' in their corral while he went up the draw to bring down two mules," said Mary. "Kid, he was gone a long time, and a feller we knew came along and said, 'Kid'll never get no mules down there.' I told him, 'Yes he will, he's done it before.'"

It was late in the fall, and the sun had long since slipped behind the highest rims when Eugene Pallette strolled out of his house and down to the corral to ask Mary if she would like to take supper with them. Mary said she'd rather wait for Kid, he'd surely show up anytime, but Pallette persisted, wouldn't take no for an answer, and Mary was escorted into their fine log home. Mrs. Pallette, who hadn't even been to see her husband's new holdings until 1939, two years after the purchase, had been

an invalid for years. Mary not only enjoyed the meal, but she enjoyed the company of Mrs. Pallette as well. Kid finally returned with the mules and that brief encounter was the beginning of a long friendship with the Pallettes.

Mary recalled that she accompanied a local man when he took a load of furniture for Pallette down to Grass Valley, California, to deliver to a relative who lived there. Pallette paid for the trip, and it was a way for Mary to see the country, but she remembered seeing the icy road beneath the floor board of the old truck as it wound its way over the Siskiyous in winter.

Eugene Pallette's purchase had originally been the H.J. Butler place. Pallette had been in Portland visiting friends and made the acquaintance of a woman who'd attended school with Ben Weathers of Wallowa County. During their conversations Pallette had made known his wish to purchase a ranch to be used for raising cattle. He said he'd been looking in every western state for the right kind of place.

Immediately a trip was scheduled to Enterprise where Pallette met up with Weathers, who took him to the upper Imnaha. Weathers had been coming to the area for years to hunt, and made the remark that if he ever saved enough money to retire, he would buy a place there.

Weathers had received a great deal of kidding from the locals to the effect that this fellow surely wouldn't buy a place clear up there on the upper Imnaha. But Pallette was taken with Butler's property. He returned to Hollywood the next day, as he was acting in a movie at the time, and a few days later Weathers received a draft to put down on the Butler place.

While Pallette was there he'd made the acquaintance of Elmer Akins, who ranged cattle in that district. So when Pallette returned a few weeks later and purchased several more places that adjoined his first purchase, he hired Akins as his manager. Meanwhile, he brought in heavy road machinery and graded a good road to his property. An old-time movie entitled "Robin Hood" was being filmed at the time, and Pallette was a featured actor, so he had to make a quick trip back to Hollywood. Pallette took Akins with him and, while there, presented him with a custom-made saddle and bridle.

According to Imnaha farmer and historian John Harley Horner's papers, Akins returned that November of 1937 to Portland, and he and another employee "returned with a five ton truck on which was loaded a new portable saw mill with a capacity of 15,000 feet per day. Also a planer and shingle mill." The lumber sawed with this would be used for building on the ranches. "He bought two Concord stage coaches and had them shipped to his place. And a friend of Pallette's in Montana sent him a pair of buffalo."

Eventually Pallete flew up in his own plane, which was piloted by "Speed" Nolter. They left the plane at the Enterprise airport. Nolter suggested, after looking over the ranch, that they could build a landing field there, and that later became a reality.

On November 10, 1937, the marquee at the Vista Theater in Enterprise announced for the first time the showing of a film starring Eugene Pallette. The title was "She Had to Eat."

A second film in which Pallette was the principal actor, "The Topper," was shown on November 17th. By this time Pallette had brought in a heavy bulldozer and Caterpillar RD-6 tractor to work on the place and the roads.

Mary remembered that by January of 1938, Elmer Akins rented rooms in the Enterprise Mercantile & Milling building in Enterprise to use for the Pallette ranch office. Times were tough back then, and many went to Akins to seek employment on the ranch, but they were notified through the *Enterprise Record Chieftain* by Akins not to seek work, as they were full.

John Harley Horner noted in his papers that Ben Weathers took him to Pallette's office, and introduced him to a Mr. Waller, who said Pallette was very interested in Wallowa County history. Horner made the acquaintance of Pallette and told him, "The first time I ever saw you, you was drunk as Hell." To which Pallette replied that he didn't remember having seen him before. Horner laughed and said, "Oh, it was in your pictures." Pallette and Horner became good friends after that.

Mary said it was Pallette who co-operated with the Forestry Department in building roads from his ranch that connected with the one from the Coverdale Ranger station and the Loop Road. These roads included the Lick Creek forest road, the Imnaha Canyon road, and the Sheep Creek highway. Prior to 1937 there

wasn't any road to connect to the mouth of Gumboot, only a trail, even though that country was settled with deeded homesteads at the time. Were it not for these roads leading to places like Gumboot, Sheep Creek, Upper Imnaha and numerous other places, the ranchers would not have been able to gain access except by horse travel.

Palette's fame grew. An editorial in the *Enterprise Record Chieftain, June 2, 1938, said

> *It is refreshing to know the way Eugene Pallette has bucked into the hardest kind of labor on his Imnaha estate. He can put in as full a day as any of them and then he can slip away from the crew and prepare as good a dinner for the others in a manner to make a chef's eyes pop out. When a man lives a time in a perfumed air of Hollywood, where $10.00 bills grow on bushes, it is rumored, and high society and ballyhoo are a trade, and mutual admiration and honied praise are legal tender, he may forget the common lot of humanity and lose touch with the real world. The actor's rugged ranch in the canyons may easily become an anchor to keep him from drifting too far. A man can't go far wrong as long as he is willing to work.*

But, as with anyone new to the county, rumors flew about Pallette and his endeavors. Soon Pallette refused to be interviewed or to give out any information to writers or reporters about his Imnaha estate. After Elmer Akins died at the Imnaha ranch from flu-induced heart trouble, Pallette's new manager was given strict orders not to let anyone take photographs.

A *Saturday Evening Post* article, printed in the December 13, 1942 edition of the *Oregon Journal,* quotes Jack Horton, US Forest Service assistant regional forester of the Pacific Northwest, as saying that "Pallette had purchased 3500 acres and was getting ready for the Revolution that he expects when the Second World War is over, where he can hole up and feel secure. As he will be 61 miles from the nearest pavement." Indeed, says the article,

Pallette often told friends that there was going to be a big blow up some of these days, and he was going to be ready for it.

The same story goes on to say,

> *Pallette had an arsenal, vast quantities of dynamite and gasoline, huge underground storage tanks. Visible was a concrete storehouse with thick walls and galvanized metal roof 60 x 90 ft. which contained a machine shop as big as an automobile plant. Huge quantities of stores, enough to stock an army post. Five barrels of vinegar, two tons of assorted canned goods, twenty sacks of coffee and stacks of smoked meats. A cold storage plant, sunk in the ground, a cellar which held 2000 empty cans and a small steam canning outfit. In addition to the saw mill, he constructed a small hydro-electric plant, run by the current of the Imnaha river.*

Eventually Pallette, having been diagnosed with cancer by one doctor, lost 100 pounds. He also lost interest in the Imnaha country. The *Wallowa County Chieftain* stated on October 6, 1949 that "Mr. and Mrs. Eugene Pallette, who have been selling off merchandise he had freighted into his ranch on the upper Imnaha during the war, left for California Monday. The Pallettes still own their land here, but do not expect to come here to live, although they say they may spend their vacations here."

Jean Butler, whose grandfather sold his place to Pallette, remembered the big warehouse sale. "It was incredible, the amounts of stuff he had," recalled Jean. He also remembered how, when the huge semi made it to Grouse Creek, it couldn't negotiate the bend in the road, so the goods had to be unloaded onto another truck coming from the ranch and transported that way.

The Pallette ranch has had several owners since its heyday, but remnants of that colorful time can still be seen today. Mary's diaries are sprinkled with anecdotes of the Pallette's "rancho," as she described it. After the Pallettes sold out, they continued to call it "The Pallette Place."

24 A YEAR IN DIARY ENTRIES

January 1, 1943
Starting a new year. The war has been on a year and looks like it will continue for some time.

While Eugene Pallette was holing up, war was raging a world away. Raising beef was considered part of the war effort, so only one of Alfred and Mary Marks's three sons would be drafted. Elmer and Kid, the cattle ranchers, stayed home. Brother Earl was stationed on the island of Leyte in the Pacific.

Meanwhile, back on Imnaha, life went on and the Marks men, as well as the other ranchers up and down the river, would continue the work they had been born to. As Mary matured from a young bride to womanhood, her diary entries established a pattern of life that repeated itself as the years rolled on.

January 2: "Kid helped his dad. We have some snow."

January 3: "Kid and Doc went up Freezeout after some horses, I worked on my rug."

January 4: "I washed and helped Doc take his horses up the river. Had dinner with Pat and Rita."

January 5: "Butchered a beef at Alfred's."

January 6: "Uncles and Mac came up and started to work on the cupboard and sink." Mary and Kid were moving into the little house she still lives in today, which was located just downriver from the old homestead place. Work progressed on her cupboards and Aunt Nettie helped Mary can beef. Kid helped his dad wean calves.

January 11: "Cold as heck today. The boys worked with the cattle. Real cold, feeding twice a day now. Good day to keep the fires going."

January 18: "18 below 0. Things are so cold they really crack around here. Went to Alfred's after the mail. Wind nearly froze me. Snow...snow...snow."

January 28: "Killed our hog today."

January 29: "We worked up our hog meat."

February 1: "Just washed mostly, my hands nearly froze hanging clothes."

February 3: "Went to town. Road was fine. Kid is trying to get deferred."

February 4: "Salted our meat and brought our groceries home."

February 6: "Nettie helped me make a quilt for dad."

February 16: "Kid and A.P. (Alfred) went to the Bridge to sign for kerosene." There was no electricity upriver yet, and there was fuel rationing during the war.

February 18: "The boys are sawing wood at A.P.'s. I went over and cooked dinner for them."

February 23: "Went down to Verde's to sign for our new stamp books."

February 24: "Went to Alfred's so kids could catch the stage." The stage transported folks who didn't own cars out to town.

March 2: "Papered the bedroom."

March 4: "Alfred, Louise and Uncle (Ira) here. We laid the front room linoleum."

March 9: "Kid and I drug poles out of Freezeout."

March 10: "The boys helped Kid build fence at the Jensen place. Kate and Will (Wilde) were up there."

March 11: "Kid went to Will's, so I did the feeding."

March 13: "Took in the dance, it was pretty good, considering the rain and snow."

March 21: "I went down to see Pinky's new white calf."

March 24: "Kid's farming at Joe's."

March 29: "The boys are plowing. It sure looks stormy. Kid and I put horses up Log Creek. Boys plowing big field on the bench. Uncle finished my cupboards."

April 8: "Went to grandad Lewis's funeral. Rained like heck all day."

April 10: "I painted. Kid helped dip cattle for ticks."

April 13: "Busty drilled grain for us. Gosh it's hot as heck."

April 15: "Went to the Bridge for garden seeds. Planted a little."

May 1: "Went to Lucille's and took in the dance and had a good time."

May 2: "Not so good after the dance. Got home at 3:30 a.m."

May 3: "Washed and packed stuff. Kid took a load of grub to camp."

May 4: "Packed up and ready to hit for camp in the morning if it don't rain."

May 5: "We came up to camp (Harl Butte Cow Camp) and of course it rained and ended with a snow. We cleaned up the dump." After being vacant from late fall until May, cow camps needed major cleaning. More often than not pack rats and mice had moved in, which required a lot of work on Mary's part.

May 10: "Snowed more and we built fence."

May 15: "Kept snowing... looks like Christmas around here. We shod Minnie Pearl. Drove cattle up Grouse Creek to camp."

May 20: "Rode Freezeout, took horses to Needham Gulch. Kid packed out posts."

May 26, Mary's 26th birthday. "We built fence on Harl Butte. It was good and warm."

June 1: Mary rode horseback down to the river to tend her garden, and "beat the storm."

July 2: "Kid got his draft papers fixed and had 19 units... 5 to spare."

July 4: "To (Wallowa) Lake, had a good time, lots to eat."

July 9: "Went to Pallette's after some cows, a hot old trip."

July 10: "Rode Sheep range, didn't find a cow."

July 11: "Put linoleum down on Harl Butte cow camp floor. A truck delivered a load of salt. Cold, snowed!"

July 14: "Kid packed water on a mule up to the fire lookout at Harl Butte, from the spring at the cow camp." Since there was no water up at the Lookout for the fire ranger, it had to be hauled up there. Mary and Kid, on horseback, "punched" 250 head of cattle up the ridge, salted them, then had dinner with friends on Marr Flat.

July 17: "Fished in Grouse Creek... fun!"

July 19: "Salted down the ridge and came home to hay. Rode down Chalk Creek, darn near roasted." After Kid and Mary put salt out for the cattle, they rode down Chalk Creek to their place on the river to put up the winter supply of hay. Think of the miles spent on horseback recorded in those two sentences.

July 24: "Stormed, lightning started several fires... haying... went to Kate's to get cherries, canned vegetables. Cooked for boys.

Picked peas at Aunt Ann's and Louise's. Hot as heck. Canned 36 pints of peas and picked cherries."

August 2: "Canned cherries, got a letter from Earl."

August 7: Mary went to town to see her mother.

August 11: Mary cooked for the last of the haying. She noted her brother Pat took a fall in the barn, while putting hay in the loft, and was hurt.

August 13: Mary and Kid returned to Harl Butte Cow Camp, where Mary cooked for the riders. There were thunderstorms, and Mary noted Elmer and Wayne (Marks) were on a fire.

August 19: "Kid and I spent the night at Lick Creek." Mary wrote that her mother would be leaving in a few days. She continued to cook for riders.

August 27: Mary returned to the river on horseback. "Canned beans, picked plums...HOT." Mary was canning on a wood cookstove, keeping the water boiling all those hours to insure the safety of those green beans.

August 29: "Canned 4 boxes of peaches. Rained. Guy Estes and Uncle were down for dinner. Went to Needham Gulch after a horse, and up to Lick Creek." Mary and Kid made numerous trips to Lick Creek, 20 miles west of Harl Butte Cow Camp, to pick up groceries. Mary would call her order in on the Forest Service phone line, and rangers would purchase the groceries and take them to the guard station there, where Kid and Mary would pack them on a mule and head back to the cow camps.

September 3: "Moved to Mahogany, was hot. I brought the milk cow."

September 7: "Went around by Pallette's in the car. I canned apples rest of day." The "car," of course, was a truck, and "around" meant driving down Gumboot Creek to where that road turns north and joins the upper Imnaha, thus passing Pallette's place.

September 8: "We went to town and bought Tom Marks's ranch. We are sure glad." This was the place Mary owned for the rest of her life.

October 14: "We moved camp today, sure is cold. Cleaned up at cow camp, and got in some wood."

October 16: "Cold and snowy when we went to gather our cattle, found our cows and took them home."

October 19: "Getting very cold and more cowboys came up to ride here at Marr Flat."

October 21: "Six or seven inches of snow. Everyone stayed in camp."

October 22: "Snowing and blowing like heck. We wonder if we can get our car out." She was afraid of being snowed in at the cow camp. Quite often, late in the year, snow storms dump so much snow this could be a problem. Mary had good reason to worry.

October 23: "The boys rode again today. It's beginning to thaw out a little now."

October 24: "They all left today but Wayne. The bunch at Nesbitt (Butte) got out today."

October 25: "The boys took our car out. They found a lot of snow. I took their saddle horses to the river." Mary, alone on horseback, drove the other horses ahead of her on the steep and snowy trail down to the Imnaha River.

October 26: "Returned to camp with Wayne and Gladys."

October 27: "The boys (Kid and Wayne) hunted and got a two-point. Us gals (Mary and Gladys) cooked a chicken dinner for them."

October 28: "Moving to the lower camp today, looks stormy." She meant moving from Mahogany Cow Camp to Harl Butte Cow Camp.

October 29: "We packed up and came home. Had a bunch of pack horses and cows. Also a quart of Four Roses."

October 30: "Rode to Jake's for a chicken dinner. Had a good time."

October 31: "Came home, unpacked some of our junk, after all summer."

November 1: "Kid and Mike (Elmer) got a big 5-point."

November 3: "Canned prunes and plums. Kid helped Uncle butcher"

November 4: "Took in bazaar, got a darn good cold, but had fun."

November 5: "Made mincemeat."

November 6: "Canned mincemeat, made ground cherry jam...Butchered hogs. Canned more. Rendered lard, made sausage, canned meat, canned sausage."

November 22: "Boys building troughs in Chalk Creek. Butchered chickens."

December 2: "Sawed wood. Fenced stack yard." A fence had to be built around the hay stack, to keep both cattle and wildlife from destroying the hay.

December 18: "Had an ice gorge. Cold. Christmas program at the Bridge." An "ice gorge" meant the river had frozen, then thawed enough so huge chunks of ice broke loose and clogged up the river. This caused the water and chunks of ice to flow onto the sparse bottom lands, where cattle were sometimes being wintered. "If we didn't get the cattle out in time, they could be injured or even killed by that terrible ice, and of course it made it hard for them to get to open water to drink," said Mary.

The Christmas program put on by children in grades 1-8 at the school in Imnaha was looked forward to by everyone on the river. There would always be food. Santa would make an appearance and the little ones all received a brown bag containing a popcorn ball or some candy treat. Proud parents and residents up and down the river always attended the "Christmas program at the Bridge."

December 24: "Cooked and baked, got ready for Christmas dinner. Went to program at Freezeout School." The Freezeout School was where the Marks and Warnock children attended school. It was just a short distance downriver from Kid and Mary's. The old weathered school house still stands today.

December 25: "Xmas, Jakes, Waynes, and Iras up for dinner. Dance at Grange Hall." This referred to the Jake Marks family, the Wayne Marks family, and Aunt Louise and Uncle Ira. The Imnaha Grange was located upriver, not far from where Alfred and Mary Marks lived.

December 26: "Slept mostly. Kid drug rocks out of road." Boulders too big to handle by hand would fall from the banks above the road, and would have to be "drug off."

December 30: "Kid hauled poles to build feeders"

December 31: "This is the last day of the year and the war is going our way now. The boys worked on the corral."

Yes, the war was "going our way now," but Kid's brother Earl would, in 1944, make the ultimate sacrifice for his country, and lose his life on the island of Leyte.

25 FOUR ROSES RIDE

… also a quart of Four Roses.

On October 28th, 1943, Mary, along with Gladys and Wayne Marks, went on horseback to Marr Flat after cows. The next day, they packed up and came home down Grouse Creek with a bunch of pack horses and cows.

"That trail down into Grouse Creek was an old Indian trail, it took an Indian to make that trail. It went straight down, no switchbacks," said Mary.

Before they'd left camp, the wives had stuck a bottle of Four Roses whiskey in Gladys's saddle bags. To ward off the cold, the gals had been sipping pretty steadily from that bottle. "It went to snowin' and blowin' again, and that bottle of Four Roses sure kept us warm," Mary recalled. As they made their way down a steep draw, Wayne hollered to Gladys to turn the cattle to the left.

Women in those days seldom talked back to their husbands. "But Gladys, she was just a-singin' away there in the saddle, in all that cold, and paid no heed at all to Wayne's orders. 'The heck with it,' said Gladys, 'Turn 'em yourself!' And with that, she let the cattle trail on past her. Never will forget the look on Wayne's face," said Mary. She recalled being in the same devil-may-care mood herself, and nothing anyone said seemed to sink in.

For years this was referred to as "the Four Roses ride."

All through the years the story was kept alive by the telling and re-telling. And that bottle of Four Roses is stuck somewhere between some rocks alongside the river.

26 A CLOSE CALL

Packed hay up Freezeout and on to Marks cabin.

Durng the 1940s the Forest Service allowed permittees to leave their cattle on the Freezeout range as long as the ranchers thought there was enough feed. This usually worked out well, as every year was different, and the ranchers judged when it was time to take the cattle off the range by the condition their cattle were in. Prudent cattlemen never let their stock get thin going into winter.

The later in the fall a rancher could keep the cattle out, the less hay they would have to feed all winter. And of course, that added to the profit — if there ever was such a thing as profit. Often, ranchers barely broke even. They asked only for a way of life, or enough money to pay off the operating debt. This was the only life they could ever imagine living. Like the old-timers before them, they were born into it.

Kid and Mary's sole income was derived from the annual sale of whatever beef they managed to raise. Grass was the key, whether it was in the form of the natural bunch grass that grew so abundantly in those rugged canyons, or meadow grass cut and cured for hay. That hay would then have to be transported, and of all the accidents that happened to Kid and Mary, one that occurred one fall while packing hay was the scariest.

Mary was sitting by the wood stove, telling me the story. I could see the whole scene before my eyes...

Ahead of her on the trail, Mary could barely see Kid through the snowstorm, nodding in the saddle. He was tired, she thought. They'd both been up before daylight fixing breakfast, then she made their lunches while Kid caught and saddled their horses.

Mary had watched him out the kitchen window, coaxing the horses into the barn with a bucket of oats. After the horses were caught, Kid threw the rigging on the pack horse and then saddled their two horses. As Mary grabbed their heavy coats and slickers off the hangers on the back porch, Kid began to hoist the first hay bales onto the pack horse's back.

Mary hurried to help Kid cover the bales with a mannie tarp and rope them down with a diamond hitch. It would be a long day, thought Mary, as she stuffed their lunches into the saddle bags.

The couple didn't speak a word to one another as they rode the five miles in a light rain up the road to where the trail began. Both Mary and Kid were used to riding along silently, each lost in their own thoughts, each observing the country they knew so well, and always alert to how the hay was balanced on the pack horse.

It was late November and the snow lay deep on Freezeout Saddle high above them. Soon, as they climbed, rain turned to snow, with only a few scattered flakes at first, dancing in the wind, until it fell thickly all around them.

Mary shivered in her saddle, and pulled her wool scarf over her lower nose and chin. The wind picked up and the cold flakes stung her eyes. While they were riding through a stand of tall ponderosas, Kid pulled off the trail and tied his horse to a tree.

"Time to put on our slickers," he told Mary, and she, too, dismounted and untied the long yellow slicker from behind her saddle. Climbing back on was cumbersome, as the slicker trailed to her ankles, and the waterproof material only made her feel colder.

"At least we won't get so wet," said Kid, as he climbed back into the saddle and nudged his horse up the trail, pulling the pack animal. Mary and Kid were packing these bales of hay to store at the old Marks cabin so there'd be horse feed during the fall gather. The cabin, situated southward from Freezeout Saddle, was already stocked with staples for the riders.

In zig-zag fashion the trail wound up into open country where there was no shelter from the stinging wind. They crossed several creeks, ice rimming the edges. Higher and higher they rode, and because of the storm, Mary's view of the distant Wallowas was soon obscured.

Although Mary and Kid shivered in their saddles, they were always happy for the moisture provided by the first fall storms. Snow was just as important to grass as rain. Mary noted there was still plenty of bunch grass to keep the cattle rustling the steep

hillsides. Still, she hoped the weather would improve before the fall ride began.

Before Kid and Mary reached the top of the Freezeout Saddle, they turned off on what they referred to as the "Government Trail." This trail led southward up the ridge. At the top they let their animals rest. Sides heaving, the sweat-soaked bodies gave off horse-scented vapors that rose into the cold air.

After the horses caught their breath, they continued along the worn trail. Far below, hidden in the mists, the Snake made its way through Hells Canyon. Approaching the old burn, Mary noticed several snow banks in the trail ahead of Kid. Here the wind-driven snow had been piling up into drifts. Mary saw the drifts, but Kid had his head down to avoid the chilling wind.

As she retold the story, Mary's voice dropped.

"Up blew a blizzard, snowin' and a-blowin'," she said, "and somehow the young horse Kid was ridin' got the lead rope of the pack horse under his tail and he went to buckin'. I could see Kid was headed for a rim with a steep drop off, so I yelled 'Jump, Kid, jump!' The next I saw of Kid was his body flyin' off into space."

There they were, two tiny figures in a November snowstorm, all alone in the midst of miles of unpeopled canyon. Knowing that without the horses all would be lost, Mary bailed off her horse, collected the pack mare, and caught up Kid's horse, who came stumbling back throgh the drifts to the other animals. After securing her horse to a scrub pine, Mary sloshed off through the snow to find Kid.

"He was lying face down, groanin' something terrible," recalled Mary, "all the while attemptin' to give me orders what to do." Finally Mary figured out he wanted her to bring his horse down and help him back on.

Mary did as Kid bade her, and with much difficulty led Kid's horse down to the steep rocky cliff where her husband had landed. With even more difficulty Mary heaved and shoved until she got him loaded on the horse. Kid thought he had broken ribs, and hoped that was all. Every step the horse took intensified Kid's pain, but Mary knew he'd bite his lip and take it. Turned out he'd hurt his back, too, but he never let on how much it hurt.

"His back always hurt, from getting bucked off so much," Mary remembered.

After several more miles of riding Mary caught sight of the little cow camp cabin all but perched at the edge of a canyon, hidden in the pines. "That shack looked pretty good to me," remembered Mary. "Thank goodness that pack horse behaved the rest of the trip. Guess it knew there'd be no more climbin'."

With a great deal of effort, Mary helped Kid off his horse and into the cabin, where she kindled a fire in the old stove. She tried to make Kid as comfortable as she could before she went outside again to tend to the animals. After the hay was unloaded, and the horses fed and watered, Mary returned to make a pot of coffee.

Kid, by now thoroughly chilled, was revived by the hot liquid. Mary had been so busy, she'd forgotten about being cold, but suddenly all that had happened hit her and she began to shake. Mostly she shook at what could have happened to the two of them back up there on that stormy ridge.

A couple of days later. Kid was able to get around enough to make the return trip to their home on the river. And it wasn't much later, said Mary, that "we were both back up there, ridin' for cattle, and me cookin' each day for the boys who came up to help gather. And there was that hay up there to feed our horses while we were there. We just did what had to be done."

27 A HARD WINTER

January 1, 1949
Cold as heck, and several inches of new snow.

Another year, and it was so cold Mary begged off going to town on Saturday, something she didn't often do, but it was 8 below and she needed to keep the fire going. On the 6th she noted that Kid's uncle Tom Marks was "pretty sick," and the next day they had to take him to town. It was still 8 below when she recorded, "Although Tom is still in the hospital, he seems better."

As the Marks family took care of their own, Mary stayed out to be close by, writing that the temperature dropped to 10 below. On Sunday she penned, "Got the hell scared out of us, we thought water pipes were froze." Mary went on home then.

Cold winters were nothing new to Mary. She remembered "when Freezeout Creek iced up and run over the banks and filled up the yard around Grandma Jensen's place, it was just solid ice, and I had a pair of ice skates so went ice skatin'. Of course there were no cars to start back in those days, everything was done with horses, but ice had to be chopped so the livestock could drink. Before I came to Imnaha, back in the 1930s, the folks would cut large chunks of ice and store them in sawdust, and they'd last most of the summer."

This would be a January to remember. "Snowed and blowed. The Park road (the Imnaha River Road upstream) is drifted full." On the 17th Mary noted, "Went to Louise's to wash. Crossed on the ice." On the 23rd the thermometer plunged to 14 below, but that didn't stop the river folk from attending Grange. The large barrel stove would be stoked until it glowed red, to warm the drafty old hall.

January 25, 1949: "Dad (Alfred) went to town on the stage." The vehicle that delivered the mail also provided transportation for oldsters wishing a ride to town. Connections were often inconvenient, but then you simply spent the night with relatives or friends, and caught the stage whenever it left for the canyons. Mary noted that Dad didn't return for two days.

On January 31st Mary wrote, "Washed. Hauling hay from the (Wallowa) valley." What she didn't write is what such a trip entailed, and what it entailed was a hazardous trip down icy Sheep Creek Hill, driving an old, loaded hay truck that had to be chained up while one hoped the brakes held. Then there were all those miles of snowy roads to the Marks's stack yard. Mary wrote, "Barney stayed the night." Barney was the truck driver, and a one way haul would be a full day in 1949. He'd return two days later with another load. Finally Mary noted, "Kid went to town after the last load of hay. Stack ran seven ton short." This meant they would have to look elsewhere for hay to purchase.

Not enough hay can be raised on Imnaha's sparse river bottoms and benches to sustain cattle during a winter like they had in 1949. Hay was hauled to places like Corral Creek, Cow Creek on the lower Imnaha, and Dug Bar on the Snake, as well as upriver to Grouse Creek. Some of the unsung heros of Wallowa County were those hay haulers. The trip downriver from Imnaha was even more treacherous than upriver, as large, loaded trucks swayed around horseshoe bends and slid down icy stretches of road that sometimes sent entire loads off the sides of steep canyons, or worse yet, into the river.

Some winters, referred to as "open winters," had less snow and allowed cattle to graze the matured bunch grasses on the southern exposed hillsides. Sometimes, when steep canyon sides became frozen, tell-tale dirt slides marked the paths of cattle who fell to their deaths below. The canyons are littered with bleached bones and skulls from such accidents. Sometimes a cow would get "rimmed in," unable to escape her prison, and starve to death. This "food for coyotes" created a loss in the rancher's already narrow profit margin.

On February 7, 1949, Mary wrote, "Louise and I washed. I helped Aunt Ann can meat." The women supplied each other with jars, lids and labor. On the 12th, a Saturday, the weekly dance was held at the Grange Hall. On the 13th, she simply stated, "Sleepy as usual. Went to Lucille's awhile."

Then for some reason Mary left the pages in her five-year diary blank from February 14 to March 4, a rare occurrence in all her years of diary-keeping. On March 4th, all she wrote was,

"Went to Louise's, she isn't very good." Mary was very close to Aunt Louise, her living just across the river and all. Perhaps Mary had been tending the aging woman, and therefore didn't have time to record her days.

Louise continued to be quite ill, and Mary made an occasional note of her sickness. Then she was busy, as they butchered their hogs, and between making sausage and lard, she scarcely had time to write about Louise. Mary's jotted-down notes are full of canning hog meat and sausage, playing cards with Walkers "on top," hauling wood, and then, "Went over to Louise's awhile, embroidered. Auntie is sure sick."

Finally, on March 18th, they took Aunt Louise to town as her condition worsened. Louise stayed out until the 30th, then returned to her home on the river, but Mary noted, "Went over to Louise's, she don't feel too good yet."

Helping Louise became almost an everyday thing — but then, helping each other was common. Mary noted that "Aunt Nettie came down and I gave her a permanent." Beauty parlors were many miles away and expensive, so the Marks women tended to each others beauty needs. They simply purchased their hairdos in a box during their infrequent trips to town to buy staples.

The daffodils bloomed, the forsythia sent out its first golden sprays, and Kid began to spring-tooth harrow the fields. The Marks clan all helped each other with the plowing, moving from ranch to ranch, which meant Mary did the cooking for the "plow crew." By April 10, Mary recorded, "80 degrees in the shade, and they rounded up horses." Gardens went in. Alfred took Kid and Mary's "car" to town to get repaired. Kid and Mary attended a barn dance, spending the entire night dancing to the fiddle music, and both were "very sleepy" the next day.

One day in May, Mary wrote, "Aunt Ann and Louise were down." Louise had made it through the hard winter.

28 THE CLUB, COWBELLES, AND CATTLEWOMEN

Because she didn't have children, Mary fed cattle, kept up with the constant housework, and then, like most other women on the Imnaha, would braid rugs from old rags, tat, or embroider pillow cases. Those rag rugs lasted through the years, built as sturdy as the women who braided them. Mary admitted she wasn't fond of these domestic feminine pastimes, but they were an antidote to the long, dark hours of winter — the time when the sun disappeared all too quickly behind the western rims.

Those pastimes were more fun when shared with others. The women on the upper Imnaha had formed what became known as "The Club," where they met at each others' homes to eat lunch, chat and tat, and embroider as many tales as pillow cases. Always the prettiest table cloths and napkins would be used. Their best dishes graced the table, laden with food they'd spent all morning preparing. In a lonely country this was a way to socialize. In her diary, Mary simply stated, "Had CLUB today at Lucille's."

On February 5th, 1949, Mary penned, "Had a pie social at school house. Had fun. Louise and I went." The Club was made up of Grange ladies, and they would discuss money-raising activities for the Grange. Baking and selling pies became their biggest fundraiser, a tradition that would make Imnaha women, including Mary, famous for their pies.

When the women of Imnaha held pie socials, they spent hours perfecting their favorite recipes. Oftentimes women established reputations for certain pies. Mary's specialty was the pies she baked from the wild blackberries that grew along the river. Dark, red juice bubbling through slits of tender lard crust conjured up visions of summer, blackberry picking, and warm sunshine. It's not hard to picture Mary and Aunt Louise packing those pies into the school house, chattering away, anticipating who would buy them, and how much they would fetch. The proceeds always went to purchase some needed item for the school or Grange.

"One time," remembered Mary, "it was my turn. I always had it in the summer because then everyone could go swimmin' in

the hole next to our house. Of course I spent summers up at the cow camps, so I come off the mountain that morning. Didn't have much time to prepare anything fancy, so served crackers, cheese and beer, then we forgot about any business and went in the river." In my mind's eye I can just picture these women having such a good time. Wish I'd been there. The tradition lasted until the year 2000, when the Grange women, older and tired, decided they'd baked pies long enough.

In addition to "The Club," there were other opportunities for socializing. On June 12, 1968, Mary noted, "Went to Gladys's for CowBelle meeting." In those days, the Imnaha ranch women made up much of the membership of this county-wide organization. Mary was a good CowBelle and spent many hours working for the organization. Oftentimes Imnaha women hosted the meetings in the spring, when people on top were tired of snow. Daffodils, flowering quince, and forsythia would cheer their winter-weary hearts. There would always be a potluck when the meetings were held in the canyons, and women would fry chicken, make potato salad, and bake pies to grace the hostess's table.

These women worked hard alongside their husbands, and enjoyed their time of friendship and visiting. But as the years rolled on and it became harder for the older women to make the meetings on top, the Imnaha women nearly all dropped out.

It was also thought by many that something was lost when the CowBelles changed their name to CattleWomen.

After the name change, the need to work in the political arena of range management played such a large role in belonging to the organization, it almost became a given commitment, and the Imnaha women felt guilty about not having enough time to give. Far removed from the newer, younger women on top, they gradually left the cattleWomen organization entirely.

In fact, by the year 2000, the Wallowa County cattleWomen had disbanded, with the remaining members joining their husbands in the Stockgrowers Association. It was a sign of the times. It seemed all the women had time for was fighting for the rights they had always taken for granted. Debates about restrictions on running cattle, grazing on public land, and many other issues that would forever change cattle ranching required women to

become political and give their time to writing congressmen and fighting for their rights. It took up time they didn't have, and caused much dissension.

The passage of years would see many changes affect these good people. Such changes like the selling out of the Enterprise Livestock Auction, where the CowBelles of years past put on enormous steak feeds for the annual Labor Day feeder sales. It was always the Imnaha women who brought up their wonderful homegrown heads of cabbage and, using "kraut cutters," shredded the cabbage for coleslaw.

Also famous were the Imnaha tomatoes, juicy and red and ripened in the canyon heat, and cucumbers from Imnaha gardens, sliced with sweet onions, swimming in a sugar and vinegar mixture. Such camaderie, such fun, those women had! Preparing food for over 600 people over the bawling of hundreds of feeder cattle and the warbling chant of the auctiooneer. Children ran about with coundess border collie dogs until well after dark, when everyone's breath hung in the air, as the morning after Labor Day often brought the first killing frost.

Those were the days! But nothing stays the same. People, places, and events change. In 2004, Jean Stubblefield, a former Imnaha CowBelle, and I had a conversation about old times and decided to organize a luncheon and invite the surviving Cow-Belles. It was wonderful to be together again. The reunion of the Wallowa County CowBelles continues to this day, although each year many more have left us.

29 FOR BETTER OR WORSE, IN SICKNESS AND HEALTH

January 1, 1958
Idaho Power is going down the river with their survey
for a power line.

Thus Mary began another five-year diary. It was to be a year of progress, but also one of trials small and large, and marked by sickness and death.

January 2: "I washed. Old machine quit me, so I finished by hand."

On Saturday the 4th it was cold, 28 below zero, and Kid and Mary went to the Bridge to watch the school kids' belated Christmas program. A few days later, they attended a meeting at the Grange Hall on electricity.

January 25: "Went down the river and shod a horse for Russell and Cora. Joe (Marks) was down trying to sell us his ranch...threw a birthday dinner for Alfred, who turned 77."

January 31: "Kid put the tongue in his wagon, and they went up the hill to see if they could find water to pipe in the house. Turned spring-like and Kid sawed a tree."

On February 9, Mary came down with a cold. Their first calf was born, and she helped Kid with the feeding. The next day brought two more calves, one coming at midnight. Mary washed and ironed; no time to be sick. Soon Kid was struggling with a cold, too.

February 15: "Our colds aren't any better. Raining." Mary ended up with an infected sinus, and had to go out to the doctor. A few days later, it was "pouring rain, river is up, rained and blowed all night...river is way high, moved the cows across the river...more snow and blowing."

March 5: "Chivareed Bud and Bonnie Rayburn tonight." To "chivaree" is to bang pots and pans and otherwise make a racket as a type of mock serenade to a newly married couple.

March 9: "Snowing and cold. Slush ice running in the river."

March 12: "Boys put up our new phone. 12 calves now."

March 30: "Kid's 45 years old today... sleepy after the dance." The next day Mary went to town to have a tooth pulled and a cyst removed from the tooth hole. She had a badly swelled up face, and worried about it, so "went back to dentist and it was ok, so came home. Don't hardly look human. Bought 10 ton of hay."

On Easter Sunday: "My face black and blue. 19 calves now, no grass, and darn little hay left."

April 8; "Went to town for dental appointment. Got seed grain and 16 baby chicks, had 4 hatch so started with 20."

On April 9, Mary noted, "Lost 4 chicks. Kid raked alfalfa, getting anxious to farm... Guess we can't buy the Simmons ranch (no money)." The Simmons place was on Horse Creek on the lower Imnaha, and this was not to be the end of that story.

The next day, "Alfred was sick, we were up there (in town) all day, as Alfred had to be in the hospital for a few days. Started to tear out the old cellar and I hurt my back, went to bed for rest of the day... Kid went to a power meeting at the Grange Hall."

Mary's back got better, but they wouldn't let Alfred come home, and then Earl Warnock had a heart attack. "Went to town after Alfred. Earl W. wasn't good, I had another tooth ground out. Doubt if I'll be able to pay my dental bill. Rained all day, I slept as my hip hurt. Kid walked the floor, he was restless. We heard Earl W. is some better."

April 21: "Earl Warnock died at 6:30 this morning. We feel so bad about it. Rained as usual. Sure is wet." Soon, "Vet came for a heifer having trouble. Calf died, hen hatched 10 chicks. Went to town to Earl Warnock's funeral. Snowed and rained all day. I feel so bad about Earl. You don't find a friend like him."

May 3: "Boys plowed gardens, Lucille and I killed 14 chickens, canned 11 jars of chicken."

May 8: "River coming up again. Working on the sheet rock, sanding. Hot, and I'm sick and not getting it done very fast... sick but painted anyway."

May 25: "Kid's got the flu. Came up to Mahogany so Kid can salt across the creek, but since he is sick I don't know. Still awful hot."

May 26: "My birthday (41). What a day. Kid feels better, but not able to salt across the creek. Thundered and showered a little."

May 30: "Went to the Divide and found the black horse with a foot cut off, so had to kill him. Rained again this eve, built fence on the Butte."

June 9: "Went to Mahogany to patch fence. Kid's stomach is upset. Went to the Divide after our horses. Rained, took Elmer's bull across the creek...rained...pushed cows down the ridge. Built fence till we got rained out, then salted. I washed and got clothes dry before the rain came. Rained all night. We started to town but hit a water spout so came back home. Road was blocked and still it pours rain."

June 16: As they moved up to Mahogany, "Kid salted as he came up. Found Mike's old mare on three legs. Guess she got kicked." The next day, the mare was "down most of the time."

June 18: "Old mare is a lot weaker. Kid rode across the creek and I took horses to Harl Butte...went to town after medicine for the horse. While Kid headed some cattle off above Gumboot Road, I washed and doctored the old mare. Gene and Mildred Marr came for supper and we loaded the horse and brought her home. Got in at Alfred's at 1:30, unloaded the horse. She stood the trip ok and is a little better, but awful sore."

June 22: "Finished at Alfred's for awhile and started on our own hay. Horse fine now. Went to the Bridge this afternoon, 100 degrees down there. Came down last night to dr. the horse and cook for the hay men. It's hotter than Hell. Old mare is walking around more and looks lots better."

)une 24: "Rained all nite last nite and haying is done till it clears off We took Joe (Marks) to town and bought his place. 160 acres for 6,000 dollars."

June 25: "Quit raining, but wet. We came to camp to see about things. The filly had a mare colt and Injun a sore leg."

The next day they "couldn't hay, rained out...hay isn't curing, cold and cloudy."

June 28: "All the hay down, raining, did finish one stack on our place. Hay still too wet to stack."

July 4: "Took in picnic at Grange Hall. Cleared off so maybe we can hay. Hot again."

July 7: "A wet old morning. Lucille and I killed 5 chickens. Partied Louise (65 years old)."

In August, "Kid found Nellie Bly with a bad leg. We took her to the vet, she is bad. Took cattle up to the head of Lick Cr. Had a bad hail storm. We got under a tree."

September 1; "Got up to come to town, and got a horse crippled, so Gene brought it on in."

And so went this incredible lifestyle, the main theme of which was WORK, all accomplished in a country so rugged and unforgiving, yet these people were able to cope, face each day, and do what had to be done to make a living.

30 ELECTRICITY, RUNNING WATER, AND A PAYCHECK

March 3, 1960
Idaho Power set our poles, so we will get busy wiring
the house.

Kid and Mary had worked for the Marr Flat Grazing Association for years, but it wasn't until March 26, 1960, that Kid was officially hired on as caretaker, a position he would hold for 27 years. Mary wrote in her diary that day, "Marr Flat hired Kid for $13.00 per day." After several years Mary insisted on drawing a wage for her labor as well. Her request was granted. Mary was quite possibly the first woman in that era to earn money on Imnaha, other than the money women received for their eggs, milk and cream. Those ranchers who ran their cattle in the association knew Mary deserved every pay check she ever got.

Things were looking up for the couple. A steady paycheck was welcome, and so was running water. Kid's brother Elmer, or Mike as they often called him, was helping him lay a pipe line to the house from a good spring across the Imnaha River, way up in a steep draw above Indian Creek. When finished, the line would bring that clear, sweet spring water to a cistern located on a high rocky rim above and across the river from her house. The water was then transported via a larger plastic pipe across the river, so that Mary's water supply was all gravity flow. This meant she didn't have to rely on electricity to pump her water. This inexpensive system provided sufficient water for her house, as well as irrigation for her yard and vegetable garden.

Mary wrote on April 24, 1960, "Boys worked on pipe line, got the pipe strung out. Ate supper at Mike's and made ice cream."

On the 25th, "Kid and Mike got water in the pipe and have it to the rim. I washed and it rained but got my duds dry."

Even though electricity was coming, and they would soon have water to the house, all the farming was still done with horses. Mary recorded on April 27, 1960, "Finished our farming and turned the team out." Even her garden was plowed with one

of those old "foot burner" plows, pulled behind a team of sturdy work horses.

It was a long, slow process getting electricity to Imnaha.

In a time when most of the West had long been experiencing the luxuries provided by the flip of a switch, the river residents were still making do with gas and wood. Mary had replaced her wood cook stove with a gas range a few years before, and, of course, the couple used wood to heat their house even after the coming of electricity. Wood was not only plentiful, but cheaper. Mary would continue to heat with wood long after the death of her husband. Not until the year 2000 would she finally have a small, modern oil stove installed. Forever after, however, Mary would say on a cold morning, "Had to build up the fire this morning."

Prior to the coming of "juice" to the river, Mary had been slowly accumulating electric appliances, like the iron and the toaster she bought when she and Kid spent two years in Lostine working for Dave Warnock. Once electricity arrived, Mary wasted no time ordering her electric stove, saving the gas stove and refrigerator to take with them when they went to Horse Creek a few years later.

On May 17th of that year, Mary wrote, "We got electricity today. I'm using heat pads because it's cold and damp. Took my milk cow to Mike's and will leave for camp tomorrow."

Just when Mary's little house was lit by cheery lights made possible by electricity, she had to leave, to spend the summer working side by side with Kid at the upper camps, riding for the Marr Flat Grazing Association. No time to bask in luxury for Mary. It was back to primitive conditions — cooking on a wood stove, reading by kerosene lanterns, using a screen cupboard for an icebox, washing with a scrub board, bathing in a galvanized tub, and wielding those heavy' sadirons. Even in camp, Mary ironed Kid's shirts.

It wasn't until late November that the couple packed up and moved back down to their little house along the Imnaha for the winter — and the novelty of electricity.

A hint of what Mary felt is reflected in her entry of November 20, 1960, recorded after the fall rides and gathers were finally over, after all the deer and elk hunters had left. The snow lay heavy,

the air thick with high country cold. "Headed for home with cows and pack horses. Lots of snow and the wind was terrible. I'm glad I'm home. No elk." Apparently they had stayed later in hopes of bagging an elk on top, but because the weather worsened decided to drive their cattle down one of those steep draws to the river, where they and the cows would winter.

On horseback there is simply no way to escape the punishing wind, and no way, no matter how many clothes you wear, to stay warm. How uncomfortable it must have been, coming down those slippery trails, driving cows in a snow storm, the wind-driven snow in their faces. How comforting it must have been to return to a home with electric lights. And, for Mary, who suffered all her life with arthritic pains aggravated by horse accidents and hard work, that electric heating pad.

31 A Few Choice Sayings

In February, 1962, Kid didn't feel good. Mary wrote, "Cowboys either get better or they die. They don't go to the doctor." Mary had many sayings she'd either learned from Kid or Kid's mother Mary, like, "When the apple trees bloom, it's time to plant the garden," or "If you want to find out about something, be like a puppy. If you dig deep enough you'll find it." Mary also learned from Mama Marks that a shovel was called an "idiot stick."

On cold winter evenings Mary nearly always baked biscuits or made mashed potatoes for supper, which meant she also stirred up some milk gravy. Oftentimes neighbors would drop in unannounced at supper time and it was the code of the river that they sit at your table for the meal. Once Mary commented, "There were so many extra to feed I nearly drowned the gravy," meaning she added more milk or potato water to the thickened drippings in the frypan.

As spring arrived, Mary began to work in her yard, cleaning out the raspberries, grubbing out the grass with a Pulaski. Named after an old firefighter, the Pulaski has an axe blade on one side of the head and a mattock on the other. It's commonly used to grub out fire lines, but also serves well in the garden for digging and cutting roots. Effective it might have been, but Mary always referred to it as a "woman killer."

In April of 1962, Mary wrote, "Kid got our cattle out of Injun Creek. They had a scatter on them." This meant the cattle tanged far and scattered, which made for a lot of riding to gather them for driving in one herd.

By May 24th, Kid and Mary were up at the cow camp at Harl Butte. "Rained all night and still at it at 7 o'clock. About 4 inches of snow on top." Back during those long, cold days in the saddle, when Mary would wish to be somewhere else, Kid would tell her, "Mary, you're just like a young robin, full of shit, wishin' for somethin' you'll never git."

But Mary had a comeback. In 2006, I noticed, still perched above the sink in her kitchen, a sign that read, *This is my house and I do as I darn please.*

In 1964, Kid and Mary, in partnership with Gene and Mildred Marr, purchased the place at Horse Creek, far downriver on the Imnaha. This was the place about which Mary had written in 1958, "Guess we can't buy the Simmons ranch (no money)." Going into partnership would have given them the extra capital to make the purchase. On February 10, 1964, Mary penned, "Have the Pumpkin and Horse Creek places bought if something doesn't happen. Went to town, snowed and roads were slick."

And on February 13 she wrote, "Went to town and signed papers on the Horse Cr. and Pumpkin Cr. ranches. Got two calves while we were gone." Pumpkin Creek is a tributary of Horse Creek, so these ranches would have been adjacent to one another.

During the six years they ran the Horse Creek place, they made frequent trips back and forth to Freezeout, traveling 30 miles between the two ranches on the Dug Bar road, a dirt track that leads downriver from Imnaha, passing by three major Imnaha River tributaries — Horse Creek, Lightning Creek, and Cow Creek — before ending at Dug Bar on the Snake River.

The elevation at Dug Bar is about 1000 feet, while the mouth of Freezeout is 2700 feet, and the Wallowa Valley ranges from 3000 to 4100 feet at Joseph. Normally winters in the valley are long, cold and brutal, full of snowy blizzards that stretch into spring. Because the lower Imnaha country, including Horse Creek, is considerably lower in elevation, the winters are normally milder, and, in open winters when there is hardly any snow, cattle can graze the abundant bunch grass without ever having to be fed hay. Livestock can winter very well on the lower Imnaha, and cows calve with significantly fewer problems than do cattle in the valley. Kid and Mary figured on wintering their cattle down at Horse Creek, and summering them back at Freezeout and the Divide.

But they ultimately found it too hard to run both places, and sold out their share in 1970. Legal difficulties may have prompted this decision, because as early as May 23, 1966, Mary wrote, "Simmons are sueing us on the place we bought. Sounds like hell

to pay. Signed our wills."

Or, just as likely, it had something to do with the infamous Dug Bar road. At that time, the road was narrower than now. But even today it is a dangerous challenge to drive. It hugs the high rims, winding like a snake higher and higher, until far below you see the same serpentine curve of the Imnaha River. Imagine the adrenaline rush of rounding a high, narrow rim with a several hundred foot drop yawning below, or, in winter, skidding on ice down a sheer incline with no guard rails between your truck and empty space.

There are places where two drivers approaching each other can see each other in time to figure out where and how to pull over. Oftentimes both rigs will pull over out of sight of each other, each thinking the other is coming on. They'll wait a reasonable length of time, then, when the other rig doesn't show, resume the journey only to meet the other rig head-on around a blind curve. Of course, back in the 1960s, traffic on the road was considerably less than it is today. The isolation of the upriver folk was as nothing compared to those hardy souls who wintered in those lower Imnaha canyons.

When you drive the Dug Bar road, you pass little splashing streams that drain high snow fields or emerge from rocky springs. These streams used to have their names, like Kettle Creek and Falls Creek, hand-printed on wooden signs. Then the road flattens out near Packsaddle Creek where, in the July heat, rattlesnakes lie stretched out on blackberry vines, eye-level with berry pickers. Upward you go again, where a fork to the left takes you to what's known as Maggie Beecher (named after a school marm), more cow trail than road and used mostly by cowboys, ending somewhere in the vicinity of Thorn Creek. Then you're plunging downward on the Horse Creek grade, a roller coaster feel to the road as it curls around and down to river level.

Another road fork appears near the mouth of Horse Creek. This is where I first met Kid and Mary. The Imnaha River makes a bend here, not far from a solitary house and outbuilding snuggled under some locust trees.

It wasn't until the winter of 1964-1965, nearly a year after they signed papers, that Kid and Mary moved some of their stuff

down there, along with the cattle. The present-day house is larger, and a far cry from the one Kid and Mary lived in, which was later moved to a higher site, to be used for storage.

In December 1964, Mary noted that it was 14 below 0 when she had to ride up Indian Creek to bring some cattle out. Everything froze up, but then it warmed and began to rain, and the river rose a foot in a day. On January 27, 1965, Mary noted, "Kid left for Horse Creek, water everywhere. Only got out to feed, and then got really wet."

Mary was left alone until Kid came home on the fifth of February. On January 31, Mary wrote, "Cooler today, but some sunshine. Sure a lonesome old Sunday. I washed curtains and windows on the outside." Every day that Kid was gone, she did all the feeding of the calves, horses, and dogs, and kept the house warm and clean.

It was a major operation to move to Horse Creek. Kid hauled down a team of horses in a stock truck and returned the next day to load up the chicken house. The weather remained cold and snowy nearly every day. Kid returned to Horse Creek, and Mary noted, "Another lonesome, old Sunday." It was February 14, Valentine's Day.

On the 15th of February Mary helped clean the Imnaha Grange Hall, after which she went to Kid's cousin Gladys Marks's for a potluck. The next time Kid came out they got more things packed and Mary went back with him. On February 21, she noted, "Had to pack stuff and load cattle so we could take them to Horse Creek. It looks stormy and is cold." Two days later, at Horse Creek, the "old milk cow had a calf and went down with milk fever, look her to town and back. She is ok."

Those few handwritten lines cover miles of rough road. The nearest veterinarian would be over 40 miles from Imnaha, and they were a further 17 miles downriver. That's a 114-mile round trip, much of it on a rutted dirt track — but they saved the milk cow, who was well worth saving as her daily milk provided cream, milk, butter and buttermilk. Not to mention her calf, which would fetch an amount of money later in the fall. If the calf was a heifer of good quality, she would be kept for a future milk cow.

By the 26th of February, Kid and Mary were both sick, but

the work had to be done. Due to the severity of the winter, they had to haul hay from Fence Creek, which is nearly all the way back to Imnaha. Up and down they went on that treacherous road in winter. Mary must have had misgivings about going into partnership on this place.

Mary noted Kid worked on the outhouse, moving it to another location. There was no running water. And of course there was no electricity, but Mary, who was used to cooking on a wood stove, had no problem with that. Surrounded by miles of unpeopled places, Kid and Mary's kerosene lanterns and gas lights created tiny pin pricks of light in those deep, dark canyon nights. Even today the only power that exists from Fence Creek to Dug Bar consists of an occasional generator.

Still, despite the hardships, there was humor was to be made and found. Once when Kid and Mary were at Horse Creek, Sam Loftus was helping them ride. Mary had just fixed Kid a sandwich to put in his saddle bags. By the time Sam walked in the kitchen she had used the last of the meat in Kid's sandwich. So Mary simply fixed Sam a peanut butter and jam sandwich, and told him, "Now, when it's lunch time you tell Kid he has to share his meat sandwich with you." After a morning of riding the men dismounted and dragged out their lunches. Sam told Kid what Mary had said. Kid didn't say a word, he just took that sandwich and laid it on a stump and took a hatchet and split it right in half and handed it to Sam. "Never will forget that," said Mary, laughing years later.

Another time Clyde Simmons came to visit at Horse Creek. He asked if there were any chores he could do. And Mary said, "Sure Clyde, you can milk the old cow." So out he went with the milk pail. Then Mary remembered she'd forgotten to tell Clyde to tie the cow's tail to her leg because the cattle were eating that fresh, green grass, and their manure was pretty runny and green. Which was the color poor Clyde was wearing when he came back to the house with his pail full of milk. I wonder if this incident had anything to do with the lawsuit!

The Horse Creek ranch was a mixed blessing. Its low elevation provided good winter range, but the price was high. Besides the dangerous Dug Bar road, there was the river. One year in

March their partner Gene Marr came down and they worked on a footbridge that spanned the river so they wouldn't have to drive or ride horseback every time they wanted to check or feed cattle on the other side. Then the April rains came, and the upriver snowmelt came flooding down.

Mary wrote, "Kid went around by Horse Creek to get across the river as its too high to cross here. He found an orphan calf and we put it on old Roany." Soon Mary recorded, "The Horse Creek bridge is caving in so can't cross. Poor old Roany is on the other side." Things went from bad to worse. The next day, there was "nothing but trouble, had to get Fred to start the truck and it quit and I had to go pull it. Kid went on to town. I'm alone tonight." And that might be a night when Mary's little lamp would provide the only light in all that black vastness.

The next day Mary struggled with Old Roany and pulled her calf out of Horse Creek. "Calf is half starved," she wrote that night. The next day Kid returned with help to stabilize the bridge over Horse Creek, and Mary noted the river had gone down a bit. But the Imnaha is a wild, undammed river. Over the years, new car bridges have been constructed one after another to replace former ones lost to floods.

The canyons they ran their cattle in were even more rugged and remote than their upper Imnaha place. They continued to maintain their home upriver all the time they were at Horse Creek, but summered their cattle up on the Divide — a long, three-day cattle drive on horseback from Horse Creek.

They didn't have to feed hay to the cows for as long as they did upriver, but the cattle had to be moved constanly to new range. Most of this range was Forest Service land, which meant they had grazing permits, and were therefore required to pay so much per "AUM" (Animal Unit Month — the amount of graze needed for a cow-calf pair per month) for the use of their fall, winter and spring range.

March 29, 1968: "My best cow calved, I have six now. Took the cow back to the vet and got three bulls, I brought one. Heifer lost a calf while we were gone." Mary called them "my" cows because she, like many other women, kept her own cows separate from her husband's. Oftentimes women even registered their

own brands.

March 30: "Grass is pretty good, picked up the cows at Pumpkin Creek, took them on to Knapper, found a cow with a new dead calf, brought her to Horse Creek." Pumpkin Creek was a long day's horseback ride above Horse Creek, so when she wrote that they picked up the cows, that meant they had to ride clear up that steep canyon, then gather the cattle and drive them home.

As spring progressed, the calves were branded in different bunches, and oftentimes one would be missed. On April 2, Mary wrote, "Put out more heifers and rode the pasture. Several slicks up there, sawed off a cow's horns, sprayed the cattle, moved Sarah before she foals. Kid started plowing and broke a shaft so had to go to town, sure didn't want to go."

Later, Kid finished plowing and took Mary to the Bridge so she could go home to work in her yard upriver while he went into town to get another piece of equipment fixed. She worked a few days at home, noting that there was just too much to do and no time before she had to return to Horse Creek.

It was a long, hard exercise to move cattle from their winter range at Horse Creek to the summer range at Freezeout and on the Divide. They'd move the cows a little at a time, giving them a chance to graze as they went. One year they started by taking 56 cows and calves to Pumpkin Creek. Then Kid shod horses while Mary washed and scrubbed. Next they "took cattle to Embler, scattered them out and darn near froze, rode again and put cows up high in Cottonwood, put out 200 pounds of salt, went to town, got our cat (tractor) fixed and picked up a bull. Rode Fence Gulch and Cougar Ridge."

After catching up with the gardening and chores at home on the Imnaha, Mary wrote,

> *packed salt, grain and tent to the Troughs (on Haas Ridge), feed looking better, went to Pumpkin Creek after a horse to wrangle bulls on. Set out tomato plants and cut lawn. Packed up and rode to the Troughs, rained like heck, then snowed all night. We rode anyway. Started 57 cows and 55 calves down Saddle Gulch, got into Cayuse before dark. Was tired and hungry. Went*

> *back to Flyblow and got cattle, drove them on out and*
> *up the ridge. Sam Loftus helped. Slept on the ridge, got*
> *up early and got the cattle started. Lots of snow and*
> *hard going but we made it to the Freezeout range and*
> *on home for the night.*

Running both ranches wore on Mary. One May, alone at home after Kid left in a snowstorm for Horse Creek, she wrote, "I'm stuck with the old cow and her calves." As if it weren't enough for the two of them to run two ranches, they had to make trips to the cow camps on top. So they were constantly on the move. At the end of spring, they had to return to Horse Creek to close up the buildings and put things in order for the summer.

> *Went to Horse Creek, turned off the gas refrigerator*
> *and cleaned the cabin, brought home a load of stuff.*

Whenever Mary and Kid returned from Horse Creek to their house near Freezeout to stay awhile, like they did when they had farming to do, they took the milk cow and her calves along so they could have fresh milk. The milk cow, the jug of sourdough, the barn cat, their dogs — all went along. I can picture them now, chugging up the Horse Creek grade, a trail of dust in their wake, milk cow hanging her head over the pickup racks, the cat curled behind Mary's head on the seat, the dog riding in the dog catcher over the cab, and the jug of fermenting sourdough between them.

Back at home on the upper Imnaha, it was back to a familiar routine. Kid and Mary spent summers checking on their cattle that grazed the Freezeout range, and tending to the other seasonal chores around their upriver place. Nearly every day in June the cattle needed salting, checking, or moving. Hours were spent in the saddle, after which, Mary noted in her diary, she would return home to iron, bake, wash or clean house.

Although they now had electricity and a gravity-feed water supply, the outhouse was still in use. Mary noted on June 14, 1965, "We moved the outhouse in the rain. Sure a job."

June rains were extremely important. The timing of this moisture kept the grass growing through the summers, which

only produced occasional thunderstorms. If the grass got off to a good start, that meant it would mature and continue to provide nutritious forage well into December. Old timers would often say, "The only bad rain to fall in Wallowa County is the rain that missed us." Of course, the rains are good for the grass, but then suddenly the hay is ready to cut, so you cut it, the fragrant hay is lying in the field...and here comes more rain.

"Then it's cussin' time — cussin' the weather one day because it won't rain, cussin' it the next because it did," said Mary.

On June 23 it ceased raining and Kid and Mary branded seven head of late calves. Mary noted, "Guess our slick-ear died." A slick-eared calf or "slick" is one without a brand. This could have been one they missed, or someone else's. If an orphaned calf was found out on those huge ranges, there was no way to tell who it belonged to without a brand.

Once the weather finally dried out, haying continued.

By 1965 the Marks "boys" were using tractors and baling hay, as opposed to all those years they used a team of horses and stacked hay by hand.

As ever, trips to town were planned so as to lump several errands together. One day in June, Kid and Mary drove to town to purchase a month's supply of groceries, and also stopped at the Grain Growers for salt, horseshoe nails and baling twine. Kid did the driving. Except for driving cattle trucks and their Model-T Ford pickup "car," Mary didn't ever drive. She never drove to town. In fact, many women in Mary's generation never even learned to drive at all. Kate Wilde would always ride out with her husband Will or a neighbor to do her shopping.

It was also in June, while Kid was up riding the Freezeout range, that Uncle Ira passed away. This made Aunt Louise a widow, and since she lived next door, the care of her would be left largely to Mary. Even when Kid and Mary rode out to town to attend Uncle Ira's funeral they managed to make a work day out of it. Kid stayed out on top to ride the Divide and check on the cattle they'd trailed up there, while Mary caught a ride back to Imnaha with a neighbor.

33 PACK TRIPS NEAR AND FAR

On June 25, 1965, Mary was baking cakes to freeze in preparation for the first Appaloosa Trail Ride. This ride attempted to retrace the retreat trail taken by Chief Joseph and his Wallowa Band of Nez Perce after they were ordered to leave their ancestral home in the Wallowa Valley in 1877.

The Appaloosa Horse Club, under the leadership of George Hatley, had organized this enormous undertaking. All persons participating were required to ride an Appaloosa horse.

The ride began in Wallowa County and followed as closely as possible the original retreat trail. Each year the ride lopped off 100 miles of the trail — twenty miles a day for five days. The first ride began at Wallowa Lake. Rides in subsequent years would start where the previous year had left off, until they had retraced the entire route that Chief Joseph s band took while fleeing from the U.S. Army, ending at the Bear Paw Mountains in Montana.

On June 28, Mary "went to town early so Tuck could get started on the ride. We got our stuff ready so we could start cooking." Gerald "Tuck" Tucker, from Imnaha, was to act as trail boss. The cooking crew and much of the camp crew would be ranchers and their wives, mostly from the Imnaha area. Mary had been hired as one of the cooks.

Mary wrote, "We got breakfast for 50 and moved camp to Midway. Have a good crew." Midway is the site of an old stage stop located on the Zumwalt road, where early settlers coming and going to Imnaha spent the night, got a bite to eat, and either stabled their horses or got a fresh team. The remains of an old barn can still be seen there today.

The next day the riders mounted up, all riding Appaloosa horses, and rode down Trail Creek and Camp Creek to A.L. Duckett's, where the crew had camp already set up. Mary noted that Kid came down to join them that night. On July 1 Mary wrote, "We made it to Thorn Creek and it's darn hot down here. Riders are doing fine." Thorn Creek is on the Dug Bar road, downriver from the setUement of Imnaha. Today there is a Forest Service guard station there.

From Thorn Creek the camp crew had to negotiate that steep, winding, rough road to Dug Bar, where they would have to set up camp and have dinner ready for the riders coming in that evening. Mary wrote, "Our last camp at Dug Bar. Had a weiner roast last night. I rode Tuck's horse to Cow Creek and we came home." That meant Mary rode horseback all that way up out of the Snake River, over Cactus Mountain, to the Cow Creek bridge, where she caught a lift back home.

Dug Bar, where the Appaloosa Riders spent their last night, is where Chief Joseph and his Wallowa Band of Nez Perce forded the Snake in 1877 when it was in spring flood. He and his people, including women and children, elders, little babies, and hundreds of cattle and horses, crossed the torrent. It was an almost impossible feat, but they pulled it off, emerging just downriver to step onto Idaho soil and elude the U.S. Army for months. Today there is a large sign there at the eddy recording that historic crossing in the spring of 1877.

Went to Steamboat Lake on a Hell of a Trail

On July 21, 1968, three years later, Mary wrote in her diary, "We met riders at Packer Meadows. Had lunch and everyone left." This was the end of the fourth Appaloosa Ride, a segment that took Mary into Idaho, and she was tired of cooking. She'd worked so hard she was feeling a little sick when she got home. With only a few days to rest up, Mary was asked to cook for yet another adventure.

This time she would be hired on to cook for 31 dudes during a 14-day pack trip through the high Wallowa Mountains.

Mary went to the doctor and began to feel better, and since Doc Blackburn gave her the OK to go, she consented.

There were two pack strings of nine animals each. She was working for Jack Hooker, who owned the Eagle Cap Wilderness Pack Station at that time. Dick Hammond and Larry Moore were two of the packers on the trip.

Hooker's wife Marilyn planned the menus and did a good job, remembered Mary. Periodically someone met the group at a specified trail head with perishables like meat. I asked Mary how

they kept their meat on the trail, and she said if it looked like it was going to spoil, she just cookcd it up and served it later. She said that happened often with hamburger.

They started on July 26. Mary's little leather-bound diary rode in her saddle bag over some of the most spectacular country in Oregon, as rugged as it was scenic. "Rode to Middle Fork Imnaha. A nice trip up past Aneroid Lake. I could see Tenderfoot Saddle." The next day, they "made South Fork (Imnaha). Horses got away. It got hot on us so had trouble, went across Bonner Flat." Then, on July 28, "Made Frazier Lake over Hawkins Pass. It's a pretty lake and a steep trail."

The high altitude heat bore down on the pack strings as they wound through the mountains. And at the end of every day, after camp was set up, Mary went to cooking... for 31 dudes. No small task when you consider she only had a small wood stove or an open fire. But Mary was up to the job.

On the 30th, they "camped near a mine on Trail Creek. A hot old trail. Pack horses broke loose and we had to lead ours up over some places." On August 2nd, an accident: "Made it to Swamp Lake. A pack horse broke loose and went into a canyon and killed itself. Was glad when we got to camp." On the very next day, they "camped at John Henry, lost a horse so makes two. lough luck." I wonder what those dudes thought!

After the ride was finished, on August 5th, Kid took some cattle to the sale yard, then met Mary at Lap Over, up the Lostine canyon, to bring her home. Lap Over was the name of another guide outfit. It is said the name originated because of the "lap-over" time span between deer and elk seasons. Long after the guide outfit left, the name stuck.

When Mary returned home to Imnaha she wrote, "Washed, ironed and irrigated. Kinda tired after all those days in the mountains. Its hot and dry. My yard and garden look good." Kid must have taken good care of the place in her absence, which was quite a feat, as he would have spent time up at the upper cow camps as well.

Soon Mary was canning, cooking at the cow camps, fixing fence, "salting up the ridge," cooking for hunters, helping with the fall gather, and then riding down the trail the last time in the

autumn with their cows.

Those adventures outside the canyon walls that hemmed her in were good for her soul. The Appaloosa Ride enabled her to experience other parts of the West, and riding through the Wallowas gave her an opportunity to see more of her own country.

Headed for the Yellowstone Park

Mary and Kid, along with several other Wallowa County folks, continued to work as cooks, packers, and trail guides for the annual Appaloosa Trail Ride. In August of 1973 the ride began in Yellowstone Park.

On August 11, Mary headed for Yellowstone with some friends, spending the night along the way. On August 12, she wrote, "Got into the park about 5:30. Over 200 people gathered to ride. Looks like a job cooking." For the following three days there are no entries in Mary's diary — she was probably cooking! Then, on August 16th, she wrote that the group "packed up and headed up the Pelican Valley, over the top and down into the Lamar River valley. Saw buffalo and lots of pretty country." Since I also happened to be on this trip, it makes it easier for me to see the story behind those hastily-penned lines.

We all met there near the West Entrance, where I helped with registration. Mary had been hired as one of the kitchen crew and Kid was in charge of hauling hay for the horses and doing the heavy lifting required to move camp each day.

After all the riders gathered that first day along the Madison River and were fed breakfast the next morning, the Wallowa County cowboys, under the leadership of Sam Loftus and Dick Hammond, packed all the food and camping gear needed for over 300 riders to spend the night in the wilderness. Leading pack mules and horses, with the riders following on their Appaloosa horses, our guides led us "up the Pelican Valley."

What a sight it was, the country we were entering, as well as the picture we made, riding single file on those colorful horses. Carefully and expertly packed on those mules and horses was the food and gear required for all those riders to spend the night in the wilderness area of Yellowstone National Park — a wilderness

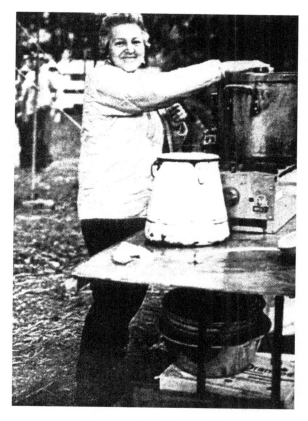

Mary on Appaloosa Ride.

seldom seen by anyone save National Park rangers, for this vast area was off limits to tourists. It had taken a great deal of persuasion on the part of the trail organizers to be granted permission to enter this pristine area.

Sam led his pack string down to the incredibly beautiful river, and Mary's description of "down into the Lamar River valley" was penned that night. In Mary's saddle bag rode her diary, but she would be so busy with her cooking duties, she would scarcely have time to write.

We were re-living history — albeit under very different circumstances — riding along the very route the fleeing Nez Perce took. It was with great respect that we viewed the Nez Perce as

we rode along, and the country around us brought reality to the story we'd read in history books.

Camp was made up the slope from the Lamar River, near an open meadow surrounded by pine trees. Myriad restrictions had been imposed on riders and horses. A nervous park ranger had ridden along to make sure all rules were enforced. Upon reaching camp the ranger dismounted and, using a bullhorn, hollered, "Remember, you are not allowed to tie your horse to any tree. Horses must be either hobbled or tethered to a log drag."

Mary cringed. A log drag? Hobbling? *Fine,* she thought, *for horses already broke to such things.* Similar doubts were echoed by the rest of the Wallowa County folks.

Meanwhile Kid, Mary and the cooking crew had built a cooking fire and were attempting to open 100 cans of Dinty Moore stew with only one can opener. Whoops! Men were using their pocket knives to expedite the task, when suddenly, without warning, all Hell broke loose.

First-time hobbled horses were leaping everywhere, their hobbled front hooves clawing the air in unison, which created a surreal scene not unlike a large circus performance, where horses are trained to hop around and stand on their hind legs. But the real threat to the total destruction of the encampment were the horses tied to log drags.

Both Mary and I recalled years later that vivid scene. Mary remembered, "Here'd come a horse, draggin' a log. The horse would look back and see this thing chasing it and break into a full gallop. One horse, he ran over a tent and a woman came out, half-dressed, wild-eyed, just in time, as the tent got caught up in the log drag. Another one came right for the campfire where we was opening those darn cans, ran right through it so fast it didn't even get burned. Cans went flying every which way. Finally the horses milled around down in the meadow for awhile, and since it was strange country for them, they eventually wandered back to their owners."

I recall observing the bewildered park ranger in the midst of it all. He stood there, confused and speechless, not to mention terrified, until he found his voice. Standing tall, with apologies to Chief Joseph, he delivered his surrender speech: "From where

the sun still stands, I give up! Tie your horses to every tree you can find!"

We often wondered if the fellow lost his job over that decision. Maybe he was just so thankful no one was killed, he didn't much care.

In due time order was restored, the stew was heated in a big kettle, the smashed bread was served, and the riders enjoyed rehashing an event which would never be repeated. We were all pretty sure that was the last time the Appaloosa Riders would be allowed to ride that particular portion of the Nez Perce trail.

The next day we descended down the wild Lamar Valley and exited the park at the northeast entrance, where the ride would commence the following year.

Mary participated in all fourteen 100-mile segments of that first ride, and repeated the entire ride several years later. The ride is still in existence today, and every August riders from all over converge to lop off another 100 miles. Mary received a plaque for her many years of cooking for that trail ride. A photo of Mary, pouring coffee from a large graniteware pot, appeared in an issue of *Western Horseman.*

Mary was disappointed that she hadn't seen a bear in Yellowstone on that 1973 ride, but it was time to head home. On August 18, she wrote, "We got breakfast for the crew and started home, camped on the Lochsa River." They returned to Imnaha to discover that a forest fire had "got to 9,000 acres and 1,000 men on it, and out of control. It's headed for Hat Point and head of Horse Creek." Luckily the fire stopped short of their cow camp on Lookout Mountain. With relief, she noted, "Cattle are ok."

The morning after they got home, Kid called to her, "Come out here, if you want to see a bear." Mary wrote later, "There was this little cub, trying to get through the hog wire fence. He finally found a rock jack and climbed over it to get to the other side, then took off bouncing up the hill. Sure was a cute little feller."

34 Woodcutting and Baking with Kid

I remember once when I was up at Mahogany Cow Camp in the fall of 1977, and Kid was helping me get in my winter wood supply. Kid had felled and limbed a large, dead tamarack tree, which he'd then cut into rounds of the right length to burn in my wood furnace. My job was to split the chunks into fourths, and then load them into Kid's cattle truck. It was a huge job, and years later, as I was cutting firewood with my husband Doug, I'd always remember Kid's words: "It takes a lot of sticks to fill that truck." As that long-ago day wore on I realized how true his words were. It did take "a lot of sticks to fill the truck." But I was grateful, as that one truckload kept us warm during that long, cold winter.

Later that day I learned how to make sourdough biscuits by watching Kid, who, after a long day of hard work, headed for the cabin, washed his hands in a wash basin, took down the sourdough crock which he'd fed that morning with flour and water, and proceeded to make the most delicious golden light biscuits I'd ever eaten.

The crock had been sitting on the warming oven door since breakfast, rising during the heat of that Indian summer day. The sourdough was working good and full of bubbles.

Kid poured flour in a clean enamel wash basin, then dumped in most of the sourdough, reserving the rest as his "starter" for future baking. Into the basin he sifted through his fingers more flour plus a dash of salt and sugar, which he began to work into the dough with his hands, moving the basin around and incorporating the flour in the bottom as well. When the dough was pliable, but still soft, he pinched gobs off with his fingers, and placed them in a black pan in which he had melted a liberal amount of bacon grease. He turned the dough over, so as to grease the tops, and set the pan back in the warming oven to rise.

Meanwhile, he built up the wood fire so the oven would reach a pretty high temperature, and then went about slicing thick chunks of venison steaks off a piece of meat he'd taken from the

cooler. There was no electricity in cow camp, just a screened cupboard that served as a cooler on the porch. Even in summer the nights cooled down enough at that higher elevation to keep most things from spoiling. Meat was kept on ice in a cooler until the ice melted, and then you went to cooking beans and eating canned meat.

When Kid thought the oven was hot enough and the biscuits had risen, he slid them in to bake. I can still remember the aroma of those biscuits baking, as Kid dredged the steaks in flour and heated more bacon grease in a cast-iron skillet. I was hungry after splitting and loading wood all day, and that simple fare provided a memorable meal. Kid had made gravy from the steak drippings by adding more flour and canned milk. I can still see him stirring that gravy, scraping all the bits of fried meat into the thickening mixture, salting and peppering it just right, and then reaching in the oven to take out those golden, hot biscuits.

We opened a jar of Mary's home-canned green beans and proceeded to enjoy our cow camp supper. Now they say that bacon grease and fried foods aren't good for you, but when I think of all the old-timers who have eaten that food for years and have lived into their 80s and 90s, I wonder. Perhaps it's the lack of hard physical labor that's killing us, not wild meat and sourdough biscuits. Anyway, I'd like to think that. And dessert? Who needed dessert when you could butter another biscuit and spoon on a goodly portion of Mary's raspberry jam?

After that truckload of "sticks" was delivered to my place and unloaded, I always appreciated Kid for the kindness shown to a single mom. He was a tough but gentle man.

I don't know exactly when they discovered that he had Parkinson's disease. As the disease progressed. Kid could do less and less. Eventually Mary had to sell their pickup, as she was afraid he would drive it off a cliff somewhere. When Kid was in the advanced stages of Parkinson's he would find the pickup keys Mary hid from him and take off, unannounced. Those were anxious times for Mary, and she did, indeed, find him one time perched just above a steep embankment where he had stalled the pickup.

"That's when I sold it," said Mary. "No more of that!"

35 KID'S PASSING

Mary's five-year diary for the years 1983-1987 is a small, green-colored one. The center binding has come loose, and because it's so small, her handwriting is cramped and hard to read. It appears Mary really took pains to pen what she had to say in so short a space. But in the four lines a day in that diary Mary recorded possibly the saddest times of her life. What appear to be smudges caused from tears blot out some of the lines. Scotch-taped to the inside front cover is a yellowed newspaper clipping.

It reads,

> YOU ARE INVITED
> Kid and Mary Marks of Imnaha will be celebrating 50 years together on Sunday, August 5, 1984. On this date all friends and relatives are invited to share this occasion with them at the Imnaha Grange Hall. A potluck dinner will be at 12 noon with reception following. No gifts please." The announcement is enclosed in a border decorated with wedding bells.

The first page of this diary set the stage for what was to come. At the very top of the page Mary had written in very small script, "Wonder how many years I'll get in this diary?" She was 65 years old, and Kid 69.

January 1, 1983: "Not so cold this morn. Mark and Terry Barnhart brought a load of straw and ate supper. Auntie better but can't be alone."

January 1, 1984: "Another year and we are not in good health. Kid's got Parkinsons and I have asthma. Over 100 head of cows to feed and over 90 to calve."

January 1, 1985: "Another year. I can't believe we kept the cows and Kid can't do much except get a little wood and sit in his chair. We went to (Bob and Carol) Garnett's for dinner. They seem to care about us."

January 1, 1986: "A New Year and things look bad for us. It did warm up and thawed and snowed. Garnetts had us up for dinner."

January 1, 1987: "A nice day and we were invited to Carol's but didn't feel like going, so stayed home. Kid doesn't feel good and I don't either. We got lots of phone calls."

Kid never got to feeling better. In fact, he didn't make it through that final January. On the second of that month, Mary ended her diary entry with, "It's lonesome." I can imagine she didn't receive much stimulation from Kid with his Parkinson's. At this point he didn't even know who she was.

The following entries became more and more depressed and Mary's asthma attacks more frequent, her anxiety over Kid undoubtedly worsening the condtition. "I've got asthma and cough, I don't like it," she noted.

This would have been the coldest part of the winter, and on January 4, 1987, Mary noted that Kid was eating better, but she was feeling worse. The next day she couldn't breathe when she got out of bed, so she called the doctor, who put her on a strong medication. The miserable days dragged on. Mary was not only taking care of an invalid, but she was doing all the feeding, wood hauling, and other ranch chores. She was thankful when Vicky Marks (Kid's nephew Gary's wife) came down to haul hay and feed the horses.

January 5: "Feel better but Kid fell twice and can't walk as hardly knows what's going on. I know he is a lot worse. Carol and Bob came down, also Gary, and we got him to bed."

On January 7th, "Carol came down and we took Kid to the hospital. He isn't hardly at all himself, and don't know us. Dr. said he could of had a stroke. It's cold and lonesome here tonight."

January 9: "It's an awful mess around here. Called the hospital and they say I've got to take Kid to Milton-Freewater to a rest home."

January 10: "Another bad day. I'm so worried about Kid and moving him. Our water quit and Gary spent all morning getting it going. Norton fixed the toilet and hot water heater popped off."

January 11: "Another day gone and it snowed a little and colder tonight. Leigh Juve had a baby girl, called her Logan. Got a load of hay today. Called and they said Kid was about the same."

On Monday the 12th, they moved Kid. It was a three-hour trip each way, driving from Imnaha to Enterprise to Elgin, and on

over the high and snowy Tollgate road to Weston, from there to Milton-Freewater, and then all the way back. "Garnetts came and we picked Kid up at hospital and took him to Milton-Freewater. He stood trip pretty good but is not good. It just breaks my heart. Ice and snow at Tollgate."

January 14: "Snowing and cold. Called hospital at Milton and Kid is not good. I feel so lost and alone. Mike Coppin brought a load of hay. $288.00. Snowdrops are in bloom."

January 15: "Carol came down to tell me they called and Kid has had another stroke. They called about 5 o'clock and said Kid passed away. Gary and Vicky came down and stayed till 10:00. It's cold, down to zero."

Cold or not, Mary's life had to go on. "Carol and I went to town to the funeral home. It was a hard day. Dad's (Andy Heaverne) buying a cemetery plot for Kid and I. It's cold and Gary kept fires."

On the day of Kid's funeral Mary wrote, "We've got 4 inches of snow and Pat had Gary pull him up the hill. We had Kid's funeral. Lots of people there and the sun shined. Got home late. Twenty degrees." Mary's house was located at the foot of a very steep hill, so the driveway was especially icy and slippery when it snowed. Quite often someone would spin out and have to be "pulled up the hill."

It was good for Mary that her brother Pat and his wife Rita were there at that time. Pat and Mary hauled a mule to the vet and had its bad eye removed, and Gary came down and fixed the broken water pipe. There were always things to be tended to — perhaps a blessing, as there were so many things Mary didn't have much time to think. And it remained cold. Finally Pat and Rita had to leave, and Mary wrote, "I sure miss them, and it's awful lonely."

Mary's work-filled days continued, and although her mind was occupied most of the time, she often wrote at the end of each day, "Lonesome as hell here." So she was thankful for social occasions. One night "Don Norton came up and took me to Bingo at the Bridge. Had a pot luck so had plenty to eat." And on February 9 she noted she "rode up to Garnett's on the mail truck, stopped to see Gary on the way home."

On February 14, Wallowa County' celebrated its centennial year and Mary wrote, "Got ready for the Centennial Ball at Joseph. Dressed in an old-time dress and hat. I went with Carol and Bob Garnett." Since she'd sold their pickup, Mary had to depend on her neighbors to take her everywhere.

36 KID'S OBITUARY

Written by Janie Tippett for the *Wallowa County Chieftain* at the request of Mary Marks.

Clarence Marks, better known as Kid, passed away Thursday, Jan. 15, 1987 in Milton-Freewater after a lingering illness.

Kid was born March 30, 1913, at Imnaha where he lived all of his life. His grandfather and grandmother, Benjamin and Elizabeth Marks, along with their 11 children, moved to a homestead at the mouth of Freezeout on the upper Imnaha in 1889 from Linn County.

Kid's grandfather, Benjamin, came by ox team from Missouri to Oregon when he was 13.

Kid's father, Alfred, filed on a homestead in Waterspout Canyon on the Snake River in 1910. Alfred married Mary Fisk, also of Imnaha. Kid's brothers, Earl and Elmer, preceded him in death. Kid's grandparents and great-grandparents are buried on the Imnaha.

Kid was married to Mary Heaveme of Joseph, on August 4, 1934.

The couple worked for the Marr Flat Cattle Association from 1936 to 1955. They lived at the mouth of Freezeout where they purchased uncle Tom Marks's place, and the old Marks's place.

After working for Dave Warnock in Lostine, they came back to work for the Marr Flat Association from 1957 to 1964, when they purchased the Simmons ranch on Lower Imnaha at the mouth of Horse Creek. Gene and Mildred Marr were partners. They sold out in 1970 and moved back to the home place at Freezeout.

During his lifetime. Kid spent many hours in the saddle and worked on every ranch from the Imnaha Store to the mouth of Gumboot.

Funeral services were held Monday, Jan. 19 at the Bollman Funeral Home in Enterprise. J.C. Sowell of Imnaha officiated with interment following in the Enterprise cemetery.

Marks is survived by his wife, Mary, who lives at the family home on the Imnaha.

Contributions can be made to a favorite charity or to the Parkinson's Disease fund in care of the Bollman Funeral Home in Enterprise.

37 Life Without Kid
Life With Asthma

All through March of 1987, Mary suffered with asthma. Whether it was cleaning in Benjamin and Eli2abeth's original homestead up the road, preparing her garden for planting, pruning her raspberries, or baking, she "ran out of air," as she phrased it in her diary. Day after day her pen recorded these ailments, along with an ache that developed in her arm. Myriad trips to the chiropractor, which didn't seem to help, and many calls to the doctor to increase her asthma medication were also recorded at the end of those miserable days.

On March 30th, which would have been Kid's 74th birthday, an event brightened Mary's life. Vicky Marks, who lived with Gary just up the road in the very house Kid was raised in, gave birth to her first child, a boy. They named him Michael. And Mary, who had remained childless all those years, lavished her latent motherly affection on baby Michael. She became more than "Aunt Mary." She assumed a sort of grandmother's role, in spite of the fact that Michael's maternal grandparents — Vicky's parents, Lyman and Doris Goucher — lived just down the river. Neighbors marrying neighbors — that's what happened along the Imnaha. They were all fine folks and not only suited to each other, but to canyon life as well.

Since Mary was now considered one of the old-timers on Imnaha, she was often interviewed by local historians who valued her stories. She noted earlier in March that "Grace Bartlett and Janie Tippett came down to talk to me about Imnaha's early days," and in April 1987 she wrote, "Two busloads of school kids were here to interview me and ask about our old log barn. When you get to be 70, people get interested in your life." More and more of Mary's contemporaries were passing on, taking their stories with them.

In spite of her many health problems, Mary's will to live kept her going, but in that year of sadness another memorable event took place, on May 5th.

"Paddy dog is staggering around. She is so old and feeble.

Makes me feel bad." And a few days later, "Don Norton took my Paddy dog away, as she couldn't see or eat."

Paddy dog was a fine border collie who had run alongside Kid and Mary for hundreds of miles while they rode horseback in the canyons. The faithful little dog had ridden in the pickup with them, herded cattle on steep slopes, flushing scattered cows out of thorn-brush thickets when it was over 100 degrees and gathering them during blizzards. She'd gotten balls of ice embedded between her toes when it was below zero and horses or cattle had to be moved, and she'd helped Mary drive that ornery old milk cow and her calf to the upper camps in spring and back down the steep trails in the fall. She'd been Mary's only companion after Kid died. Mary missed the old dog like she'd lost another member of the family. She remembered the joyful litters of pups Paddy had raised, and knew her progeny were scattered on ranches all over the county. But she also knew there would never be another Paddy dog.

Mary continued on with her incredibly full life. She would saddle up her horse and ride up "Injun Crick" to check on her spring or move horses, noting thistles growing here and there, and wishing Kid were still alive to deal with them. Then she'd return with her "woman killer" Pulaski and attack the noxious weeds herself.

She cleared another, smaller garden spot in the meadow, south of her vegetable garden, and planted it to baking squash and corn. By the middle of May her gardens were up and so was the river, running high with snow melt. But May, with all the pollen in the air and the onset of lawn mowing, also brought Mary continued asthma coughing fits.

Baby Michael continued to bring moments of joy into her life, and Vicky was good to bring him by often. Other times, just to socialize, Mary would catch a ride on the school bus with Barb Warnock. Her friend would pick her up and drop her off on the way back and forth from Imnaha River Woods. This subdivision, sometimes simply called "the Woods," was miles upriver, but as long as there were children attending the two-room school at the Bridge, the bus made the trip back and forth twice a day, five days a week.

Mary's asthma was merciless. She went on a trip with Pat and Rita to Fallon, Nevada, to visit some of her relatives, only to have the trip cut short with an asthma attack. On the 26th of May she wrote, "My 70th birthday and I feel like heck. Still weak and shaky from the trip. I had a good time and don't see why I had to come home sick."

In early June, Mary noted that her hay was ready to cut, but she couldn't find anyone to do it. On the 15th, Max Walker and his wife Mariel came down, and they all rode horseback to Lookout Mountain. They found the Marks cabin had survived the winter. The original cabin had burned up in the Freezeout fire years earlier, but a new one had been built. After Kid died, Mary kept the Forest Service permit and the cabin, and refused to give anyone the key. In order to keep her permit she had to maintain the fences, repairing any that needed it. But on this day Mary just cleaned up the cabin and packed out the bedding. She returned home to find that Gary had cut her hay, only to have it get spoiled by rain. "Guess Gary will have to haul it off," she wrote.

The fourth of July found Mary and her sister-in-law Geanne way upriver at Indian Crossing, where they found enough huckleberries to make a pie. It wasn't too hot and Mary noted that for a change she felt good. During the last weekend in July, Mary rode out to the Chief Joseph Days rodeo in the town of Joseph with Pat and Rita.

The hot summer drug on, with occasional thundershowers and ripening berries which Mary picked to make jam. On August 10 the hay next to house needed cutting again, and she noted that Lyman Goucher cut it for her. "I've got to shock it," she observed. Sure enough, the next day she forked the hay by hand into piles so it could be loaded onto a truck and stored.

On August 14th, Mary made dill pickles and "the damn vinegar gave me asthma." Yet another piece of bad news came when her sister Mercy called to tell Mary that their other sister Alice had cancer of the liver.

Work wouldn't wait, but friends, relatives, and neighbors continued to step up to help Mary and keep her company. On August 18th Mary rode to Lookout Mountain again, this time

with Don and Vadna Norton, and "we worked on the fence, built two jacks and a new gate, and set the fence up on the Snake River side."

Well-built fences last for decades, and usually a fence built with four stays between rock jacks will keep cattle where they belong. But when elk become startled by hunters in the fall, they push and crowd themselves right through those stays, and much to the dismay of ranchers, their fences snap. Also, winters are hard on fences. During heavy snows, they sag when the snow drifts against them. So when Mary said they "set the fence up," she meant they had to splice and re-stretch the wire, and re-set the rock jacks. Hard enough work on level terrain, not to mention what it would be like on that steep Snake River side.

But it was Mary's range now that Kid was gone. It was up to her to maintain the fences and follow the Forest Service rules that applied at the time. Mary noted that the next day they set up the fence on the Freezeout side. Riding horseback at 70 was just part of the job.

But at least Mary didn't have to drive cattle any more. After Kid died, she sold them all.

On August 24th, Mary wrote that "Don brought me some crab apples so I canned some and made jelly. A bear was in the spring, so I didn't have any water tonight." The next day she wrote, "Gary got the water going. He said the old bear did a good job, took the pipe out and that cut the water off. Hot and dry."

On the last day of August Mary wrote, "Carol came down and helped me can pears and make pear jam. It was a hot day and it's dry. Ted and Leigh and baby visited me yesterday and we went to Dr. Driver's party." That would have been at the place just upriver that Uncle Ira and Aunt Louise used to own.

After Ira and then Auntie died, Mary was left with the responsibility of keeping the old house clean, and disposing of most of the couple's possessions. Later she was also in charge of maintaining the house in Joseph that Aunt Louise had lived her last years in. This house would become a source of rental income for Mary in later years. And, of course, Mary continued to manage the large amount of land she and Kid purchased in the canyon, including maintaining the upper cabins. "Fred, Anna Mae and

Inez Meyers went with me to Lookout Mountain and fixed the water trough and hauled out some salt."

Mary kept the cellar at the old homestead spotless, which meant she had to sweep the dusty floor, which aggravated her asthma for days. On September 4, 1987, she wrote, "I cleaned on the cellar at upper place. Dust didn't help my asthma so am having trouble breathing. Deer are eating my garden and it's so dry, takes lots of water." The next day, "I stayed in the house, out of the dust. Maybe it will help my asthma. Still hot and dry and lots of fires, but none close."

Mid-September arrived. The deer were still eating on her garden. Mary noted, "I'm feeding some hunter's horses for a few days." Mary wrote the next day that her own horses came down so she got a good look at them. The horses grazed the steep canyon sides across the river from Mary's house. I suppose when the water was low in the fall, they crossed and came over to the other side. But the sight left her missing Kid again, for she saw that "little Bit's feet look awful, and Pete's are long." It must have made her feel helpless to watch these things happen, wondering if she could still trim horses' hooves.

Later in the week, "Geanne left, sure was a lonesome old Sunday." A few days later, "I sure feel lonesome and wish I felt better." The next day, "Vicky and I picked corn and we fixed it for her. Took about all day." I suppose they froze or canned it, and because Kid was not there anymore to cook for, Mary didn't save any for herself She probably had enough left in the cellar from the year before.

On September 18, 1987, Mary penned, "I rode up with Jim [Blankenship] to take the mail. Most everyone is gone from the river so I'm alone." Jim used to carry the mail from Joseph on Mondays, Wednesdays and Fridays. He would stop at the tiny post office at Imnaha at the Bridge, then travel upriver as far as the Imnaha River Woods. Just as she did on the school bus, Mary most probably rode from her place upriver and back for the company with Jim, who was a fine person and knew everyone. Often, when Jim delivered the mail upriver, he would spend the night in a little cabin just off the road, and return on top the next morning.

Mary enjoyed her ride upriver with Jim, but when she returned home and called her sister Alice, the news wasn't good. Alice was failing fast.

Loneliness continued to plague her. "I went to town with Carol. It was a quick trip. I looked about a new stove. I sure feel lonesome and wish I felt better." It almost appears most of Mary's ills stemmed from missing Kid.

October 3rd was opening of buck deer season and Mary wrote, "Brought my 2 pt. buck in and hung it up. Awful warm for fresh meat and lots of hunters on the river." The next day she noted that Ferm Warnock, an old-timer and bachelor from downriver at the Bridge, came up and helped Mary sack the meat. Because it was so hot, she had to sack the meat during the day and lay it in a cool place, then hang it again to chill at night. This was how the canyon folks kept their meat from spoiling, until it turned cold enough to leave it hanging.

There was so much heavy work, Mary had to enlist help. There were potatoes to sack and haul to the root cellar, and a friend graciously "dug the spuds, while Betty and I went to Harl Butte. Awful dusty and dry. Lots of hunters." Later that week she canned seven quarts of venison and packaged the rest for the freezer. In spite of the deer eating her garden, she was also harvesting and storing carrots, onions, tomatoes and squash.

She'd already made pickles and canned the sauerkraut she'd let ferment in a large crock. And she got help with jobs that were just plain unpleasant — Gary killed the skunk that had been bothering her.

In the midst of this putting food by for winter, "Nancy called and said Alice died. I feel so bad." Another death in Mary's family in a year full of sadness.

The fight with the water continued. "I went up to the spring and found a break in the pipe. Turned the horses out, it's so hot and dry."

On October 15th, Mary wrote she had a TV installed. She didn't seem to be too thrilled, just said it was a long day, and she got awful tired. Perhaps it was because her neck and shoulders were hurting. Could have been from an old horseback injury when she got bucked off in the rims. But a few days later she said

she was having fun with the TV, which must have been a novelty at first, as there were not many sets on Imnaha at that time. Reception was poor or non-existent unless one had a dish-type satellite receiver.

By the end of October, Mary was ricking up wood brought by Gary and others who were looking out for her. Elk hunters were converging on Imnaha, and Mary noted this when she went upriver for some pitch to be used for fire-starter.

Ferm Warnock came up and took Mary to Harl Butte where Ferm hunted, as he had a bull tag. They saw some elk, but they were ail cows and calves. Still, Mary wrote, they had a good time and picnicked at Spoon Springs.

Mary was having trouble breathing again because of the dry, dusty fall, so the doctor fixed her up with an inhaler. In spite of her discomfort, she cooked for Grange "doin's" like she'd done for years. On November 2nd Mary noted they had the first rain in two months and her asthma let up some. However the rain didn't amount to much and she "choked up again." Her breathing got worse and she caught a ride to town, only "the car broke down on Sheep Creek. I went to the Dr., didn't find out much and I am no better. Coughing a lot." The next day was no better: "Feel bad and choked up worse. Dr. is gone so I don't know what to do."

But she did get her elk.

On November 21, Mary wrote, "We all went to Beeler Ridge. Snowed and blowed. We got three elk in quaking asp. One Hell of a place. Boys worked down to the river, and Roxanne and I brought the pickup home. Cold, windy and snow drifting." The next day, "Roxanne and I took the boys to head of Turner Creek and they walked down to skin the elk and to pack my calf out. Snowing a little on top, but not too cold." During anterless elk season, calves are legal to shoot as they haven't yet grown any antlers and can't be distinguished from a full-grown animal.

New Year's Day of 1988 must have felt like a time of reckoning for Mary. I can picture her staring out her kitchen window at the layer of snow covering her fenced-in garden, her eyes wandering past the road above her little house to scan the canyon wall to the east, the same familiar scene of layered rimrock reaching to sky that she'd been staring at for 55 years. Perhaps she noted several

mule deer midway up the canyon, huddled under the branches of a large ponderosa pine. She might have walked to the bedroom window and looked the other direction, up to the western canyon that seemed to wall her off from the world, or watched the river, freezing now from the bottom up and scarcely moving.

Because Mary was a good housekeeper — and because if there was something to be done, she did it — she would have decided to wash her windows. And she would have carried wood in for her fire, which was her only source of heat.

Kid had passed away on January 15th of the previous year. That evening Mary sat herself down to record her day in her small five-year diary: "It was a long, lonesome day" she penned, "and I think this is my last winter on Imnaha."

The next day, Mary's neighbor Don Norton came up to get some water, as his well pump wasn't working. Mary, plagued with asthma, didn't feel very good. Perhaps the wood smoke aggravated her allergies. Because Mary wasn't feeling any better the following day, she asked Vicky to take her out to town to see the doctor. The hill coming down to Mary's house was just a sheet of ice, so Vicky had to chain up before she could pick up Mary. The doctor prescribed some medicine for Mary that seemed to help — that is, until the next bout of asthma landed her in the hospital, as it sometimes did.

The winter of 1988 was long and cold. Mary noted in her diary, "lots of snow, and the river iced over again." She shoveled a trail to the wood pile, so she wouldn't have to slog through the snow while carrying arm loads of wood to the house. On January 21, Mary noted that the snowdrops were in bloom alongside her house, but the next day it snowed again, completely covering the the tiny blossoms.

On February 2nd, the temperature dipped to 10 below zero, and Mary noted reports from town — Joseph and Enterprise — of 29 and 34 below. Because she had to burn so much wood to keep warm, her wood pile got dangerously low until Gary cut her some birch, and Gene Daggett brought her more wood.

About this time her TV broke down and Gary had to stop by and fix it so she could watch "Lonesome Dove." Mary noted on the 25th of February that her phone went out. She wrote, "It

was a long day, no telephone and cold." Later that week she had to face the income tax, and wrote that her lawyer told her she would have to pay quarterly, as she had no dependents and the one payment was too large.

Mary was also left with the task of selling Aunt Louise's house in Joseph. When Mary recorded, "The gal that's buying Aunt Louise's house hasn't paid the taxes for '85 on. She is behind on payments. That damn house of Auntie's is making me sick," it was obvious that Mary's diaries took the brunt of her frustrations, her needs, and, mainly, her loneliness.

Winter turned to spring, and spring to summer, which brought the year's high point. Mary was chosen as one of the Grand Marshals of the Hells Canyon Mule Days, held in Enterprise. She shared the honor with well-known local Imnaha cattleman Joe McClaran. Both Mary and Joe were, by now, legends in Wallowa County. To qualify for the title of Grand Marshal, one had to have worked with mules, and Mary sure had her share of that. Mary and Joe proudly rode down Main Street, Enterprise, in the non-motorized parade that year, with a founder of Mule Days, Max Walker, driving a team of mules that pulled one of the original hacks used before the advent of the car. The newspaper photo showed all three of them grinning broadly.

Years later, in September of 2001, Mary would again be honored, this time with her old friend Sam Loftus, as Grand Marshals of the Imnaha Canyon Day Parade. The two old-timers led the small parade through the only street of the tiny settlement of Imnaha. When they made their way along the parade route, folks were looking at two of the last survivors of those once numerous old-time cowboys and cowgirls that made their living along the Imnaha River.

Took our cattle to Chalk Creek. I went on home and dug spuds.

On October 15, 1945, Mary had penned, "Took our cattle to Chalk Cr. I went on home and dug spuds." That meant that she herded the cattle down a steep canyon trail, left them to graze a new area, then rode back to her house to unsaddle her horse and dig her spuds. Just an ordinary day for Mary.

Forty-seven years later, on September 9, 1992, she wrote in her diary, "I dug my spuds — picked cukes and tomatoes. Don Norton came for a hair cut and hauled my spuds and fruit to the cellar. Still hasn't rained so have to irrigate." When Mary penned those lines, she was 75, and not riding horses like she used to.

But she carried on with her life as she had always known it, the seasons dictating what needed to be done.

The winter of 1988 hadn't been her last on Imnaha, as she had speculated on New Year's Day of that year. Five years later, on New Year's Eve, 1992, Mary wrote, "Started to snow at dark and we have 3 or 4 in. this morn. This diary ends another five years. Wonder what the next five years will bring?"

39 EPIC FLOOD

In December 1996, Kid had been dead nearly nine years and Mary was approaching her 80th birthday. Although her old friend Lyman Goucher, now widowed, had been driving his pickup up the road to Mary's for breakfast and supper for quite some time, Mary was still living alone in her small house on Imnaha.

December 23, 1996: "Eight inches or more of snow, but warm." The winter of '96-'97 had been, thus far, one of unusually heavy snowfall, and a hint of the impending disaster was given in Mary's use of the word "warm." Traditionally, December is the cold month, and any snow that falls along the river usually stays at least until early February or March, when a southerly flow of mild chinook wind melts it all away.

December 26, 1996: "Lyman cut me some wood. It's warmed up so maybe the snow will leave."

December 27, 1996: "Snow is melting. I went to Lyman's and helped him pull a calf."

In all the years Mary had lived along the Imnaha she had never experienced more than minor flooding, but she must have suspected and been preoccupied with the threat of the rising river, because the next two pages in her diary were left blank.

December 31, 1996: "Lyman's family and I and Randy Garnett celebrated New Year's Eve. Barbara Warnock called and said the water was up to her door. I came home and found water running around my house. Went to bed but didn't sleep."

Lyman had tried to talk her out of staying at her house that night but she persisted, saying she wanted to be there to protect her things. Included among those "things," stored in a shoe box, were Mary's five-year diaries. She spent that long night placing her valuables on the highest shelves in her closet, writing in her diary, and listening to the increasing roar of the rising river. At one point Mary opened her bedroom window and wondered at the power of the water that swirled around her house. She felt like she was in a houseboat, and paced the floors in the dark.

The electricity was out. The phone was out. Mary didn't know it, but she was completely isolated from the outside world,

because massive mud slides had obliterated both upriver and downriver access.

Forty-five miles away, on top, New Year's Day had blown in on the warm breath of a chinook wind. In a matter of hours entire fields were transformed into lakes, but the snow only continued to melt. Ducks and geese, attracted to these large bodies of water, cavorted about as if it were spring.

By evening on January 1st, virtually all the snow in the Wallowa Valley had melted, and Prairie Creek and the Wallowa River were raging torrents of froth. At Gumboot, mud slides had washed out the Loop Road. Tributaries like Gumboot Creek and the north, south and middle forks of the Imnaha were sluicing into the main river. The Imnaha swelled and rolled past ranches, carrying uprooted trees, farm equipment, and small livestock.

January 1, 1997: "Lyman came up and got me. We waded to his car. Everything is flooded. My wood is gone and the rest is going. I spent the night at Lyman's."

The town of Imnaha was having its own problems. A small house, perched above the river bank in back of the old cafe, had been swept away downstream. Recorded on video, the image of that house floating on the raging water was seen on TV all over the country.

Skip and Pam Royes's freezer was swept off their porch, along with their beloved Corgi dog. A huge ponderosa pine that had stood for decades alongside the bank quivered a few minutes, then silently succumbed to the force of the current. Pam watched as its massive trunk and bobbing evergreen needles floated away around the bend.

Folks scurried to locate generators, and the Red Cross appeared with drinking water and food, but Sheep Creek was on a rampage too, and travel from Joseph to Imnaha was risky, as sections of that road were also washing away.

All that balmy day, in spite of bird song and respite from winter, there was an eerie feeling in the air. Up and down the Imnaha, people were stranded in their own little pockets between mud slides that hindered any means of escape.

The next day Mary penned her four lines: "I came home and stayed. Water in the front room. Randy and Gary took out

the rugs. All the corrals and fences are gone." The water had come down through Mary's meadow with such force that it took everything in its path, including a storage shed, which was lodged in an alder thicket.

The U.S. Geological Survey had monitored levels on the Imnaha River since 1928. The "100-year flood" level was considered to be 9,000 cubic feet per second. On January 1, 1997, the Imnaha River reached an estimated flow of 20,000 cubic feet per second. It was, as the newspaper said, "an extreme event." The waters gradually receded, and the long slow process of cleaning began. In spite of living in chaos, Mary took time to record her days.

January 3: "Am trying to dry the house out and am about sick. Lymans company helped shovel mud."

January 4: "Lyman got a generator and the kids moved my meat to the house. The freezer in the old house is shot. Too much mud. I've lost a lot of things and I don't know if I have flood insurance."

January 5: "Things are drying a little. Helps to have the power, but it's awful. Barbara moved back in her house today. Ruby was down and Lyman ate supper. He has several calves."

January 6: "Colder. Lyman came up and we went to Gary's. Lyman saw a cougar in the crik. No phone. My wood is going fast. I have sore hip. Cold is better."

As the days went by the county road crew worked overtime to clear the muddy rubble. Power was finally restored, but the phone lines took much longer. When Mary's neighbors could travel about, they brought her reports of washed out bridges, like the one at the Imnaha River Woods development upriver. Since the telephone line was still knocked down, any news was transmitted this way, by "moccasin telegraph," which, on the river, worked quite efficiendy.

January 7: "Things are still froze down so can't do much. Vicky was here a while and Lyman ate supper. Still don't have the house back together. No snow and it's not too cold and still have wood."

January 8: "Vicky was down and Barbara and Grant brought my mail. My place looks worse every day, but I still have a house and am alive. Lyman helps me all he can."

Built on a rise, Lyman's house wasn't flooded, but it continued to rain and Mary worried over his calves being born in the mud, and over Lyman, who wasn't getting any sleep.

January 11: "Not so wet and kinda quit raining. Vicky and Barbara came down and cleaned the mud out of the storehouse. Sure a muddy mess and I lost a lot of stuff. Christina helped me in the house and it started to freeze before they got through."

Soon neighbors had hauled Mary more wood, and split and stacked it for her. Good thing, for the cold of winter eventually returned, and heat was a necessity.

January 15: "Red Cross were down but they can't do anything to help us clean up."

Mary attended a community meeting at the new church at the Bridge, where she listened to the woes of her neighbors downriver. She heard about how the Coots house washed away, and how it flooded up Big Sheep and at Garnett's up Grouse Creek. It "didn't miss much," she wrote of the flood.

February 6; "I sorted some stuff in the store house. Sun shined so I could open the doors so things can dry out. Water mark two feet high on the walls."

While friends and neighbors continued to help each other, it seemed to Mary that government officials weren't of much assistance. She wrote, "Went to another meeting on the flood. Same old deal. Didn't sound to me like we will get help." And on February 19, "Three people from FEMA, the flood damage was here looking at the river. They say we can't put a 'cat' in the river. It will kill the fish. So guess we will flood again if the river gets high."

February 20: "I tried to clean some more and got some mud washed off of stuff. It's such a mess I don't know what to do with the mess. The darn weather don't help as it's cold and freezing."

One day Doug (Doc) Morgan, an old friend of Mary's who lived at the Bridge, drove up to take Mary to the root cellar at the old homestead to load up on potatoes, onions, apples and canned goods. Then she fixed supper for Doc and Lyman.

When it began to snow again, folks started to worry about more flooding. The river people attended more meetings about

the flood damage, but Mary continued to be pessimistic about any help.

February 23: "Saw some robins so maybe spring is on its way. Some of my bulbs are coming up through the sands."

March 9: "Cheryl, Barry (Cox) and kids were up to help. Also Gary, Vicky and kids and Barbara Warnock and her grand kids. It didn't rain so we got the garden cleaned off and a lot of sand hauled out."

On March 30th, Kid's grand-nephew Michael turned eleven. Mary always remembered that date because he'd been born on Kid's birthday.

All that spring Mary suffered with leg and knee problems. When they would swell up she'd have to call someone to take her out on the 100-mile round trip to the doctor. Of course Mary's condition was aggravated by the fact that she couldn't stop shoveling at the flood mess, or working on the wood pile. When her legs began to heal, back Mary would go to the hard work she'd always known. It would be well into May that year before Mary could start looking at the river without trepidation.

April 10: "It snowed all day so things are wet. Its too cold for the river to come up."

April 19: "River is getting higher."

April 20: "Rained this morn so was slick and soppy. River broke through and five steps from the house."

April 24: "I mowed the lawn. It's spotty but green. The river is high and running through the store house. We had to move stuff out of it."

April 25: "Looks like a good day after all the rain. River is down as its been 38 degrees and new snow on the mt."

April 28: "Started to rain about dark but river is down."

April 30: "Sun did shine and the river is coming up.

May 3: "Luke mowed my lawn and it was high. Its looking better and the tulips are real pretty."

May 16: "Warm all night, and the river going through the yard and barn lot. It thundered and rained a little. The river is awful high and muddy."

May 26: "River is high but not flooding."

At last the weather turned hot, and anxieties about the river receded from Mary's diary entries. On June 4, she wrote, "Dan and Lyman finished the garden fence. Sure looks good and garden is coming up."

40 KINDRED SPIRITS

In April 2000, when Mary was nearly 83 years old, the loneliness that had plagued her since Kid's death was eased by the companionship of a kindred spirit.

The April morning sun had surfaced over the eastern canyon wall, but its warm rays hadn't yet penetrated the small river bottom where Mary was working in her garden.

There she was, a small-boned woman carefully raking over a row of newly-planted radishes. Wearing worn gloves, faded jeans, work boots and a bird-bill hat with the words "Wallowa County Grain Growers" printed on the front and her neatly-curled gray hair protruding from the sides, she finished the row and leaned the rake against the garden fence.

Earlier, in the coolness of dawn, she had planted a row of lettuce. Mary always used a small length of black plastic hose to measure the space between her rows so they would be even. Before planting, she'd spent several mornings raking the manure her friend and neighbor Lyman Goucher had hauled from his barn yard and dumped in a pile in the middle of her garden.

Now the newly-tilled soil was rich and friable. It had taken several years to restore it to its former fertility after the January 1997 flood delivered a deposit of gravel, rocks and sand.

Dark thunderheads moved silently over the rims, casting shadows across the canyons as Mary finished up her planting.

She walked down the path to her house, stepped over her cat, "Troubles", sleeping on a burlap bag on the step, and entered her small porch. In the kitchen she sat to unlace her boots, but left them on as she lifted one dainty but sinewy hand to brush the hair back from her sweating forehead. Her slight frame, not much over five feet, appeared fragile, and her darkened complexion was wrinkled, reflecting years of toil. But in spite of the years, Mary's former beauty was evident in her Spanish eyes, in her figure, and in the confident, dignified, nearly regal way she held herself. There was a certain grace to her, even though her speech was purely "Wallowa County."

A pan of sweet-roll dough had been rising in the sun on the

kitchen counter. Mary washed her hands, opened the flour bin drawer below her, took out a sifter and shook flour onto a pull-out board. Grasping the bowl with both hands, she dumped the dough out onto the board, kneaded it a few times, then used a rolling pin to roll the dough into a long rectangle. After spreading the surface with a liberal amount of melted butter, Mary sprinkled a mixture of cinnamon and sugar over all, then curled the dough into a long roll. Next she took a greased thread, cut the roll into rounds, and placed them in a greased fry pan.

While the cinnamon rolls baked, Mary finally took off her boots. Lyman would be arriving for breakfast soon, and Mary knew the smell of those rolls would start his day off right.

Lyman Goucher lived several miles downriver in a large log home he and his wife Doris had built themselves. After helping to realize their dream of building that house, Doris came down with incurable cancer that ultimately led to her death.

Loneliness in lonely places, such as the remote Imnaha River canyon, brings people together who, given other circumstances, might never have met. Little did it matter that Mary was 14 years older than Lyman. He'd lost his wife to cancer and Mary had lost her Kid to Parkinson's, and so it seemed only natural that these two seek companionship. It wasn't long before Mary was cooking supper for Lyman there in her little kitchen.

It all started when Mary would wave to Lyman as he passed above her on the road, coming and going upriver to see his daughter Vicky, who was married to Kid's nephew Gary. One morning, when Mary waved from her garden, Lyman drove down her steep driveway to visit and Mary invited him in for a cup of coffee. A few days later Mary asked Lyman if he'd like to come to supper. As time went on Lyman began appearing for breakfast and supper on a regular basis.

That was it. Two lonely people, who had known each other while their spouses were still alive, became close friends. It gave Mary something to look forward to, someone to "do" for. Mary was concerned about his health, she said. He worked too hard on the ranch, and during the long winter months, when it was cold and snowy much of the time, Mary longed for someone to care for and nurture, the way she had longed to nurture the children

she never had, the way she cared for Kid all those years until his death.

After that, the long evenings, when the day's work was done, were less lonely for both Lyman and Mary. They continued to live separate lives, choosing to keep their own homes, but they became very fond of each other despite the large difference in their ages, and their friendship grew. Lyman did the dishes, and helped with the cooking as Mary aged. Oftentimes he would invite Mary to his log home downriver.

At first Mary worried about the gossip their relationship caused, but then the years passed and time has a way of erasing frivolous talk. The sight of this couple out in public became familiar and accepted. The important thing was that Mary and Lyman could give the other what they each needed.

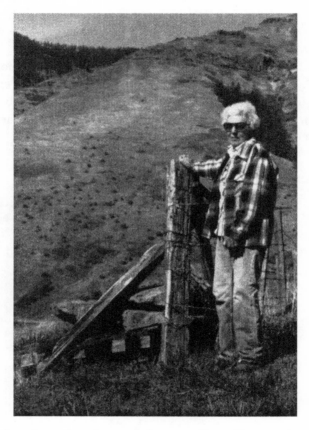

Mary by rock jack near cabin site. (Janie Tippett photo)

41 REMEMBERING THE FOREST SERVICE

On the morning of April 15, 2000, my friend Ellie and I took a break from the Imnaha Writers' Retreat and hiked to Freezeout Saddle. The sign at the trailhead said "2 mi" but it felt like more on that long switchback trail.

On top, we looked down on Snake River. There was quite a bit of snow on the old burn and the norths, but none on the saddle, and lots of wildflowers so I picked a bouquet for Mary of dogtooth violets, shooting stars, larkspur, yellow bells, blue bells, arrowleaf balsamroot, prairie stars, and kitten tails.

Mary was just on her way in from working in her yard all day, grubbing out the old "flood junk" and limbs along the river. Her old gray cat Troubles had followed her when she worked near the river, and now was trailing her back toward the house. Gary's son Michael had just mowed her lawn. Everything was spotless. The tulips were blooming, as were her forsythia and flowering quince. She had the sprinkler going on the lawn, as it still hadn't rained enough to do much good.

Mary invited me into the house and I gave her the bouquet of wildflowers. She loved them! Then I sat down, feeling a bit done in after that long hike up and back. When Mary learned where I'd been, she began telling stories about the trail to Freezeout Saddle when she and Kid trailed their cattle up there. She explained that the trail that took off to the right was the old Marks trail leading to the Marks cabin. "Then," she said, "there was another trail up there, near the saddle, that we called the Government trail."

I supposed they called it that because that area was on Forest Service land. Mary said the Forest Service district ranger, Wade Hall, was easy to work with. One time in the '50s, she said, "I was ridin' my horse on the Upper Imnaha road, pullin' two pack mules loaded with salt." She was headed up Freezeout to put salt out for their cattle, when along came Wade Hall. It was about ten o'clock in the morning. Wade stopped his car and called to Mary, "This is a helluva time to be leaving camp." And Mary came right back with, "Gosh, you'd think I was working for the Forest Service!" She said Garnet Best was riding with Wade at the time

and "they just looked at me with their mouths open and tore off down the road."

Fred Talbott was another Forest Service employee who helped Mary a lot when she got a special use permit after Kid died. But often, according to Mary, the Forest Service "seemed to be picking on us." She probably felt that way when the Forest Service reduced the number of cattle they could have in that area, telling them they could only run 20 head, Gary 20 head and the Freezeout permittee 20 head.

Another time, said Mary, she and Kid had cut a lodgepole for repairing the fence and a fellow took a photo of it and turned them in. Mary wrote the Forest Service a scathing letter. "They probably just burned it," she said.

Recalling another incident, Mary said, "The old Marks trail wound through the burn and fallen trees were a problem getting the cattle through, so Kid and I were cutting trail using a chain saw and someone turned us in, as it is now Wilderness and only cross-cut saws can be used." Think of the work it would have been for this older couple to use a cross-cut saw! So mostly they would use the Government trail, which was on top, where there were fewer trees. Mary remembered many trips taking the cattle along that cold trail to Barton Heights, and there would always be snow when they took them up on top. She recalled it being "the longest, toughest, meanest trail" when they had to take the cattle to Pete's Springs on their way to Barton Heights.

After being up there in that steep, rugged country all morning, and seeing the snow on those high ridges above us to the south, where Mary and Kid would have trailed their cows, it was easy to imagine her stories.

About that time Lyman drove in, bleary-eyed, dirty and work-worn. He hadn't realized it was already three o'clock. He was hungry, hadn't had anything since breakfast. "Got any of that baloney left, Mary?" he asked. "I need a sandwich and also one for the hired boy, Randy, he's gettin' pretty gaunt."

While Mary made three sandwiches and hunted around for a paper sack to put Randy's lunch in, Lyman said they'd been digging rocks from the field all day, and "I got the mother rock, so now I hope she'll quit having little ones."

Mary made tea for the three of us and, while Lyman gobbled down the sandwich Mary made for him, he began to rave about the price of parts at the local co-op, the price of a roll of chicken wire, and the price the local electrician charged. "Incredible." he said. And I had to agree. My own husband complained daily of the cost of everything from fuel and parts to just about everything it took to run a ranch anymore. Lyman said he didn't buy the chicken wire.

"Just too expensive," he said, and abruptly got up and left with two sandwiches for Randy.

"Don't dig any more of those mother rocks," I kidded as he walked out the door. Then Mary and I finished our tea, and I walked back to the retreat.

Mary at the Lou Warnock homesite.

Three days later, I took another break from writing. I picked Mary up in the morning and we drove up Freezeout Creek road, then turned to the right down across an old wooden bridge that spans the creek.

"Kid, he built that bridge," said Mary, "when we had to run this place once. And where that house is, where Randy and Liz Garnett live now, that was where Grandma Jensen lived."

I concentrated on negotiating the many rocks in the rough dirt road that led past the newer house, oftentimes driving way off the road where it was smoother to avoid tearing a hole in my oil pan. We climbed a steep hill, bouncing over more half-buried rocks sticking up in the road, when ahead on the left I caught a glimpse of several domestic rabbits, surprised at the sound of our approach, scurrying under an old shed.

"There it is," said Mary. "That's the little house Kid and I moved into when I was 16 and a new bride. It was the original Lou Warnock homestead cabin." She observed, "It's been moved."

The one-room shack was small and falling apart. I envisioned it perched on the canyonside further up the road. Now it was being used as a storage shed. The weathered hand-hewn shingles were peeling off and the old wooden boards that provided the siding reflected the effects of time. It was at least as old as Mary, who is nearly 83, I thought.

We climbed out of the car and I photographed Mary there beside what used to be her home. Then, stepping through the old door and taking care not to fall through the floor boards, I gave Mary a hand to help her up into the building. Junk was crammed into every corner, but we could see how the little shack must have looked. Mary pointed out the long high bench, covered with tin, that served as the sink counter top where she could set her pans of water carried from the spring. A small window looked out over the sink area.

Mary looked puzzled. "I wonder what happened to the door that led to our bedroom," she mused. Because the building was all boarded up and another window looked out the back of the

cabin, it seemed unfamiliar to Mary. "We had a root cellar too" she said, "and a door leading to it. We had a daveno that sat here along with our bed until we got the bedroom built, and then I could move the bed out and just use the daveno. That was nice then," she said.

"I loved this little house. Papered it, and hung curtains. We had a little porch out front, where we could sit and look at the view up and down the river. A wood stove here," she pointed, "and a table and chairs. Didn't own much stuff, so didn't need closets."

I watched Mary trying to reconstruct her little home of so long ago, and just imagined that, in the winter, it would be a cold, drafty place, as there was no insulation, just bare boards with cracks in them. Now the wallpaper was cracked and peeling, and the unmistakable smell of pack rat, wild and musky, permeated the little shack.

We returned to the car and drove a few feet further to a wire gate.

I started to get out to unhook it, but Mary said, "No, I'll do it." And out she bounced to open the gate. The rocks got worse, but the view got better, and below us appeared a feedlot with several yearling heifers, staring. I could hear a hound dog baying in the old barn near the gate, and three milk goats scampered up the hill and into the midst of the yearlings.

"Right there," said Mary, "there used to be a garden. Don't know where the water came from, must have been piped down from Freezeout Creek. And way up there," she pointed, "there used to be an old trail, and sometimes we'd ride out that way. It wound up through the timber and came out at where Ruby and Hugh Holmes used to live, on the Freezeout road. Then we'd just ride down that. I loved that old trail."

Looking back the way we'd come, Mary remembered, "We used to drive a team and wagon up this very road to get to our place. Oftentimes we rode horseback. Once in awhile, when it wasn't muddy, an old pickup could make it up here. But mostly we used the team."

Presently we came to a young apple orchard, planted by a wealthy newcomer. It was all fenced in and newly sprayed. At

the orchard there was just a semblance of the old wagon road, all grown over with grasses. Mercifully, there were no rocks, just a soft carpet of grass from then on as we wound around the side hill, far above the Imnaha River. Steep draws filled with ponderosa pine and thorn-brush thickets marched to the sky, and the rimrock country stretched to the horizon on both sides of the river.

"There's the old yellow pine," said Mary. "It's still standing." She seemed happy. We drove on and on, until we came to a rotting rock jack that was holding up a droopy fence line. "Park here," said Mary, so I did as bid and we stepped out into a breathtaking scene with a view of the river below and canyons marching on. I photographed Mary leaning against the rock jack.

"Kid, he built this fence," she said. I noticed a small, rusted lard pail, leaning on its side, filled with equally rusted nails and staples, just begging for someone to come along and repair the stays and rock jacks — but the hands that built it were now buried in a cemetery in Enterprise.

We scrambled over the fallen wire gate and continued to walk a well-worn path. Presently Mary veered off to a small flat area perched on the edge of a steep drop off. "Here," she said, "is where our barn stood. Once I had this bridle that Kid's dad gave me, and it had a romal [a long leather quirt]. I was just unsaddling my horse, and somehow my spur got caught in the romal. My horse took off, dragging me along right to the edge of this cliff here. Don't know what made the horse stop, but he did, and a good thing."

"Where was the house when you lived in it?" I asked.

"Just up here a-ways," she said, and took off walking. Two clumps of narcissus were all that remained at the site. They grew below a rocked terrace Mary had built back in 1935. "The terrace was right here at the edge of my porch," she said. "Wonder what happened to the root cellar?"

It appeared that the new owners had filled the site in with junk, buried most of it, and then heaped more junk on top. "A dump now," said Mary, sadly.

Mary pointed downhill to a spring. "That is where we hauled our water from," she said. "Downhill with the empty buckets,

uphill with the full ones." I judged the distance to be a quarter mile from the cabin.

I tried to picture the little shack squatting on that tiny level spot in a canyon that overwhelmed it. In spite of the harshness of the location, the sink window would have commanded an incredible view upriver, and across the canyon one could look up-country toward Jayne's Ridge.

"See? It still has snow on it," said Mary, pointing south. "That draw just below is Grouse Creek, that's where we rode up to the upper camps and drove our cattle up." I pictured Mary riding from her place all the way up there, and guessed it was probably more than four miles to Grouse Creek, then four more to Harl Butte or Marr Flat. All those miles, all those years, all a horseback. So many hours this little wisp of a woman had spent riding these canyons!

"That's Chalk Creek, runnin' up there," said Mary, "below Geanne's house." And she pointed to a new home perched high above the road and across the river, above the old home where Alfred and Mary Marks had lived. "That's where I had to ride to, to get the mail, down to the folks's. And see that draw there? That's Line Creek, and see that ground across the way? That all used to be farmed, even that little spot up that timbered draw. Every spare inch that could raise hay was farmed," she said. "It was important to have hay to feed the stock in winter."

And then I knew why the little shack was built on a rock pile on the edge of a cliff, as was the barn. They didn't want to waste any ground that could be farmed.

I could envision Mary sitting on her little porch, looking down and across at this sweeping view of the canyon, feeling the breezes and watching the seasons change, the snow line creeping lower in the fall and receding when springtime came to the canyon. I noticed an old, gnarled apple tree growing up the draw from the house site. The serviceberry in bloom resembled drifted snow, and a few enormous ponderosas lent a high-country feel to the place.

"That son-of-a-bitch who bought the place, he really ruined it here," blurted Mary, pointing to where logging roads further up scarred the landscape. The largest trees had been cut and skidded

down the steep canyon sides.

"That was the line fence to the original homestead," said Mary, and she pointed to a high fence line that skirted the highest rims. "It went way up there, 160 acres, but it didn't seem that big." Mary remembered how Kid would ride up those steep draws, select a dead tree, cut it, and drag it down with a horse, then cut it up for fire wood. "I was so happy here," said Mary. "I hated to leave this little place. This was my first real home."

I could picture Mary's curtains fluttering above her dry sink, smell the cleanliness of her newly-papered walls and scrubbed wooden floor. I could imagine her dishes all put away in their simple apple box cupboard, their comfy little bed, the cherished daveno, perhaps a water glass filled with yellow bells on a crude little table. I could see in my mind's eye the root cellar where she stored her canned fruit, venison, apples, potatoes, and sauerkraut, the wood stacked up in a small woodshed, the new wood cookstove (with all of its lids), perhaps a hooked rug on the floor, one made by Grandma Marks. A tea kettle boiling and screens on the window to keep out the flies.

All this I imagined, and saw that the little shack was a metaphor of their lives: lives lived not against, but in harmony with, the canyons.

"Of course," explained Mary, "Kid was working [without pay] for the Marr Mat Grazing Association before we was married, so when May came around, we both packed up and moved to the Harl Butte Cow Camp on top. I hated to leave my little place, but it was getting hot by then and it was cooler on top. We didn't return until way into November, when Kid had gathered all the cattle he could find and we came back down here."

"Except," she remembered, "the year Grandma Marks died. We had to stay right down there and help Granddad. But the next year we moved back up here. I used to miss my little home so much. I'd saddle up my horse, ride up here, and start a little fire and just putter around." It was easy to imagine Mary riding up that steep trail, unsaddling her horse, and being "at home" again in her own little space.

"That's the way it was back then," said Mary. "You took care of your own kin. If some member of the family needed help, you

just did it. No nursing homes in those days."

I proposed hiking up to the old apple tree to photograph the view, but Mary said, "I'll just stay here," and I sensed she wanted to be alone with her thoughts.

On a slight rise leading to the house site, a solid carpet of low-growing filaree fairly glowed with bright pink color. Far below I could hear the sound of the Imnaha, full of white riffles and snow melt as the high country released its winter snows. Across the river, arrowleaf balsamroot splashed yellow color over the greening hills, and several mule deer grazed on the opposite hillside. South of them, Gary's pack and dude horses lifted their heads from munching the lush bunch grasses. Suddenly, a young horse broke loose from the herd and raced, snorting, downhill to a salt box. It was a scene right out of a western novel.

When I returned, I found Mary leaning against an old corner post that supported a sagging gate. "One of Kid's posts," she said. "Looks like it could last another 60 years. See? It won't rot. Pitch clear into the ground, all the way through. Didn't need any of that post treat they use today. Kid knew how to build a fence and set a good post."

Near the barn site, we stumbled upon the rough-hewn remains of an old slip, a huge heavy sled built to haul loose hay. Slowly being claimed by the canyon, yet still showing its well-built construction, the slip remained as a testimony to those who worked this harsh land. More of Kid's work, I mused, and then I thought of all the myriad things this man, and others like him, had left behind. Their legacy is the sturdy pole gates, the rock jacks, the slips, the hand-hewn log watering troughs, the bridges, the barns, the houses, the outhouses, the corrals — everything built to last, from materials at hand, from the land. Even the little cabin's foundation consisted of evenly-spaced rocks.

Mary shared stories as events of the past kept surfacing. "Once I was awakened by the sound of a mower cutting hay, and I looked out the window, and there was Kid. He had my mare Sorrely hitched to the mower! I was so mad I didn't make any bones about it. Guess it scared him, he never used her again. And poor little Sorrely, once she got herself cut on the rump, real bad, when she fell over a rim and lit on a rock. Cut open an L-shaped wound.

You could see the yellow layer of fat. We put her in a squeeze chute and I sewed her up with a darnin' needle and fish line. Took a while but she healed up just fine."

Far up the canyon a cold front appeared to be moving in, a change from the sunny April morning we were enjoying.

"We sure need rain," Mary remarked, "things is awful dry." And I could imagine this spot in July and August, burnt up and breathlessly hot. Of course Mary would be up at the cooler, higher elevations, riding with Kid, checking the cattle on the associadon grazing allotment, salting, packing mules, cooking for gathering crews.

"Did you ever get lonely up here?" I asked Mary.

"No," came the quick reply. "We always had company, even way up here." She recalled one birthday when she was newly married, and "here they come, carryin' homemade ice cream and cake on horseback, what a time we had. Sometimes friends would ride for miles to visit, and they'd spend the night, too far to ride back in one day."

More stories spilled out of Mary's memory, and I detected a wistful look in her eyes, an almost sorrowful look, of times perhaps not so good, when she WAS lonely and things didn't go right. Days when there were horse wrecks and folks broke bones, when the wind whistled through the cracks in that little shack, when the cabin caught fire. But mostly, I could tell, Mary had been happy here. Her face reflected the canyon life she lived, and in her hands one could read the work, the incredible amount of work. A lifetime of it.

We drove back down the steep, rocky road to the house and over the bridge, passing Liz Garnett coming home from work, pulling over to let her pass. Back to the Freezeout road, past the mail boxes still bearing the faded names of people long gone now.

Mary was anxious to return to home and "get at the flower beds." I knew she'd be using her Pulaski to grub out the quack grass. The place was neat and tidy, and exhibited the results of staying in one spot and loving the land, nurturing it like the children she yearned to nurture. Even when the river took her garden, her corrals, her yard, and her storage shed, she and her friends rebuilt it all.

It could happen again, she said, but life goes on.

"Any day now the radishes and lettuce will be up, and I'll cut the sproutin' potatoes and plant 'em this afternoon," she said matter- of-factly. Mary, well into the winter of her own life, was still planting food to last another winter on Imnaha.

43 Autumn Memories

"The turkeys are out here scratchin' around the yard," said Mary. We were visiting over the telephone later that year, in November. How I envied my 83-year-old friend, able to watch wildlife out her living room window. "How are you this morning?" I asked, wondering if the arthritis was still causing pain in her lower back.

"I'm fine," she said. "Just waitin' for Lyman and Doc Morgan to pick me up and take me down for breakfast."

Knowing what a treat that would be for Mary, who fixed breakfast every morning for Lyman and all the fall deer and elk hunters who stop in, I detected happiness and anticipation in her voice. She liked being part of this canyon life she'd lived for nearly 70 years. She, like me, loved the excitement and cameraderie of fellow hunters. Mary couldn't get out and carry a rifle anymore, but she could listen to the stories of those who did.

"Doc, he got his cow elk," said Mary. "They gutted it out in the hills. He had a Chesnim tag. They loaded it in the pickup and drove down to Lyman's. Wanted to use the tractor with the lift, so they could skin it. But Lyman, he was up Line Creek, chasin' after those nine cows he was out. And Doc didn't know how to run the lift! Anyway, Lyman, he come back and got it a-goin' and now they're comin' to take me down there."

We continued chatting while Mary waited for her ride, and the conversation turned to the old burial plot where Benjamin and Elizabeth's bones lay. Mary said that there were Indian graves there on that river bottom, where they used to raise hay. She lamented the condition of the plot. "Last I saw, the fence needed fixin' and that old lilac just ran over the headstones, but somehow I think Elizabeth and Benjamin are happy there. What does it look like now?" Mary asked me, knowing she would never make it over there again. I told her that Elizabeth's headstone had fallen, but Benjamin's was fine.

"When Kid was alive, he mended the fence," she said. "And if he was here and well, he'd prune the lilacs." I told her perhaps one day someone could tend to that chore, knowing that, although intentions were good, it probably wouldn't happen.

Then Lyman and Doc showed up, driving down the steep hill to Mary's house. "Here they come now," Mary said. "Sure wish you was here. And Janie..."

"Yes?" I said.

"You should see the turkeys now. There's this big tom struttin' around them hens. He has his tail feathers all fanned out — darndest thing." Then Mary said goodbye and hung up the phone in her little house under the rim rocks.

As I donned jacket, hat and gloves to step out into my own morning, my thoughts were of Mary. They were with her as I scattered whole wheat to my chickens, gathered yesterday's eggs, and poured a bucket of water into a heated pet dish. They were with her as I forked hay to my two milk cows. They were with her when I petted Stargirl's month-old bull calf, and remembered an old black and white photo Mary had given me of her own cow's calves — twins, they were. The two Hereford calves stood beside their mother in a small barn lot, next to a crude shed that Kid had built on a flat spot above a steep draw.

"I was so proud of them," she said. "Wasn't they nice calves?"

I remembered clearly that day the previous April when Mary took me up to the very site where that shed once stood.

As I petted my calf, I envisioned Mary coming out of her tiny shack of a house and walking down the steep canyon side to the shed to fork hay to her cow and calves. As I looked upward at a V of wild honkers flying low over my cow shed this morning, I wondered if a 20-year-old Mary took time to observe the wildlife in the canyon around her. I bet she did. I bet she told Kid later at breakfast how she had watched the deer scramble down the rocky draw to drink in the river below her. Just like she would tell Doc and Lyman over breakfast about seeing that gobbler strutting around those hens.

I could see her throwing her arms around Doc, giving him a hug, congratulating him on shooting his cow elk, and sitting back and listening to the story of the hunt. It just wouldn't be November without an elk hunt and the stories that go with it, without those dear friends coming back fall after fall, not really caring if they killed an elk at all, just being together on the Imnaha, sitting around the table, eating a hearty breakfast.

The following spring, as I had for years, I returned to the Imnaha Writers' Retreat at the place that used to be Uncle Ira and Aunt Louise's. And, as I had for years, I stopped by to visit Mary. It was April 9, 2001. We talked about Lyman, how discouraged he was with his big Limousin cattle, how a heifer he was doctoring for foot rot charged him and got him down.

"Wonder he wasn't killed," Mary said. "I told Lyman, us ranchers must have all been born with rubber necks or else we wouldn't survive, guess the cow twisted his neck pretty bad." She said she cooked a roast last night and he would hardly eat. "On top of everything else, nearly 70 head of elk are eating up his new seeding on the benches above his house."

Mary led me outside to where a patch of red tulips bloomed around the trunk of a large locust tree and said, "Darn, look here, what the dad-blamed deer did last night." And then I saw where the deer had nibbled the tops of some of the plants and actually pulled several of the bulbs right out of the ground. Mary's Crown Imperials were beginning to bud alongside the river. "Skunk Eyes," Mary called them. "When they bloom you can see these little eyes and they have tears, they are crying because they didn't pray, and now they spend their life being sad."

Mary told me Lyman had hauled her some manure for her garden, but it needed to be spread around. She showed me where she'd used her "woman killer" to dig out a patch of quack grass near her flower beds, and commented on the little grape hyacinth she had transplanted from alongside the river. Her flowering quince was budding, but she was aggravated its shoots that were coming up in her tulips. I pulled a couple out, but they were pretty well anchored to a tap root running underground.

The forsythia was nearly through, and a bit damaged by the frost. Shivering in her light cotton blouse, Mary walked along the path with me, pointing to the walnut tree. "See, these will be walnuts and these will be leaves...if it doesn't freeze again." Then she said a neighbor upriver had gotten some Walla Walla Sweet onion plants for her, but it had been too snowy and cold

to work the ground. Up on the rims the white snow contrasted sharply with the greening of the lower canyons. Ice falls, created by the water overflowing from the cistern that provided Mary's water supply, glistened in the April light.

Finally it was time to leave, and I suggested Mary better return to her warm house, as a cold wind was blowing. As I left, I watched her stoop to pull a weed, then make her way slowly back to her porch.

On the 18th, after more than a week of writing, I visited again. I left the retreat by walking across the swinging foot bridge over the Imnaha, and made my way up the road to Mary's. I noticed a softening in the morning air, the leaves on the trees responding to a warmth and balminess not felt before. I could sense the grass taking on a deeper hue of green. A rufous-sided towhee sang joyfully in a nearby seedling cherry tree. Its feathers weren't ruffled up with cold, but relaxed, and there was a sheen to it, a brightness in its tiny eyes. I glanced downward to the sheer rock face below the road, where a pair of water ouzels had built their nest. I noticed white droppings that had splashed down over the rock, and the river rushing just below. The river swirled around itself here in an eddy, perfect for bull trout and for spawning steelhead to rest on their way upstream to a lesser creek to lay their eggs.

Feeling like singing as I walked, making a joyful sound like the towhee, I suppressed the desire because I was not a bird.

No, I was a 67-year-old woman who was going to visit her neighbor, who was nearly 84. But somehow I knew, as did Mary, that under our breasts beat the hearts of 19-year-olds. Did other aging women feel this way? This I pondered on this April morning as I walked down her driveway.

I found Mary flouring her bread board and dumping biscuit dough out of a bowl. I watched as she gently shaped the dough with her hands, patting it out into a square and talking all the while.

"How are you, Janie? Did you have a nice Easter Sunday?" she asked.

"Wonderful," I replied. "And you?"

Taking a biscuit cutter made from an old Mep's lemonade can with both ends removed, she skillfully cut out her biscuits. "Lyman, he wanted to take me out to town for dinner, but I didn't want to go. You know they only serve steaks at night, and during the day they serve that food I don't know nothin' about, so we didn't do much, just fixed us a bite here and got a little bit of yard work done. Did you notice Lyman hauled me some more manure for the squash patch?"

"I did, Mary, but he didn't spread it around. Perhaps later I can come over and fork it around for you."

With a practiced hand, Mary placed each biscuit in an oiled, blackened pan.

"Bet that pan has a history," I remarked.

"Bought that years ago, from Duckett, when he run that store at the Bridge," she said. Then she opened up the cupboard to show me a Pyrex pie dish she'd also purchased there. On the counter were two slices of boned-out elk steak, and the makings for gravy. When Mary saw Lyman's pickup coming down the hill, she slipped the biscuits in the oven. Then she dredged the elk steaks in flour, and when the oil in the cast iron fry pan was smoking hot, she seared the wild meat on both sides, removed it to a warmed platter, and proceeded to make milk gravy. Taking an ice-pick-looking utensil with a rounded handle, she poised the sharp end over a can of milk, made a fist and gave the handle a sharp punch. As Mary punched two holes on either side of the can, she sang, "No tits to pull, no hay to pitch, just punch a hole in the son-of-a-bitch." Still laughing, she sifted flour into the meat drippmgs in the frypan.

Lyman, smelling of hay, manure and fresh air, burst through the back porch door and headed for the bathroom to wash his hands and face. He wore a denim-striped work shirt, worn at the elbows and tucked into an equally worn pair of jeans. Over the jeans he wore leather chaps held up by a pair of faded red logger suspenders. Lyman wasn't a big man and carried not an ounce of fat. He canted forward when he walked. On his feet he wore heavy work boots, scuffed and caked with manure and mud. He had just come from hauling and feeding hay to his cows. With his hat off and his face scrubbed in Mary's bathroom, his balding

head shone under the kitchen light.

"Well, how are things this morning?" Mary asked.

"Looks like rain, sure as hell hope it does. Hope somethin' gets this grass to growin'," he said, helping himself to coffee before he sat down at the small metal table.

"How you been?" he asked me. "Over there with all them writers again I see, noticed smoke comin' out of the chimney last night." A two-day-old beard was sprouting on Lyman's face, his eyes were bleary from lack of sleep amid days filled with work. Those eyes reflected all the hard luck life had thrown at him. Losing his wife, struggling to eke out a living from the canyons, low cattle prices, fighting the government over grazing regulations, and, at age 71, worried about how long he could hold on, how long his body would take the grueling work demanded of him. He was starved, he told Mary.

Looking at him there would melt the heart of any woman. It seemed at that moment he was just a hungry boy, sitting at his mother's table, waiting to be fed.

Lyman poured canned milk and sugar into his coffee, swirling it with his spoon, then emptied a pint of Mary's canned apricots into a bowl and devoured them. When Mary's gravy was thickened, he stood, walked to the stove, poured it into a bowl and carried it to the table. He took the biscuits out of the oven while Mary served the steaming steaks. Lyman took up his fork and knife, cut a huge chunk of steak, and after savoring it slowly, poured gravy over two biscuits. "Here," he said, forking over a slice of meat for me to taste. "Taste this elk from last fall. Mary, she doesn't put enough salt on, but I'm not supposed to eat too much anyway."

It was delicious, juicy and full of flavor.

"It's good meat," he said, "fattened on my alfalfa field." And Mary laughed, remembering the day they cut and wrapped all that meat.

When Lyman finished up his meat, gravy and biscuits, he took another biscuit out of the pan and slathered Mary's pear jam over it, then had another one to finish off his coffee, this time covered with ground cherry preserves. With a satisfying burp, Lyman leaned back in his chair. No apology needed. The burp merely

signified that he was full. A man that works that hard is entitled to a few unheeded burps, I mused.

I arose to do the dishes, but Lyman got there before me. "You get out of here," he said, with authority enough to convince me. "This here is my job." And he proceeded to wash those dishes so fast I scarcely had time to find a dish towel.

"Guess what I saw yesterday," he said, hands immersed in sudsy water. "A rattlesnake den. There they was, six of 'em, sunnin' themselves on a rocky ledge. When they heard me comin' they all slid into this hole. They was ail tangled up together. Never seen a den before."

"Hope I never do," I said.

Then he was gone, uttering a hasty goodbye as he donned his hat and jacket. Work to be done; always work waiting. The porch door banged shut and then we heard him say, "Damned cat," as he stepped over Mary's cat Troubles, who was sleeping right in the middle of the step.

"He's goin' to check his fence lines today," said Mary. "He'll saddle his horse and ride the old parts, mend wire and repair falling down rock jacks. He won't eat any lunch, never does, but he'll show up here around 4:30 starved again, to put away his last meal of the day. Sometimes I just run out of ideas of what to fix, but Lyman, he's not particular, he'll eat anything. He always does the dishes, and when I'm tired he'll do the cookin'."

The kisses Lyman planted on Mary's brow were tender and loving. There was respect in this relationship, and more than that, each one was sensitive to the other's needs. Mary knew what his day would be like. She had fixed fence. She'd spent all day in the saddle, gone hungry, been too cold and too hot, been sore from lifting or stretching barbed wire.

"Your pansies look so cheerful," I told Mary.

"They's this big dandelion growin' right in the middle of 'em," she said. "Can't reach low enough to get it out and not step on the pansies."

I knew Mary, always alert for weeds, would fret about that one. "I'll do it on the way out," I said, picking up her little digging tool.

While I was digging that dandelion, I could see her smiling at me through the kitchen window. Then, as I walked past her Walla Walla Sweet onion patch I noticed she'd been digging quack grass, buttonweed, and dandelions herself—enough to fill a pail.

As promised I also spaded up another area of her garden, which provided a diversion from writing. When I walked back to the porch to leave the tool, Mary was sitting in her chair resting. "Thanks," she said. And I thought in reply, *thanks to you, Mary, for a gift I couldn't put into words. Thanks for showing me a slice of your life, for providing me with living proof that life goes on after the death of a mate, for just being you.*

And then I walked back to the retreat.

45 A Fall Gather at Harl Butte

In the fall of 2001, Lyman, who was running his cattle on the same range that Kid and Mary did all those years, asked my husband Doug if he wanted to bring his horse up and help gather and ship calves in late September. I was delighted. Mary had asked if I wanted to help with the cooking, which made me even happier. It was time for the "fall gather," which meant all the cattle owned by three outfits would be rounded up and sorted. Calves would be weaned and shipped, and cows preg-tested and vaccinated. It was an established tradition that neighboring ranchers all pitched in to help with the work, as it took a quite a few hands to accomplish these tasks.

Since Mary was recovering from a recent stroke which had affected her right hand, she wouldn't be able to go, and it would be up to me to cook. I jumped at the chance. This experience would allow me to live in the pages of Mary's diaries. How could I write about this woman's life without spending a night in her cow camp, cooking for the cowboys?

And I did write, by hand in the tiny cow camp kitchen, at the same table at which Mary penned so many of the entries in her diaries. I had just finished cooking breakfast, and the cowboys, Doug among them, had saddled up at daybreak and ridden off up the hill toward the old log corrals. As I began to write, Mary's familiar diary entries came to me: "The cowboys came up to ride and I cooked."

We left our ranch on Prairie Creek, 50 miles from Harl Butte, in the midst of a fall storm. Doug had rolled up our sleeping bags, saddled his horse Hummer, and loaded him in the horse trailer. I threw corn, eggs, sausage, steak, a can of tuna, squash and bread in a cooler. A change of clothes and a toothbrush and we were off! A sudden storm brought rain — such a relief, as dry lightning was forecast, and we'd surely get more forest fires. It poured going down Sheep Creek hill and along part of the Loop Road, but quit at Lick Creek. The evergreens looked washed and green. We turned off at Harl Butte Road, and saw numerous deer and a few deer camps already set up. No dust on the gravel roads,

but wonderful clear, fresh air, and so much cooler at that higher altitude. I loved the fall feeling, the aspen turning amid a cold wind, mists caught in canyons and swirling around the Wallowas, obscuring them. This would be the first fall storm.

Farther and farther from civilization we drove, passing signs for Mahogany Cow Camp, Marr Flat, Spoon Springs — all places in Mary's diaries. Ten miles beyond Mahogany brought us to a weathered two story cabin at the end of its own rocky road. Actually, the two faint tracks that forked off below the main road to Harl Butte Lookout could more accurately be described as a cow trail interspersed with sharp rocks which appeared to grow out of the ground.

The old cabin showed the effects of cold winters, hot summers, and lack of use. It was hard to tell the difference between the color of the bark of the surrounding ponderosas and the cabin, so perfectly did it blend into the clearing. It almost appeared as if the cabin had taken root in the meadow alongside the bed of a spring-fed stream that Mary could never recall being dry. The forest was slowly claiming the clearing. Memories and stories seemed to haunt the place, lodged in the fallen rafters and lurking in the weedy corners.

Doug stopped the pickup on the main road while I jumped out and opened the gate — a gate built years ago by Kid, I mused, marveling at the skill and workmanship it must have taken to construct it. Using crude, often handmade tools, and materials supplied by the nearby forests, Wallowa County's old-timers created these functional swinging gates, many still in use. They are gates that women can open, as opposed to those barbed wire affairs that are stretched so tight there's no way most of us can close them, especially after we've struggled to unhook those thick loops of wire that fasten over the gate post.

Nearby, in the tall, golden grasses, lay the remains of an older gate, rotting into the soil like a fallen tree. The old moss-covered wood would eventually return to the land from whence it came, adding to the mulch, which would, in time, nourish another tree. After I removed the rope loop from the post and slid the wooden latch open, the gate swung free with no effort on my part. Thanks, Kid! There were three horses wandering around

the cabin enclosure, so I closed the gate behind me.

A large stock truck and a smaller pickup with racks on were parked between the cabin and the crumbling remains of an even older log cabin. The ancient structure's roof was collapsing. Mossy, rotting logs had settled at rakish angles, and the semblance of a porch roof jutted out in front. This, then, was the second cabin, the one Mary was so happy to move into, until it, too, needed to be made more convenient in order for her to cook for the cowboys. I'd remembered reading in her diaries about how the "boys" arrived with new windows for this çabin when it was being built, and how excited she was. It was all coming alive to me.

Mary had also told me about the first cabin near the gate, a small crude log cabin built so long ago that the only evidence it ever existed was stored in Mary's remarkable memory.

Walking along a rotting board walk that led to the main cabin, I noticed a dead pack rat that looked as if it had been tossed from a trap. A door, loosened from its latch, was swinging in the wind, and a second door was firmly latched but opened easily when I turned the knob. I hollered "Anyone home?" All was still. The wind moved the whiskers on the pack rat, and a strong scent of horse sweat came from the porch, where two saddles hung suspended from the ceiling by a rope.

As I entered the small porch, I noticed several 5-gallon cream cans full of water, a rat trap, and a screened wooden cooling cupboard containing cheese, canned milk, a slab of bacon, and a jar of apricot jam. An ice cooler on the wooden floor contained icewater in the bottom, a jar of mayonnaise, a bottle of cattle vaccine, and a few bottles of beer. Split wood and kindling filled another space near where narrow wooden steps led upstairs to a large open room with a slanted ceiling. Light from two small windows allowed me to see a large ornate iron bedstead which had been painted white and bore a double mattress, plus two other single beds. The bed springs were those coiled wire ones used so long ago. A sleeping bag hung from the ceiling, safe from pack rats. Everything was orderly, but one could tell there was an on-going battle being waged on the mice and the rats. Their musky odor lingered.

Back downstairs, I tried the door to the kitchen, but it wouldn't budge. Assuming it was locked, I returned outside and spotted a small, caved-in wooden bridge that once spanned the small stream. But now there was no water evident, nothing but a streambed to indicate there had ever been water there. Beyond the bridge a worn path wound its way through wild rose brambles and snowberry bushes, laden with white berries, to a tiny outhouse. Inside the one-holer, every nook and rafter held a nest of some sort. Birds, pack rats, mice and other woods creatures were delighted with this wilderness home. A worn broom stood in the corner, so I swept the old wooden floor as best I could.

The meadow was fringed with thorn-brush thickets and a few water-starved aspens. The ponderosa pine and fir forest, stretching to the breaks of the Imnaha on one side and Big Sheep on the other, looked to be creeping in to claim the clearing where the cabin stood. Oregon grape leaves were turning red, and tawny-colored grasses caught the late afternoon light, while hawthorn bushes the color of coral added their own light. The sun burst through the clouds. Rain-washed and clean, the scene was a watercolor painting!

I walked back to Doug, waiting in our truck.

This time he went down to try to get in the kitchen door while I sat in the pickup and read my mail. We'd gotten it on the way out, and I hadn't had a chance to read it. It was warm in the pickup and cold outside, as the sun had gone down over the distant Wallowas. The wind had blown most of the clouds away, however, and the sky was clearing. Doug discovered the kitchen door was just stuck, as the linoleum covered wooden flooring had heaved and thawed so many times in summer heat and winter cold that it had warped. A strong shoulder shove did the trick.

On the way back to our truck, Doug stopped at the pickup parked in the yard. I hadn't thought to look in it for a vehicle registration to see if it belonged to Lyman. He checked, but there was no registration over the visor. Still, we knew it was Lyman's, as I recognized the pickup from when I would go to the Writer's Retreat on Imnaha.

Although it was late in the day, we decided to visit the Harl Butte Lookout before unpacking at the cow camp. Mary had

recendy visited a woman who had spent three summers there with her ten year old son. Mary said she was a writer and photographer. What a neat life for such a woman! I would have loved to have met her.

Up the road we passed some cattle bearing Lyman's brand, and came to a large set of log corrals, past which we turned up the steep road to the lookout. Half way up I got out, opened a wire gate, and walked the rest of the way up to the fire lookout, gasping at the steepness of the climb but finally reaching the top to find a fierce wind blowing. Misty clouds sped past so close I felt like I could touch them. We were at over 6,000 feet in elevation, and the air smelled of snow. I gazed east to see Freezeout Saddle, a place I'd climbed to several times, and beyond it the Seven Devils in Idaho. I could see the Imnaha and its side canyons, our Zumwalt country to the north, the Divide between the Sheeps, and canyon after yawning canyon draped in swirling mists.

I envisioned Mary riding all this country for all those years. The pages of her diaries jumped to life. I remembered reading about her riding with Kid from Imnaha up over the top to drop down into Big Sheep, where she and her brother Pat cooked at the sheep camps. And I remembered reading about Mary riding her horse up to the fire lookout to visit the wife of the fire ranger, and how they came down to the cow camp below Harl Butte to get water. Now I knew what Mary felt when she talked with glowing eyes about those times. And now that I could be here, see it, and feel it, I envied Mary and her life.

It was freezing and late, and I only had on a light jacket. The wind came up and all the dead pine needles of summer sifted through the cold air. In spite of the chill, I found the views just overwhelming, and I had to drag myself back to the pickup.

I opened and shut that man-made gate, putting my shoulder to it like Doug taught me — darn wire gates weren't meant for a woman — and got back into the pickup. We drove that steep, narrow road back past the log corral, through the cattle, and on to the cow camp. Once again I opened Kid's swinging wooden gate, and shut it behind Doug so the three horses wouldn't escape. We pulled up in front of the cabin and unloaded our gear. While I opened yet another horrid wire gate and held the horses at bay,

Doug parked the pickup and horse trailer outside the pasture fence to be out of the way. Then we moved our gear inside.

The kitchen was wonderful! Taking up quite a bit of space was a handmade wooden table, covered with a patch of worn linoleum showing years of use. Linoleum of a different pattern clung to the wooden floor, worn by years of cowboys' boots trodding over it. If floors could talk, this one would have told stories of generations of cowboys who'd come up to ride, not to mention the many years Mary's own boots trod that very floor.

In one corner stood a four-burner gas range, with a trash burner wood stove top to cook on. Two gas lights hung on wooden supports from the ceiling — one over the dry sink, one over the table. A clock I couldn't locate ticked and tocked. It was the only sound, save for the wind and the horses stomping and grazing outside the window. Four aged wooden chairs were scattered about — one very old ornately-carved one, two without backs and held together with baling wire, and one with a knothole in the seat. A long, crude wooden bench stood against the wall.

Two 10-gallon milk cans supported a hand-hewn plank, which served as a shelf to the left of the stove and provided space for a box of kindling and a stack of newspapers. Nearby a queen-size mattress and box springs rested on a hand made wooden frame, low to the floor. The large porcelain sink, which looked like it hadn't had water piped into the faucet for years, sat below a sliding window that afforded a view of the gate and road beyond. The sink held two tin dish pans, and the linoleum-covered counters provided space for a dish drainer that held the washed breakfast dishes. Numerous blackened fry pans hung from nails on the walls, and pots and pans were stacked everywhere. A large enamel roaster pan held utensils, and a coffee can containing tea bags as well as ground coffee sat on the counter. Staples like flour were stored in cans. A large plastic bag, suspended from the ceiling to keep it from rodents, held toilet paper and paper towels.

While Doug tended to Hummer, I laid our sleeping bags out on the mattress next to the table and started our simple supper. I had to hunt for everything. A long search finally turned up a can opener, and then we were in business. We'd left our ranch in

such a hurry, I'd just thrown in a few items, although, of course, I'd remembered the steaks for the big feed tomorrow. I opened a can of tuna, found an onion in the screened cupboard on the back porch, and then, using the mayo from the ice chest, made ham sandwiches. Then I cooked some fresh corn I'd picked in my Alder Slope garden that afternoon. Using the gas stove proved to be a challenge but I soon got the hang of it.

So there we were in cow camp, at home in our little cabin in the woods. Mary hadn't known if Lyman would be there or not, so she'd said, "Just go in an' make yourselves at home." like the old days, I thought. And I wondered how many more years we'd have folks around that would say that.

Still, like Goldilocks, we didn't know if or when the bears would come home. It was a mystery, as the pickup and stock truck were there, and coffee grounds had been in the sink. There was no place for the horses to water, as everything was dry, so we knew someone had to come back to care for the stock, but we didn't know who or when.

As darkness seeped into the clearing, we lit the gas lights and I put water on the stove to do our few dishes and make postum and coffee after we ate supper. Later, returning from a trip to the outhouse, I saw through the trees those lights glimmering through the windows, providing tiny pinpricks of warmth and cheerfulness in the midst of miles of unpeopled places. Stars glittered in a cold September sky, and moon glow spilled through the ponderosa pines. Far off in the darkness an owl hooted, and the horses snuffled and snorted in the meadow.

This, then, was where Mary and Kid worked for over a quarter-century for the Marr Flat Grazing Association. I was beginning to understand all those entries penned in Mary's diaries under the heading "Harl Butte." Taking it all in, I thought of Kid and Mary living up here all those springs, summers and falls. How lucky they were! Many folks spend their entire lives searching for what they had here.

I was just brushing my teeth over the sink when I noticed headlights bumping down the rocky road. Mary had said to go on into camp, and on second inspection I had found Lyman's registration — it still had his deceased wife Doris's name next to

his — in the glove compartment of the pickup. We WERE in the right cabin. Still, I wondered a little nervously who this might be.

A small pickup pulled beside the front door, and Lyman and another cowboy climbed out. They both looked incredibly tired.

"We were wondering where everyone was," I said as they walked in.

"We were invited to supper with the three Warnock boys at Mahogany," explained Lyman, introducing the other cowboy as Randy. They had ridden gathering cattle all day, and had worn out their horses. So they tied the horses to trees and walked down into Squaw Creek looking for a few missing pairs. No wonder they were tired and driving 20 miles round trip just to eat supper.

Before Lyman and Randy could go to bed, they and Doug had to go out to lead the horses up the hill in the moonlight to a water trough that held the last of the dried up spring's water. While they were gone, another set of headlights appeared in the late night, and a rig pulled up to the gate. It turned out to be Randy's girlfriend, who had driven all those miles from Joseph to tell him his stud horse was sick.

"He ate some molding hay," she said. "He was lying down and groaning, wouldn't get up." She was so worried she thought she should drive clear out here and tell Randy. Of course, there was no phone. Randy went out and sat with her in the pickup for a long while, then returned. He decided not to go into town, but told the girlfriend to call the vet. He couldn't do anything and was needed the next day here for the shipping and weaning. So she turned around and drove all the way home. I wondered if she just wanted to see Randy.

It was 9:30. The cabin was warm and cozy from cooking and the afternoon sun's warmth had been stored in the old wooden boards. The windows hadn't been opened, I supposed to keep mice out of the kitchen. "The Warnock boys will be here to help early in the morning," said Lyman. "Think we'll turn in."

Since we obviously had the downstairs bed all ready to jump into, Lyman said that he and Randy would bunk upstairs. Lyman had quite a time carrying his sleeping bag, slippers, and flashlight into the cabin and up those steep, narrow stairs, so I helped him out and grabbed the flashlight. First, of course, he had to squeeze

between those two saddles hanging from the ceiling on the porch, then he had to avoid the rat trap he'd set on the floor at the head of the stairs.

After the two men went to bed, I took note of the rest of the cabin. Hanging from huge nails driven into the wall just inside the kitchen door were worn jackets, weathered and sweat-stained cowboy hats, and a pair of greying long johns with numerous holes in the crotch patched with denim. The knees had been patched too, one patch pale green, the other yellow. Fly swatters, old and well used, lay around the room. A broom, with the bristles worn to nubbins, was propped up in one corner.

On the table reposed salt and pepper shakers, a pint jar of sugar, a brand inspection book, a deck of playing cards, a jug of cooking oil, and a roll of paper towels. The lone picture on the walls had been torn from an old faded calendar. It was a print of a painting depicting an Indian in full regalia leading his warriors on an attack of an "iron horse." The Chief was in the act of shooting an arrow at the engine while galloping alongside. The picture had faded somewhat over the years, but was otherwise amazingly well-preserved.

Above the picture a wooden frame was still in place that once held the Forest Service telephone Mary so often wrote about in her diaries. Mary reported most any emergency and relayed messages over that phone, and she remembered some of them, like gunshot wounds and fires. The phone had long since been disconnected, although miles of the heavy wire can still be found. Mary even ordered her groceries over that phone, which were then delivered by Forest Service rangers to drop-off places like Gumboot. Of course Gumboot is miles from Harl Butte, but it beat going to town. "Besides," said Mary, "we had to go there to salt cattle anyway."

A small built-in chest held newspapers and reading material, all aged. There were kitchen cabinets, crudely built of plywood. And the cabin itself had been built using lumber from when a house on Marr Flat had been torn down. Dave Warnock had been responsible for the newer cabin, which had made Mary so happy. She said the old log cabin leaked, and was cold and drafty, a miserable place to cook for the 20 cowboys who came to help

with the fall gather.

The cupboard held a few staples, all stored against mice.

A tin dipper to dip water from the cream cans hung on a nail over the sink, as did a wash basin. A wooden crate near the stove held matches and potholders. Coffee pots, a tea kettle, and a large cast-iron griddle sat on the stove. For a bachelor cabin it was pretty tidy. Mary, unable to come up to scrub like she used to, and not able to come up at all this year due to her stroke, had always made sure the cabin was neat and clean. Mary said Chris Moore from Imnaha had come up to scrub the floor recendy. Indeed, it was clean and swept.

The windows were fly speckled and dirty, but little time is spent any more in cow camps. The Marr Flat cattle Grazing Association had disbanded, and only a few permittees even use the cabin anymore, and only for short stays during spring and fall. It hardly seemed worthwhile to wash the windows.

Once in awhile a hunter will obtain permission to stay there from one of the ranchers who run cattle in the area. Lyman said snowmobile riders would often break in during winter and use up all the kindling. There was always the fear they would burn the place down. The stove pipe, in fact, was nearly burned through, so we decided not to use the wood stove to cook on in the morning.

Since Lyman had said we had to be up by five, we hit the hay. After turning out the gas lights, we sank into our sleeping bags, which were all laid out on the comfortable, clean mattress. The odor of coffee grounds and onion wafted from the sink, and the faint smell of mouse reminded me that Lyman had set the trap behind the stove before going to bed, using bacon rind for bait.

The unseen clock ticked, the wind sang in the pines, and the horses snuffled and stomped past our window. The moon had cleared the dark outline of the forest. I slept fitfully, waiting for more company — a cougar, a bear, a pack rat — or for the next cowboy to stomp outside to relieve himself, the door protesting and groaning with each swing. I heard a horse squeal once when another one bit it. It was impossible to sleep.

I made it through the night without getting up to go out and pee, as I thought I might run into a cowboy out there.

I awoke at 4:30 and dressed in the dark, having slept all of two hours. Thus began our day. I fixed a hardy breakfast of bacon, eggs, toast and hot coffee for the "boys" as they began saddling up before daylight. Soon the Warnock boys rumbled down the road and everyone rode off to the corrals.

A new generation of hawks circled high above, and beyond, in the meadows bordered by yellowing aspen, a new generation of cattle bawled for calves penned in the nearby corral. A new generation of cowboys yelled and hollered, driving the herd behind a dusty cloud, and someday a new generation of cooks will take the place of the old ones. But on that day, 84-year-old Mary Marks still presided in spirit over the feeding of hungry cowhands.

By the time all the calves were shipped and the cows preg-tested, it was late afternoon. When those hungry, weary hands trooped into the cabin to fill their plates with steak, gravy, potatoes, corn, coleslaw, cucumbers, bread, and slices of Imnaha tomatoes, they were eating the same food Mary prepared in 1943 — and they smiled just like the boys had back then as they washed it all down with coffee and homemade blackberry pies.

After doing the dishes and mopping the floor, we loaded up Hummer into the horse trailer and reluctantly departed. A peacefulness descended on the old cow camp as I closed the gate, saying goodbye until next fall.

I paused above Mary's driveway and filled my senses with the scene below. An early morning breeze lifted the yellowing birch tree's leafy limbs like it would the golden tresses of a young girl. The dry canyon sides across the road were studded with bright coral-colored thickets of thornbrush. A golden glow was in the air, seemingly reflected from the brilliant yellow leaves of a small English walnut growing next to a larger one. The larger tree, burdened with nuts, had split down the middle, the victim of an early fall windstorm. Or was it just too heavy with nuts? Still attached, the fallen limbs reposed where they fell and the nuts continued to ripen.

Pink cosmos danced in the breeze alongside the garden fence. Pansies, as bright and fresh as they were in April, bloomed in a corner of Mary's vegetable garden. A large deer fence enclosed cabbages and tomatoes, which continued to bear. Having survived the first frosts, long green cucumbers hid beneath withered vines. Potatoes had been dug and stored in the root cellar, but a row of carrots remained for Mary's winter soups and stews. As the winter progressed, she would cover the carrots with dirt, then straw. The corn had been eaten or canned, and the dried stalks fed to Lyman's cows. Slowly, Mary's garden was being put to sleep, just as it had had been for nearly 60 years. I walked down the hill to her yard, past the garden, and saw Mary, her gray head bent to some task over the kitchen sink.

Framed in the window, so intent on whatever it was she was doing, Mary didn't know I was there. I paused, taking it all in, feeling her aloneness, her years slipping by. I wondered what she was thinking about.

Troubles, her cat, was curled up sleeping on the gunny sack rug on the back step. A cat house, made by a visiting elk hunter, sat on the side of the steps, but Troubles never used her house. The large cat's place was just under the door jamb so that everyone entering Mary's back porch had to step over her. That is, until Mary went out to work in her yard, when Troubles would follow Mary about like a faithful dog. And when the weather turned

cold. Troubles slept under the bunkhouse. Mary couldn't have a cat in the house because of her asthma, and the multitude of cow dogs Mary and Kid raised over the years had never been allowed in the house.

I stepped over Troubles, opened the door, and hollered, "It's me! Janie!"

"Been thinkin' of you," Mary said, giving me a hug. Then she returned to the sink where she was cutting up a couple of brush pheasants. "Lyman, he run into them on the road, felt so bad, got out and wrung their necks. Meat's not hurt too bad, I'll fry 'em for supper. Did you hear Lyman go by this morning, 'bout 3:30?" she asked.

"Sure did," I replied. "Matter of fact, it woke me up, and I wondered who was driving past in that rattling old cattle truck. Where was he going?"

"Helpin' the Warnock boys," she said. "They're up to Mahogany Cow Camp, they're shippin' their calves today. Lyman, he'll eat breakfast with the boys in town this morning after the calves are weighed and unloaded. They'll all be plenty hungry by then, but the Cheyenne Cafe will fill 'em up."

I envisioned platters of ham, eggs, hash browns, and perhaps a side of sourdough hot cakes. In our home town of Joseph, our cow town turned tourist trap, the Cheyenne Cafe was still a place where hungry cowboys who had begun their day at 3:30 could walk in with cow manure on their boots, dust on their hats, and patches on their jeans, and feel at home. Up the street they couldn't, among the life-sized bronze versions of themselves planted on Main Street. Sometimes it seemed as though their vanishing lifestyle had been stilled in watercolors, photographs, and oils as well, with price tags attached, for wealthy collectors of Western art.

"How're you feeling this morning?" I asked Mary.

"Oh, not so good. Darn, just not up to par, and my back still aches, hurts most all the time. Guess I just do too much."

I remembered seeing her out in her garden, hoe in hand, when I walked past yesterday morning. She finished cutting up the little wild birds, placed them in a bowl of water, and put them in the refrigerator. "You want something to eat?" she asked.

"No, not now," I said. Sensing she was making the most of Lyman not coming home for breakfast, I asked if I could help with anything.

"Sure can," came the quick reply, and she took off like a little bird to her bedroom. There sat her sturdy wooden bed, stripped down to its mattress. "If you could just help me move the bed back from the wall," she said. And she reached down to lift one end.

"Don't you lift," I told her, thinking of her back. "Let me do the lifting." But it was too late. She already had hold of the bottom.

"I'll be just like this at her age, I mused, stubborn as a mule."We could just roll it," I suggested, noticing coasters on each leg.

"No," she said. "Kid, he fell once, with the Parkinson's, a week before he died, and landed hard right here and broke the bed frame. Ken, up the road, he mended it, but I'm afraid it will break again."

With the bed away from the wall, I could see a slight accumulation of dust, but nothing compared to what I envisioned under my own bed at home, where entire families of dust bunnies were procreating at that moment. Then I put such thoughts out of mind. After all, I placated myself, I didn't suffer from asthma, and vacuuming just once a year under the beds allowed me more precious time to write.

"Here," she said, "Use this little dust buster thing. I don't like it, but it gets that part next to the wall." I got down on my hands and knees and went to work. When that was done we moved the bed into different positions until I had vacuumed the entire bedroom rug with a larger vacuum. I dusted the headboard and then, quick as a flash, Mary had a bottle of window cleaner in one hand and a clean rag in the other. Since her stroke, her right hand didn't function like it used to, and I could see her struggle to reach the top of the window, so I took the cleaner and rag and proceeded to wash both bedroom windows.

"This here was an electric mattress pad," she said. "A friend gave it to me, and I just took all them little wires out and it works fine, just washed it." A set of freshly-laundered sheets and pillow cases sat on a nearby chair; together we put them on the bed.

Mary had to have the sheets on just right, crease in the middle, foot tucked in, hospital-style.

Mary seemed to enjoy having me work with her, and we worked well together. During our precious 30-year friendship I had come to understand how Mary liked things done.

Next came a brand new non-allergenic electric blanket she'd ordered from a catalog. I unzipped the plastic bag and out tumbled the fresh blanket, its cord and control attached. We spread it on the bed, smoothed out the creases, and plugged it into a wall socket. A red light came on and I read the directions, turning the knob slowly to the right until it clicked, then turning it one more digit. I let Mary do it several times until she felt comfortable with it. At that moment I wondered about my own mother, and felt thankful my stepfather was with her. We lay another blanket over the electric one, and then a comforter.

"Little Cheryl, she gave me this," said Mary. "She said it was her mother's and she wanted me to have it. Could you use this old electric blanket?"

"We never seem to have enough quilts for our large family," I said. "Sure I'll take it. I'll pick it up later when I come back this afternoon. And I'll take your apples to the root cellar." She opened the lid to her washing machine and took out several towels, a pair of sheets and pillow cases. "Here," I said, "let me hang them on the line." And I walked outside to her clothesline, strung between two locust trees.

I was aware of the river running only a few feet away as I gazed up the canyon to the highest rims and wondered how many times Mary had done the same. It was pure pleasure hanging out Mary's clothes, and refreshing being out in the clean air after working up a sweat inside, where Mary kept her little home just right for her but too warm for me. When I returned with the laundry basket, I realized it was nine o'clock and that all I'd had for breakfast was a glass of water. My body needed nourishment.

"Have you eaten anything?" I asked Mary.

"No," she replied. "Let's fix us some breakfast." And with that she went to the fridge for two pieces of side pork, which were soon sizzling in the pan. "How about an egg?" she asked.

"Sure," I said. The smell of that side pork made my stomach rumble.

"Here, make us some toast," she offered, handing me two slices of bread. "Oh," she said, "Lyman sold his calves."

"Great," I said, knowing his humor would have improved and things would be better for Mary. Ranchers uptight about not selling their calf crop oftentimes took their frustrations out on their wives. After all, it was their only cash flow of the year.

"Yeah, he finally found a buyer for those big calves," she continued. "Sure was worried about running out of pasture, and feeding that hundred dollar hay."

"I bet," I sympathized, buttering the toast. We ate hungrily, this little 84-year-old woman and I, savoring our food, drinking coffee companionably. Normally not a coffee drinker, I enjoyed my cup as we smiled across the years that separated us, gossiping about the river folk.

"The fellow up Freezeout," I asked, "the one with all those dogs, what do you know about him? And whose dogs are those wandering up and down the road?" And I wanted to know about the new outfit that bought the old Garnett and Stertz places up Grouse Creek, and wanted to know about all those newly-planted alfalfa fields, and them pumping water out of the river.

Mary knew the answers to all my questions. She told me about going to town to her doctor appointment, and about Lyman's x-rays and blood test. "His knee's not as bad as he thought," she said. Seventy-three-year-old Lyman doing the work of a 30-year-old, his body wearing out. Doctor amazed at his physical condition. "Lyman, he couldn't eat before his blood test and by the time my own appointment was over, he was plumb starved. Mark and Addie said they'd take us to dinner at May's, next to Courtney Motors there in Enterprise. Do you know, most places won't serve steaks at noon?" said Mary. "And that's when ranchers often eat their big meal of the day."

"Not many ranchers left," I said. "Now they cater to the nine-to-fivers, who want salad and soup for lunch. They don't call it dinner anymore, just lunch."

Changes — so many changes, and so many new faces Mary didn't know in Safeway. Hardly anyone of her generation left.

"Sometimes, I feel so alone," she said, "all of my friends gone." When the last crumb was consumed I cleared the table and did the dishes, both of us talking away. Mary pulled a bleached towel from a drawer and carefully dried each plate. I noticed her silverware and spatula, well-used, and I imagined how they were carried by pack horse to and from cow camps over the years. She had a story for every utensil, like the spoon Kid flattened out to use for a spatula to turn pancakes. You could tell she was attached to every one.

When we finished, Mary hugged me again. "Thank you," she said.

"Don't thank me, Mary. It was my pleasure." And I told her she was like my own mother, who lived so far away.

Walking back to the retreat, just across the river from Mary's place, I reflected on my morning. Those three hours of sharing a slice of Mary's life were just what I needed.

At age 84, Mary still celebrated New Years Day on Imnaha in 2002 by visiting neighbors along the river. Along with her constant companion Lyman, Mary participated in an annual tradition that most probably stemmed from those early years.

"It was cold and the flu was going around and I didn't really want to go this year," Mary told me, "but Lyman, he wanted me to go, so I went."

A large group of neighbors and relatives started out at Barbara and Grant Warnock's with appetizers and drinks, then drove to Lyman's and ate salad, then up to Vicky and Gary's for the main meal.

"Of course we had to have a toddy at each house," confessed Mary, "and Lyman he was pretty tipsy by that time. Vicky, she had fixed ham and scalloped potatoes, bless her, and we ate that. I was pretty glad to have real food, as it was getting late. Of course, we had to have dessert, and guess what? Dessert would be way up to the River Woods.

"I didn't really want to go any further, so I said to Lyman, 'Maybe we ought to go back and check that heifer, see if she's in labor yet.' I was thinkin' if we did that, Lyman would give up the notion of dessert, and I could go to bed. So we drive back down to his barn and shine the light on the heifer, she hadn't done nothin'. And Lyman, he's in this party mood. 'Come on Mary, don't be a party pooper, let's go have dessert.'

"So up to the Woods we went. Those new people fixed a sort of torte thing that was really good, and of course hot toddies to go with. Everyone was havin' a good time, and some of the kids were darn near asleep by midnight," Mary said. "Before we left, Gary, he brought up the story about Lyman and me comin' back from the Bridge one night. So I made sure Lyman had a couple cups of coffee before we struck off downriver."

"What story was that?" I asked.

"Well," she began, "we was comin' back upriver and seen these bright lights parked by the gravel pit, and wondered about it, so Lyman he slowed down and stopped to find out who it was."

It turned out to be a cop, and he was waiting to nail Lyman for speeding. The speed limit on the river had been 35 miles an hour, but some neighbors had complained about folks driving too fast, so they had lowered it to 25 miles an hour.

Mary continued, "The cop said, 'You're drivin' over the speed limit, and you don't have your seat belts on.' Lyman, who had been driving about 35 miles an hour, could hardly believe his ears. And being Lyman, he gave that cop a piece of his mind.

"Lyman said he didn't know the speed limit had been lowered," said Mary, "and besides, he was always careful. And who wants to use seat belts if you might end up in the river and have to fumble around to get out of the durn contraption? Why, a feller would want to get out quick, and go to swimmin' for shore, not mess with those ridiculous things," she added.

"Did the cop give Lyman a ticket?" I asked.

"No sir," said Mary, "he just grinned and gave Lyman a warning about speedin'. By mornin' that story was all up and down the river. And every year at New Years they bring it up again. Always good for a laugh. So everyone had to kid Lyman before he left. 'No speedin' now, Lyman,' they'd say. I'll admit I was pretty relieved when Lyman dropped me off. 'You're on your own now,' I told him. And hoped he'd make it to his house. It was 1:30 when I finally went to bed."

'"Was it worth it?" I asked Mary.

"Oh sure," she said, "it was fun. But I'm pretty beat today. Slept in till 8:30. And now Lyman he's giving me a bad time for sleepin' in. Can you imagine, me sleepin' til 8:30 of a mornin'?"

48 Mary's Last Years

Mary's health deteriorated in her final years. The asthma that had plagued her most of her life, aches and pains associated with her lifestyle, and broken bones, many of which had never been reported, all came back to haunt her as she aged.

She moved in with Lyman, where she continued to cook, clean, and help with the calving. Lyman's calving shed was visible from the kitchen window. Often, she'd pick up a pair of binoculars and watch a heifer in labor. She'd report to Lyman if the heifer needed help. All those years of being around cattle meant Mary could tell if things weren't going well.

Mary made it up to Marr Flat Cow Camp near Harl Butte one last time, in 2005. Barbara Warnock hauled a rocking chair up for her to sit in, and Mary made sure the cooks got everything right. She was too ill the next fall to make the trip, and somehow it didn't seem right without her. She hadn't missed a fall weaning for many years.

After returning from a trip to California in January of 2006, I called Mary to see how things were going down on Imnaha.

"Not good," she said. "I fell when I was out to town, and crushed a vertebra. Can't get around very good. Lyman's busy calving and, poor guy, he just don't get any sleep. If you come down, could you bring us some things from town?"

"Sure," I replied, not knowing what I was getting into. That Friday, Mary called me three different times to give me lists of things they needed.

"I need you to call in a prescription for me. I can't go through all that rigamarole to do it," she said. "Here's the number of the prescription."

"Oh, yes," said Mary on the second call. "We need two gallons of milk, a dozen eggs, a laxative," she said, "and a case of Coors Light beer."

I was just leaving the house when she called again.

"Lyman needs some of that milk replacer stuff to feed the bummer calf, and while you're at Grain Growers you might pick up some of that Working Man's hand cream. Lyman needs it

badly, and on his feet, too. They're really chapped."

I drove to town, traded my car for Doug's new little pickup, and ran Mary's errands. By the time I turned upriver on the Imnaha it was nearly 11:00. Twelve miles later, I was driving down Lyman's steep driveway and up to the log house. Inside, I found Mary sweeping barn yard dirt and hay into piles on the kitchen floor.

"That man," she said. "He just brings the whole mess from out-side...inside." Empty vaccine bottles littered the counter. Boots with manure clinging to them were thrown helter skelter under a rack of worn, torn jackets and overalls. And then here came Lyman, 78 years old, limping up the road with several days' growth of beard on his face, thin, overworked, sleep-deprived and bleary-eyed. I stepped outside to greet him.

"Eight calves since midnight," he said. "Joe, he quit me. Got mad 'cause I told him, 'Damn it, Joe, get out from under the forklift, you'll get killed.' He just stomped off, didn't come back. Can't get good help anywhere, now."

A fellow Mary and Lyman referred to as "the Poet" was fork-ing manure and soiled straw out of the calving shed.

"He's a poet," said Lyman. "Don't know anything about a cow, but he sure is good with that fork. lives down near the bridge. Says he likes the work. Say, that twin in the shed needs a bottle. I got to go check on a cow calving down by the river."

"I'll feed the twin," I said, and off Lyman went, carrying a set of pulling chains in his hands.

Back in the house, Mary said, "Lyman, he didn't come in for breakfast until 9:00, and he fried himself six eggs. Sure glad you brought eggs."

Using the milk in the fridge, I filled the calf bottle and was just warming it in hot water when Lyman burst in.

"Say, being as you have the pickup, maybe you could haul that calf out to Tucker Down Road. I'm giving the bummer calf to the Fluit girls, that would save Joanie a trip down."

Wondering how that was going to work in Doug's new pickup with no racks, I gulped but said, "Sure!"

"I'll just set him in the second seat there behind you. He can't go nowhere, might slobber on your pony tail or chew the seat,

but it'll all clean up." Then he was gone.

I headed down to the barn lot to feed the calf. It was cold and windy, but it was warm and cozy when I opened the stall door to where the little calf was bedded down in clean straw. The calf saw me, made a beeline for the bottle, and drained the entire contents in seconds. I made a hasty retreat before the twin calf ate me alive. It was a big, smoky-colored calf, born in a mud hole, and the mama cow only claimed her first calf.

While I was walking back up to the house I thought more about hauling that calf out. I envisioned calf slobber, pee, and worse on the new upholstery of Doug's Utde Ford Ranger. Worse yet, I could see myself averting my eyes to look back at the calf, and running off the road.

After I washed out the calf's bottle, I brewed water for tea and ate the sandwich I'd packed for my lunch. I was visiting with Mary over another cup of tea when Lyman came in again.

"Calf had one front foot back," he said. "Would never have been born. Cow couldn't dilate." He washed his bare arm off in the utility sink inside the door, amniotic fluid running down his sleeve, bits of cow pasture clinging to his elbow. I let him finish, then took a breath.

"I've been thinking, perhaps I shouldn't take that calf out. Don't think Doug would be too happy about messing up the new pickup. Might take a long time for that calf manure smell to go away."

"No problem," said Lyman, a bit sheepishly. "I shouldn't have asked you to do it in the first place."

Whew! I was relieved.

The wood stove was really cranked up and it was warm and cozy inside. Mary then told me all her woes. About how she hurt so bad getting in and out of bed. Trouble sleeping, trouble doing anything. I took a load of clothes out of the dryer and folded them, put clean sheets on her bed, peeled potatoes for supper, and dredged around in the deep freeze outside on the porch for meat for their supper and breakfast. Lyman came in again.

"I invited the Poet for breakfast in the morning," he told Mary, and left again to haul hay.

"Darn him," said Mary. "He knows it's hard to cook for extra folks. Well, I'll just lay everything out and they can cook their own."

"That's the way," I said. "Let them serve you."

Lyman appeared again, letting in a gust of cold air. "I need help moving a bunch of cows off the hill." So I grabbed my jacket and slipped on a pair of boots that lay near the door, and we were off. The cows came down easily to the calving pasture but got sidetracked near a stack of hay. It took a bit of coaxing, but we finally got them through the gate. When I returned to Mary, she looked rested and a bit better. Our visit and the help I'd given her had boosted her morale.

There were a lot of rugs in the dryer. She said, "Yeah, Lyman brung that little twin calf in the house right after it was born. Poor thing, shivering. Mama didn't lick it off. We laid it on them rugs in front of the stove, and purty soon it dried off and warmed up. Lyman give it some milk. I felt bad I couldn't get down and rub it with a towel, but purty soon it blinked its eyes and stood up and slipped on the floor and fell down. Then it was up and running around, we had to make a barricade for it. Got all the rugs pretty messed up."

I let Mary take a nap, as she hadn't slept well the night before. I puttered around doing odd jobs. When Mary woke, she said, "Lyman says, 'Don't know what I'm a-goin' to do with all these cows. I don't need 'em, too much work, gettin' too old.'" And I thought, yes, he was certainly right on that.

Then Mary said, "Been thinkin' I don't want to go through another summer down here. Time to go out on top to the nursing home."

A time and a season for everything, I thought. But how hard it must be to make these decisions, especially since everything Mary loves is down here in the canyon. And when Lyman leaves or sells out, there will go the last cow man on the upper Imnaha, the last one to make his living solely on the ranch. There are other ranchers, but they are absentee owners or else they or their wives work "out" to support the ranch. Others, born on Imnaha, work for the corporate ranchers. It'll never be the same again.

One by one the old family ranches are being sold to outside

investors, large corporations, and new folks who weren't raised on Imnaha. Sadly, when the last of the old timers have to leave us, we will have lost a generation of folks who knew the value of working together to survive. Living in isolation taught them to help each other. Perhaps in the simple yet extraordinary lives of these folks there is a lesson to be learned, a lesson that could save a nation starved for the very values expressed in the daily living Mary so faithfully recorded in her shoe box full of small five-year diaries.

I hugged Mary and waved to Lyman, who was on the tractor hauling hay, and as I passed Lyman's pasture there were 15 wild turkeys pecking on the new green grass. On the opposite side of the canyon a herd of mule deer grazed. It was a peaceful scene to the outsider, but underneath there was turmoil and sadness and hard, hard work — year-round, never-ending work that took a toll that showed on Lyman and Mary. But as I drove up on top I thought, as lives go, these two had really lived on the land they knew like no one else, had watched the seasons roll, and rolled with them.

Mary passed away on April 20, 2007, at the Wallowa Valley Care Center, where she had been a resident for several months. She nearly made it to her 90th birthday, which would have been the very next month, on May 26th.

Mary's little house, and the canyon land that she and Kid lived in all those years, remains in the Marks family.

49 Spring in Imnaha

March 23, 1959
Washed and ironed. It rained in the eve. I scattered
manure on the raspberry plants.

Spring comes to Imnaha in the night. Spring is a she, soft, warm, sweet of breath, unlike Winter, whose white robes continue to blanket the high rims, whose very existence gave names to Freezout Saddle, Creek, and Trail. If one is attuned to the seasonal shift, one awakens in the middle of a March night to gaze upon the moonlit waters of the Imnaha and note the absence of frost on basalt and snake grass. One will hear the tree frogs over the sound of water, and sense the silent flight of the owl.

Long sweeps of flashlight beams illuminate corrals where cows calve silently in the the dark hours. Mary and Kid slip out of their cozy bed to don old jackets and walk out in the inky darkness. Night check. Kid and Mary know about spring on Imnaha. They can feel the change.

At dawn meadowlarks perch on rose-hip-laden bushes to startle the morning. Mergansers fly, two by two, upriver. Hawks sit in high stick nests perched in leafless cottonwoods. The earth warms slowly and Mary steps out the back porch to walk around her house. Her snowdrops are blooming.

On a high, sunny bench, steam rises in the morning air, and a newborn calf struggles to free itself from a warm, moist placenta. Hidden from view, a bald eagle waits patiently for its breakfast. A small herd of elk move dreamily around the steep canyon side like a desert caravan, grazing old grass mixed with the first greening. Life in the cow elks' bellies stirs to the sun's warmth.

Mary notes the first buttercups and kitten tails appearing on a sunny slope above Indian Creek. Later comes the celebration of yellows, when the Oregon grape, arrowleaf balsamroot, dandelions and yellow bells bloom.

What used to be icefalls melt under spring's breath, and hundreds of waterfalls cascade over blackened basalt on their way to join the Imnaha. At the edges of these falls tiny ferns struggle for existence and drink the spray that nurtures them. Watercress

pushes through the ooze in springs that flow with renewed vigor. Trails lead to these springs and tracks of cougar, bobcat, quail, mule deer, elk, weasel, coyote and cottontail rabbit spell out who has been there.

On the upper Imnaha in April, there is an explosion of apple blossoms. Their fragrant whiteness, tinged with pink, marks the old homestead where Kid's grandparents settled at the mouth of Freezeout Creek. Lilacs, iris, and daffodils brighten the abandoned yard, and in Mary's own yard tulips, forsythia, flowering quince, and pansies bloom. Whenever the lilacs bloom where Kid's grandparents used to live, she thinks of them. She remembers Kid telling her about Benjamin and Elizabeth, and when it's lilac-blooming time she walks across the river and down to the small burial plot where the couple sleeps, their bones mingled with the midden of the first inhabitants along the river.

Kid has dumped a load of manure on Mary's garden. Today she spreads it around with a manure fork, and hauls some in a wheelbarrow to spread around her raspberry patch. After the rains fall on the garden, soaking in the manure, Kid will till the soil, and then onions, lettuce and radishes can be planted.

Mary wonders when the rattlesnakes will come out and sun themselves on the high rocky ledges. They've been sleeping all winter. She hears the cry of cowboys, the barking of border collie dogs, and waves to her neighbors driving cattle past on the road above. She takes note of the river and its color change. The snow is melting up high in the mountains, and swelling the river. Another spring has come to Imnaha, and Mary is another year older and another year wiser from living here. Like the river, she flows with the seasons.

Soon it will be turnout time, and Mary and Kid will trail their cattle up Grouse Creek to the high forested country around Harl Butte. They will spend most of the summer living in a crude cabin but there will be frequent trips back down the trail to their place on the river. Mary will still tend her garden, and later she will return to can the fruits of her labor. As in years past, she will spend equal amounts of time in a saddle and in the house. It's all part of being a Marks and a canyon woman. It's all part of Mary's life on Imnaha.

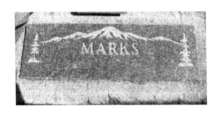

Kid and Mary's headstone.

What makes the engine go?
Desire, desire, desire.
The longing for the dance
Stirs in the buried life.
— Stanley Kunitz

What do I want
among these folks,
who live where the wild
wind-hearted horses still run
who will not be dead
until they are.

Is it the blessedly real,
like dinner tonight down at Mary's
only it was Lyman's place,
good looking rancher,
seventy five,
doesn't say much
yep, nope, pass the potatoes,
do you ladies want
squash pie or apple
beneath pie plates
I hear baler,
tractor, forklift,
the engine hum in Lyman

Underneath my good
breeding and manners,
a drone of longing
but I am a guest
and the log house
is solid and beautiful, with elk
racks, stuffed cougars,
the intact symmetry

of wood
piled for winter,
and something else,
beyond what is necessary
for survival, in Mary and Lyman,
as if they are the last two diamonds
of the West,
two wild high cards
in the last good poker game,
hard to imagine
who will be left
to deal.

Way back in the canyon
where the herders camped
Mary peeled apples, she was sixteen
prettiest woman in the valley I'm told,
under eighty eight years
she is roan, leather polished,
as if all the wind
that has touched her
is in her,
all the years of wild onions,
clumps of mountain blue flax,
make of her a root cellar,
an earthen storehouse
of canyon years.
She is Lyman's woman
they say she keeps him
in line.

What can I say
between bites of mashed potatoes,
homemade applesauce,
canned green beans,
how can I ask them
if they hear
ancient airs,

between swallows
far back in the hills
banshee cry of sorrow
for this last wild place.

Let me not sentimentalize
one hawk-wild outcropping,
indignify one dust speck, one stream-swept stone
let me grow to love my insignificance
any dwelling I build here
is a house of cards
humility and wing-beat the rafters.

These ranchers
their engined anthems of tough work
the body's calibrated know-how,
flit through a certain long held dream,
I am a water ouzel dipping shallows
I take a drink
balance on the tenuous branch
but do not dive in
to touch corded
muscle, ropey vein, run
my finger along tight
press of lips
instead, I rub together
the dry wood of my ribs
want to give my heart
that oldest primal fire
because we have forgotten
how to loosen desire
but we still want to.

Merna Ann Hecht
Imnaha Canyon
October 2005

CPSIA information can be obtained
at www.ICGtesting.com
Printed in the USA
JSHW061114221222
35292JS00001B/6